STUDYING WITH THE MASTERS

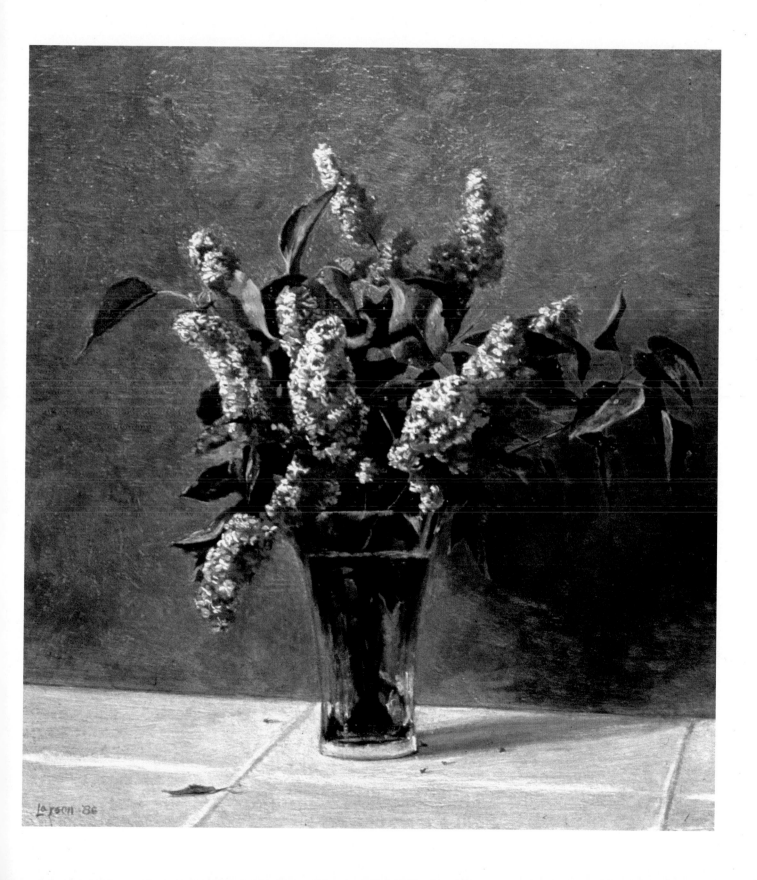

STUDYING WITH

Dean M. Larson

THE MASTERS

Lessons from
Rubens
Velázquez
Turner
Degas
Monet
Sargent
Matisse

WATSON-GUPTILL
PUBLICATIONS/
NEW YORK

Art on first page:
Dean Larson
LILACS
1986, oil on canvas
16″ × 18″ (41 × 46 cm)

Art on title page:
Dean Larson
STILL LIFE WITH PEACHES AND PEARS
1984, oil on canvas
16″ × 20″ (41 × 51 cm)
Private collection

First published in 1986 in New York by Watson-Guptill
Publications, a division of Billboard Publications, Inc.,
1515 Broadway, New York, N.Y. 10036

Library of Congress Cataloging-in-Publication Data
Larson, Dean M.
 Studying with the masters.

 Bibliography: p.
 Includes index.
 1. Painting—Studying and teaching. 2. Pictures—
Copying. 3. Painting—Technique. 4. Artists'
materials. I. Title.
ND1120.L37 1986 750′.28 86-13234
ISBN 0-8230-4994-9

Manufactured in Japan

First printing, 1986
1 2 3 4 5 6 7 8 9 10/91 90 89 88 87 86

Acknowledgments

I would like to thank the following people who helped make this book possible: Bonnie Silverstein of Watson-Guptill Publications; the Baltimore Museum of Art, especially Nancy Boyle Press and the museum library staff; Hans C. Schuler; Ann Didusch Schuler; Frederic Schuler Briggs; Will Wilson; Fred Machetanz; Stanley Pollack; and Gordon Sparber. Special thanks to Charles Gentile and my parents, Ron and Emily.

Dean Larson
STILL LIFE WITH APPLES
1985, oil on canvas
12″ × 18″ (30.5 × 46 cm)
Private collection

Contents

RUBENS:
Master of Three-Dimensional Form

VELÁZQUEZ:
Exemplar of Pure Painting

MONET:
Master of Jewellike Textures

SARGENT:
Painter of Lively Brushstrokes

TURNER:
Brilliant Painter of Light 42

DEGAS:
Champion of Composition 60

MATISSE:
Creator of Emotive Color 118

Developing Your Own Paintings 134

Introduction

NO MATTER how you paint, whether realistically or completely abstractly, having a thorough knowledge of your craft—as well as your subject—will allow you to express your ideas successfully. But how do you acquire this knowledge? Learning to paint by trial and error—which is, unfortunately, what often happens—can be a frustrating experience. For centuries, an important method of teaching art involved copying the old masters. The process of copying trains both the eye and the hand; it also provides instruction on composition, the use of color and value, and painting techniques. The seven artists discussed in this book—Peter Paul Rubens, Diego Velázquez, J. M. W. Turner, Edgar Degas, Claude Monet, John Singer Sargent, and Henri Matisse—all copied previous masters. For them, copying was not merely a student exercise; it was a source of ideas throughout their artistic careers.

Dean Larson
STILL LIFE WITH CHESTNUTS
AND CHINESE PORCELAIN BOWL
1985, oil on canvas
10″ × 12″ (25 × 30.5 cm)
Private collection

As a student, I was fortunate in finding a small art school in Baltimore—the Schuler School of Fine Arts—which emphasizes studying and learning from the work of great masters. The curriculum there is much the same as in the French ateliers of the nineteenth century. One of the few differences is that instead of starting out by copying engravings, the students begin by doing many drawings from plaster casts of classical sculpture. Hard charcoal is preferred in developing a light touch, and getting the right proportions and values is stressed above all else.

Emphasis on drawing from the antique continues throughout the four-year program, but when the drawings from plaster casts reach a certain level of proficiency, students are assigned master drawings to copy. Rubens is a favorite, and I can recall copying many of his graphic pieces. The next step is to execute a copy in oils. Rubens and Velázquez, among others, are recommended as artists from whom a great deal may be learned about oil painting methods.

A school situation, where younger students work side by side with advanced students, under the supervision of a gifted artist, is of course ideal. Yet for people with commitments that don't allow for full-time study, there are still many other opportunities for proper training and for developing one's talent. Many museums now allow artists to paint copies directly in front of the original paintings. There are always a few restrictions, such as making the dimensions of the canvas two inches smaller or larger than the original, but for the most part museums are helpful in making the arrangements.

The idea of this book is to provide a start for your own study with the old masters. There is information about the techniques and materials the artists used, and there are demonstration paintings, which reconstruct how a particular masterwork probably progressed from start to finish. The job of making a copy is easier when you know how the original was done. And not only is it easier, the results are much better—the original and the copy look the same not only on the surface, but all the way through.

Of course, you must also learn to observe the painting carefully. When you go to the museum and stand in front of the original, ask yourself such questions as: Where are the lightest lights and darkest darks, and why are they placed where they are? Where is the focal point and what characteristics make it prominent? How is the eye led through the painting? What kind of compositional devices, if any, did the artist use? Move up close to the painting and look at the edges. Are there any areas where the priming is exposed? If so, what color is it? Do the grounds show anywhere else in the painting? Answering some of these questions may require repeated viewings of the work.

As you study the masters, bear in mind that good painting is a continual decision-making process. When you paint, you are constantly making choices. And the same was true of the great masters. It is not useful to think of them as superhumans. However gifted, they took the same chances and experienced the same difficulties artists face today. Yet they were not daunted by the challenges they took up; instead, they found solutions to their painting problems.

Each of the artists selected for this book highlights a different painting challenge. By studying how these painters worked and how they resolved the problems they encountered, you will learn much about form, composition, color, light, brushwork, and the handling of paint. Then, as you move on to create your own work, you should be better able to solve the problems you encounter. Painting is never easy, but the more knowledge and information you have, the easier it becomes.

Basic Methods and Materials

MAKING an accurate copy of an old master painting requires a lot of careful research. It is a good idea to call the conservation department of the museum and inquire if any examination records are available on the artist. If luck is with you, technical analyses may have been done on the very painting you are copying. If, however, such records are not available, there are some helpful periodicals you can refer to. *Art and Archeology Technical Abstracts* briefly describes most of the published technical information for each year and tells where the complete source can be found. Also look at the *National Gallery Technical Bulletin, Science and Technology in the Service of Conservation*, and the *American Institute for Conservation of Historic and Artistic Works*, which publish technique and material-related articles.

Throughout this book I have attempted to use the most reliable documentation available, but—even with modern conservation analysis—it is often impossible to be absolutely certain about an artist's exact working methods. The bibliography on page 142 lists the major sources I used. What follows is a brief overview of the basic materials I used in painting the demonstrations. More specific information is given in the discussion of each artist.

PIGMENTS. Modern conservation analysis allows for the precise identification of the pigments used in specific paintings. In addition to this research, however, I recommend that you prepare color swatches on a piece of canvas. Take a scrap of canvas and paint spots of each pigment on it. You can also mix the pigments with white, black, and other colors. Then hold your color swatches up to the painting. Museum guards may wonder what you are doing, but as long as you do not touch the painting, it is all right. Certain artists— many of the Impressionists, for instance— liked to use pure pigments in spots, so their palettes are easier to discern than those of artists who blended continually. Also, bear in mind the yellowing effects of varnishes, which may alter the colors. After you determine the pigments, experiment with them. Try to discover which combinations and mixtures the artist preferred.

For the artists in this book, I have included photographs of the modern-day equivalents of their palettes. Most of the pigments are the same ones the artist used, but, for those that are now obsolete, I have chosen the closest possible substitute. Note that vermilion and cadmium red light are basically interchangeable. Naples yellow, however, is a color that varies greatly depending on how it is manufactured. Naples yellow light has a cool cast, toward green—like lemon yellow. Naples yellow deep is much warmer. When not specified light or dark, the color implied is Naples yellow medium, which is generally a lighter shade of the warm Naples yellow deep.

For the demonstrations on Rubens, Velázquez, and Turner, I ground powder pigments, as the artists themselves would have done. Degas, Monet, Sargent, and Matisse all used tube paints, so in doing those demonstrations I employed commercial paints. Powder colors are much purer and more permanent, but the grinding process can be restrictive, especially for on-location work.

MEDIUMS. For the demonstrations, I have tried to use the medium the artist is said to have used. In my own work I prefer the Maroger medium (see page 137). Other paint-

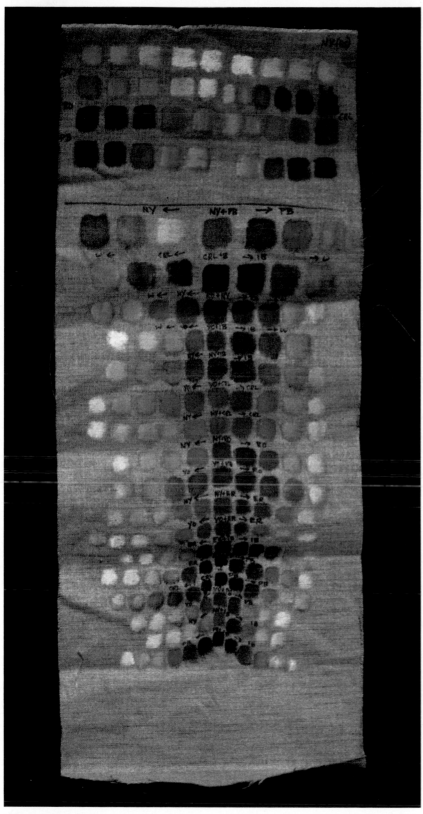

A color swatch like this one can be helpful in determining the mixtures used in a specific painting. On the top at the sides are pure colors, like Naples yellow or yellow ochre, with increasing amounts of white added as you move toward the center. Below this are various two-color combinations, such as Naples yellow and Prussian blue, with different amounts of each color as well as different quantities of white. The more time you spend preparing a swatch like this, the more accurate your information will be when you compare the swatch with the painting in the museum.

ing mediums I recommend are Copal Painting Medium-Heavy and Liquin (manufactured by Winsor & Newton).

OILS. The demonstrations in this book have been done with black oil, raw linseed oil, or washed, cold-pressed linseed oil. Black oil is oil cooked with litharge to speed its drying time (for recipes, see Joseph Sheppard, *Learning from the Old Masters*, pp. 10–19, and Mary Carroll Nelson, "Siegfried Hahn and Howard Wexler: Classical Principles and the Maroger Medium"). Raw linseed oil is by far the easiest oil to come by, but it contains many impurities. Cold-pressed linseed oil is oil extracted from flaxseed without using heat. It is more expensive and harder to obtain than raw oil, but is much purer and less likely to discolor over time. A method for washing oil is given on page 19.

BRUSHES. For bristle brushes, I recommend Signets, manufactured by Robert Simmons. Grumbacher bristle brushes are also of good quality and readily available. For sables, Robert Simmons are good, but the best ones I have found are called Martora Kolinsky. They come from Florence, Italy, and can be obtained by writing Zecchi, di A. Zecchi and Figli, Mesticheria belle Arti, 50122 Firenze via dello Studio. Most useful are the series 100 (rounds) and the series 102 (filberts). Although overseas mailing can be complicated and slow, the results are worth the effort.

CANVAS. Many of the old masters preferred to work on toned canvases, as it is generally easier to see color and value relationships against a tone than against a stark white. Some artists, however, prefer working on a white canvas. Essentially this is a matter of preference, and there are advantages and disadvantages to both choices.

I always work on natural linen canvas, which gives a superior surface and stretches better than cotton. Onto the untreated canvas I apply two or three layers of rabbit-skin glue, followed by one to three layers of white lead, applied with a large palette knife (each layer makes the surface smoother). When mixing the white lead, I use some turpentine and a drop of Japan drier to speed the drying time. Even with the drier, however, the longer you let the canvas dry, the better. Rubens often waited months before using his canvases.

Another advantage of linen is that it is very strong. Keep in mind that the binding strength of paint is largely dependent on the strength of the grounds beneath the paint layers. The stronger the ground, the longer the painting is likely to last. A fairly heavy linen coated with rabbit-skin glue and white lead remains one of the preferred grounds.

Master of
Three-Dimensional Form
RUBENS

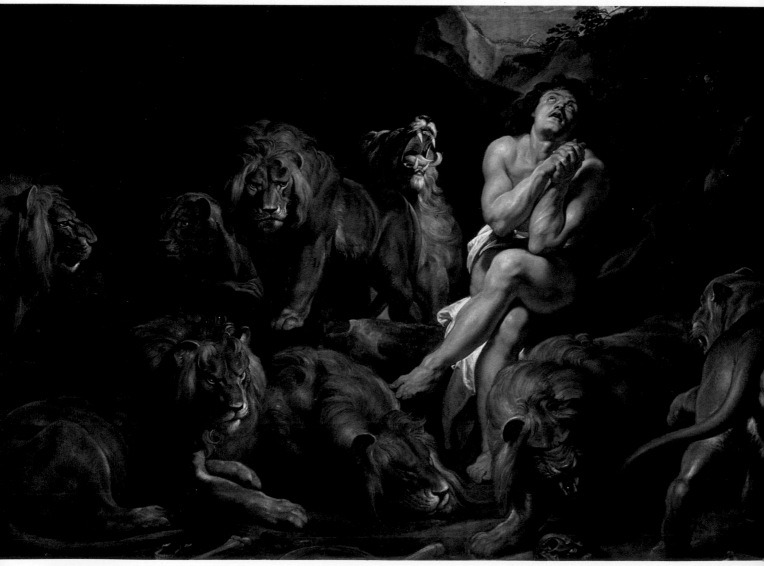

Peter Paul Rubens
DANIEL IN THE LIONS' DEN
c. 1615, oil on canvas, 88¼″ × 130⅛″ (224 × 330.5 cm)
National Gallery of Art, Washington, D.C., Ailsa Mellon Bruce Fund

PETER Paul Rubens (1577–1640) is

renowned for his ability to create the illusion of three-dimensional form and to give life to his figures. At times his compositions transmit such dynamic energy that it is difficult to believe they are mere two-dimensional representations. In his depiction of movement and restless energy, Rubens represents the epitome of the Baroque style. In opposition to the Renaissance ideal of perfect proportion, his work is said to seek beauty in ugliness.

Rubens had a large influence on his contemporaries, and approximately two thousand paintings are attributed to him (or his workshop). Some critics find his paintings easier to admire than to love, but wherever one stands in one's opinion of his work, there is much to learn through the study of his technique.

Life and Studies

Rubens was born to Flemish parents, who were residing in Germany at the time. When he was still a boy, his father died and shortly afterward his mother returned to their original home in Antwerp. In 1591, at the age of fourteen, Rubens began his formal art studies with Tobias Verhaecht, a landscape painter. The following year, however, he started to study with Adam van Noort, an able figure painter, who was also, later, a teacher of Jacob Jordaens. In 1596 Rubens probably entered the studio of Otto van Veen, who had studied Italian methods for many years and was skilled in portrait and figure work. Rubens may also have studied with other artists during these formative years.

In the studios of these teachers, Rubens probably served a traditional apprenticeship, spending his days grinding pigments, preparing canvases, and copying master drawings. He also became familiar with the complex symbolism so integral to Flemish painting of the time. It may be encouraging to note that Rubens was not a child prodigy. Instead, it was through hard work and discipline that he became a master of his craft.

In 1598, at the age of twenty-one, Rubens was admitted to the Antwerp Guild of St. Luke. Not only did membership in the guild enhance his reputation as a professional artist, but it also enabled him to obtain certain important painting materials, such as cold-pressed linseed oil.

Two years later, in 1600, Rubens set out for Italy, accompanied by his pupil Deodatus van der Mont (who figured in many of Rubens' paintings during this time). In Italy Rubens became court painter to the duke of Mantua and saw many great artworks in the duke's collection, some of which he copied. Indeed, copying became a passion with him, a means of study that he never outgrew. While in the duke's service, Rubens traveled extensively both in Italy and in Spain. On a trip to Rome, he saw the Sistine Chapel and many other masterpieces by Michelangelo, Raphael, Leonardo, and Caravaggio. In Venice he studied the paintings of Titian, who became a lifelong inspiration. The ideas and techniques he learned from studying these masters provided a solid foundation for his mature work.

In October 1608, while still in Italy, Rubens received news that his mother was critically ill. Departing for Antwerp immediately, he arrived home only to find his mother already dead. He decided, however, to remain in Antwerp and was soon appointed court painter to the regents of the Netherlands. It was also at this time that he married Isabella Brant, who appears in a number of his paintings.

Although Rubens often worked with assistants, this painting is executed entirely by his hand. In it you can clearly see the swirling movement typical of his compositions as well as the amazingly lifelike appearance of his figures.

Peter Paul Rubens
VENUS AND ADONIS
c. 1635, oil on canvas, 77⅝″ × 95⅛″ (197 × 242 cm)
Metropolitan Museum of Art, Gift of Harry Payne Bingham

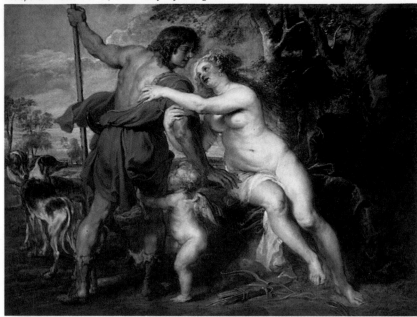

Rubens painted a variety of subjects, including mythological scenes and portraits. Note how, in both these paintings, the positioning of the figures and the lighting contribute to a feeling of movement. Also note the different treatment of the male and female figures in the painting Venus and Adonis.

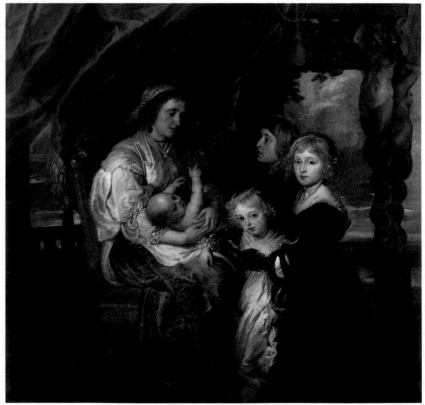

Peter Paul Rubens
DEBORAH KIPP, WIFE OF SIR BALTHASAR GERBIER, AND HER CHILDREN
1629–30, oil on canvas, 64¼″ × 70″ (163 × 178 cm)
National Gallery of Art, Washington, D.C., Andrew W. Mellon Fund

Rubens soon opened a large studio, and apprentices, including Anthony van Dyck and Frans Snyders, began to work and study with him. He received many commissions and, in addition to painting, designed title pages for books; made copies of coins, gems, and medals; and restored old paintings. On the whole, Rubens was highly successful, but one unfortunate incident occurred when Lucas Vorsterman, a former assistant, attempted to kill him. The two men, however, reconciled their differences and Vorsterman worked for Rubens again, many years later.

Highly intelligent and fluent in six languages, Rubens was called upon by various nations to perform diplomatic duties and was eventually knighted by the kings of both Spain and England. In 1628, on one of his diplomatic missions, Rubens traveled to Spain, where he met and befriended the much younger Diego Velázquez (see page 27).

Rubens' first wife had died in 1626, and in 1630, at the age of fifty-three, he took a second bride, sixteen-year-old Helena Fourment. Between Isabella and Helena, Rubens fathered eight children, although the last (a daughter) was born posthumously. He died in 1640 from heart failure, brought on by an attack of gout.

Ideas on Painting

Rubens was successful at combining the rich northern tradition of painting with the monumental, energetic Italian style. He had a conscious partiality toward large canvases and asserted that a large scale allowed him to be more courageous in expressing subjects distinctly and authentically. Indeed, he claimed that his talent was such that no undertaking, no matter how vast in size or diverse in subject, was beyond him. In his studio he kept scaffolds for work on these large paintings.

Rubens' subject matter extended from biblical, mythological, and historical scenes to portraits and genre scenes. Often he included landscapes as backgrounds in his paintings, especially in his late work. During this final period he also did a number of purely landscape subjects, sometimes with the addition of a few small figures. These landscapes display the aggressive energy so characteristic of Rubens' work.

COMPOSITION. Rubens imbued his subjects with life through his handling of composition. He avoided static geometric forms and instead preferred curves. To create rhythm in his paintings, he often repeated irregular S-shaped curves, setting up a kind of swirling motion.

Another technique Rubens frequently used was to keep the horizon relatively low. This allowed for large expanses of sky, clouds, and trees. The figures or other subjects in the foreground were usually near the bottom of the canvas, thus grounding the composition.

FIGURES. Rubens' round, soft female figures are quite different from his muscular, robust men. In *The Art of Painting,* Jacques Charpier suggests Rubens followed a specific formula in painting women. His ideal of female beauty may be inferred as a woman of medium height with gracefully proportioned limbs, not overweight but moderately fleshed out, with the flesh solid and firm, and with pale pinkish coloring. Her face was full of grace and without wrinkles; her neck, somewhat longish and rounded. Her shoulders were medium broad; her arms, round and soft; her fingers, long but plump, suggesting a delicate touch. Usually her breasts were ample and slightly separated; her waist was narrow, although her thighs were large and full. From the rear view, her upper back was flat with a slight depression in the middle, running down the spine; her buttocks were plump and round, tucked up and not drooping at all, while her legs were straight and slightly plump, descending gracefully to her feet. As for the feet, they were usually small, with a rounding of the flesh on the instep.

Drawing Techniques

Rubens' drawings are often considered his most immediately appealing works. One of the greatest draftsmen of all time, he was a master at subtly describing three-dimensional form with hachure lines—parallel strokes that follow the shape of the form. Rubens combined these hachure lines with slightly heavier outlines to create extraordinarily sensitive sketches.

Rubens used drawing for different purposes and altered his style accordingly. At times he used drawings instead of oil sketches to decide on the composition for a painting. In these drawings he continually made changes and alterations, so they tend to reveal more about his excited imagination and energetic working methods than his abilities at subtle rendering. In any case, when Rubens intended his drawing as a plan for a painting, he squared it up, placing horizontal and vertical lines in a grid over the composition. A corresponding grid could then be placed on the canvas, with proportionately larger spaces between the lines, depending on the size that he wanted. The drawing could then be transferred to the painting surface by matching,

Peter Paul Rubens
PORTRAIT OF ISABELLA BRANT
1620–25, oil on wood, 22½″ × 18⅞″ (58 × 48 cm)
Cleveland Museum of Art, Mr. and Mrs. William H. Marlatt Fund

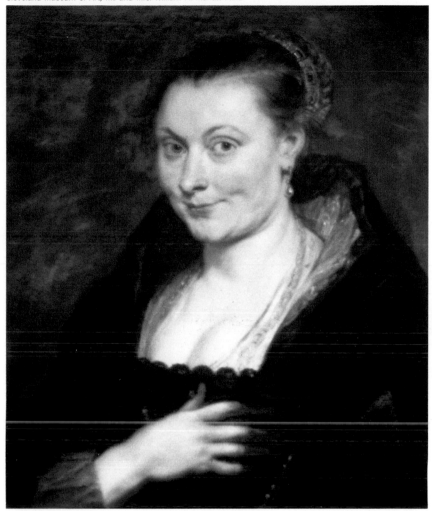

The portrait above shows Rubens' first wife, Isabella. In the drawing you can see his skill as a draftsman and his masterful handling of lights and darks to create the illusion of volume.

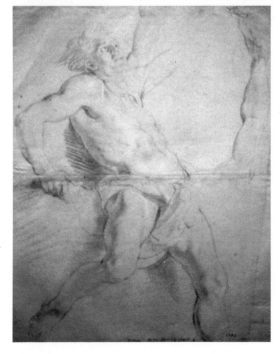

Peter Paul Rubens
STUDIES OF A MALE NUDE
1612, chalk on paper
Nationalmuseum, Stockholm, Sweden

15

Suggesting Three-Dimensional Form

This detail from Rubens' painting *Daniel in the Lions' Den* (shown on page 12) reveals his remarkable ability to create the illusion of three-dimensional form. Notice, in particular, the relationship between the highlight (A), the shadow (B), the reflected light (C), and the cast shadow (D). As the form moves from the highlight into the shadow, there is a sense of roundness and the edges are soft. The reflected light along the side of the leg brings out the fullness of the form, while the dark tone of the cast shadow helps to throw the form into relief. Within the transitional areas, observe Rubens' use of subtle grays (E), made of black and white and possibly some blue. These delicate grays lend a softness to the form and increase the feeling of roundness. Also look at Rubens' use of midtones (F) and the way he intersperses cool tones within the flesh to make the warm tones tell.

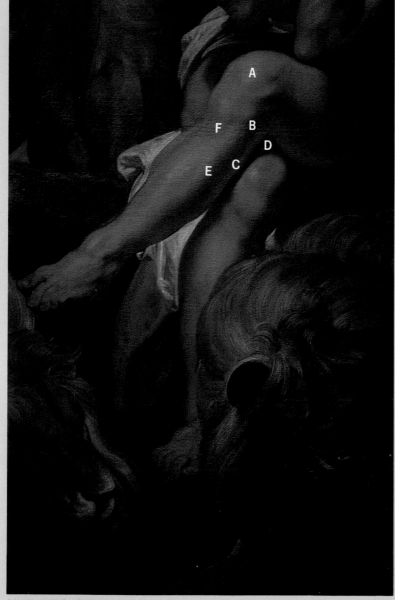

DANIEL IN THE LIONS' DEN (detail)
National Gallery of Art, Washington, D.C.,
Ailsa Mellon Bruce Fund

point for point, where its lines intersected the grid.

Rubens also did drawings from life to fix such details as the hands, faces, and feet in a painting. At other times he drew from statues and plaster casts, but he took care not to copy them too closely. He explained to his students that artists should keep in mind the differences between two-dimensional and three-dimensional artworks: drawings and paintings should be light and lively, without the heavy, static feeling of plaster casts.

A technique that Rubens used in drawing as well as in painting was to place tones side by side, but not to blend them too much. Each tint was applied in its proper place, one next to another, and then the various tones were slightly blended, pulling the whole together.

Painting Techniques

Rubens usually began with preliminary sketches and then did a finished oil sketch, called a *modello*, which might be presented to prospective clients for consideration. When a design was approved, he might have his assistants began the work on the actual painting by taking the finished sketch and transferring it to the larger canvas. Working from the *modello*, Rubens' assistants sometimes did most of the painting, with Rubens adding only the accents and final touches. Indeed, the quality of the work by Rubens' studio was so high that it is often difficult to distinguish what exactly was done by the master's hand.

When Rubens himself worked on a painting, he first placed a few, loose strokes of charcoal or chalk on the canvas to mark the general composition. Once this initial drawing was satisfactory, he began outlining the drawing in varying shades of brown and then used lighter brown washes to indicate shadow areas. Rubens decried the practice of mixing even small amounts of white into the shadow colors; he was also careful to keep the darks thin and transparent. After establishing the darks, he indicated the light areas with white lead. This initial layer provided a reflective ground for future layers of flesh tones or drapery. It is generally thought that Rubens used his white sparingly at this stage, except for the brightest highlights, where thick impastos might be applied. When brushstrokes appear in the finished painting, it is often only in the highlight areas.

After laying in the figures, Rubens gave the background a tone. He then began to apply local tones, blending them only slightly to avoid any muddying of forms or loss of fresh-

ness in the color. Often he placed delicate grays in the transitional areas between lights and darks. In general, he applied color thinly, except in the light areas. He is reported to have painted with a cup or jar of turpentine beside him, probably to thin his paint or perhaps, as some authors have argued, to remove excess varnish or medium from his brush.

Frequently, if Rubens could finish a small painting in one sitting, he did so. There is even a saying attributed to both Rubens and van Dyck: "Endeavor as far as possible to complete your picture *alla prima*, because there is always plenty to do afterward." For large works, however, Rubens built the paint up in layers and allowed it to dry between stages. It is thought by some that within the layers, Rubens alternated regularly between warm and cool tones.

If the painting called for it, Rubens used glazes, applying lead tin yellow or madder lake, for example, to give brilliance to the drapery, lips, cheeks, or whatever called for it. At the end, he added the darkest darks and the brightest lights, using these accents to enhance the picture's freshness and heighten the feeling of animated, three-dimensional forms.

After the painting was complete, Rubens allowed it to dry before putting a final varnish on it. In the summer Rubens expected a painting to dry in about a week if there was a fair amount of sunshine. In the winter, however, the paint dried much more slowly. The longer the picture was allowed to dry, however, the better. It is not known exactly what Rubens used to varnish his paintings, but it may have been his painting medium plus a little sun-bleached oil for greater resistance to moisture and protection against cracking.

One aspect of Rubens' finished work that is especially appealing is his use of soft edges. Rubens learned how to handle these *sfumato* edges from his study of the Italian masters, in particular, Titian. To avoid any hardness in the final picture, he took care to paint into and soften the outlines that were drawn in the original lay-in. If you look at the finished work, you can see how the delicate, transparent and semitransparent tones in the transitional areas soften potentially hard edges.

Peter Paul Rubens
DECIUS MUS ADDRESSING THE LEGIONS
1617 (?), oil on wood, 31¾" × 33¼" (81 × 84.5 cm)
National Gallery of Art, Washington, D.C., Samuel H. Kress Collection

In this sketch for a painting now in the collection of the prince of Liechtenstein, you can observe some of Rubens' working methods. Often he outlined his drawing with brown paint (A) and then laid in the shadows with thin, transparent paint (B). He continued to paint thinly when applying local color, as is evident in the detail here. Thick impastos were used only for the brightest highlights.

Materials

DRAWING TOOLS. Rubens used different materials when sketching: pen and ink with pale gray washes, black chalk, or red chalk, often of a sanguine color. He probably preferred chalk to charcoal because it tends to stick to paper better. At times he added touches of body color, mixing watercolor with white to make it opaque. Spots of white body color might set off the brightest highlights, or other opaque colors might be used to create colored drawings.

Rubens drew on both paper and panels, whatever was on hand at the time. His sheets were usually of a medium to medium-rough texture. Although he was partial to white paper, at times he used parchment or buff-colored paper with black and white chalk.

PIGMENTS. Technical analyses have detected many of the colors Rubens employed. His palette probably included the following colors:

Yellows: yellow earth (similar to yellow ochre), lead tin yellow (Naples yellow light), yellow lake (cobalt yellow).

Browns: burnt sienna, van Dyck brown.

Reds: red ochre, vermilion (similar to today's vermilion or cadmium red light), madder lake (alizarin crimson), red lead (cadmium red light).

Greens: malachite (a clear, yellowish green, now obsolete), verdigris (a light blue-green, now obsolete), terra verte (similar to green earth).

Blues: genuine ultramarine or lapis lazuli, azurite (similar to cerulean), smalt (cobalt blue).

Blacks: plant (now obsolete), asphaltum (a blackish brown, now obsolete), bone or ivory black, charcoal (a bluish black, now obsolete).

White: white lead.

Rubens was careful in selecting his pigments, choosing only those of the purest quality. His colors were ground each morning by his assistants. There is much speculation, however, about the contents of the solution with which the pigments were ground. Some speak of an oil, others of turpentine. Grinding pigments in turpentine is not usually practiced today; the disadvantage is that the colors dry quickly. When it is done properly, however, and the paint mixed with a small amount of an oil medium, the covering power of even a thin coat is extremely strong. Through this method, deep darks can be achieved instantly, whereas, with oil-ground pigment, darks require either thick paint or many paint layers.

Rubens was well aware that his colors might become dark and faded if deprived of normal sunlight during the drying process. His remedy was to expose the painting several times to the sun, reversing the action. Today we know from scientific research that discoloration can result from surplus oils collecting in the paint. Exposing the painting to light allows the sun's ultraviolet rays to dry out this surplus oil and return the pigments to their original brilliance.

PANEL SURFACES. Rubens asserted that small paintings were more successful on wood than on canvas. His panels were usually made of oak or walnut (South American mahogany also works well). Through a special division of panel-makers in the Guild of St. Luke, Rubens had access to high-quality hand-planed panels. Many of them were made from two or more pieces, glued together edge to edge or with a slight overlap.

To prepare his panels, Rubens probably first applied one coat of animal glue (rabbit-skin glue works well). He then added at least two or three coats of animal glue mixed with a generous amount of whiting. If you try this, be sure to sand each coat slightly with fine sandpaper, or scrape it with a razor

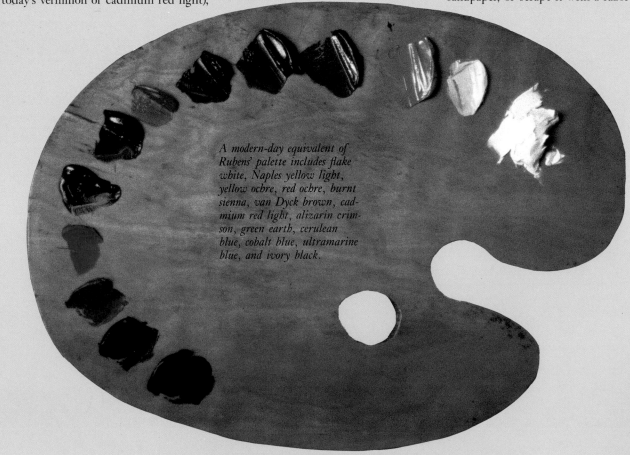

A modern-day equivalent of Rubens' palette includes flake white, Naples yellow light, yellow ochre, red ochre, burnt sienna, van Dyck brown, cadmium red light, alizarin crimson, green earth, cerulean blue, cobalt blue, ultramarine blue, and ivory black.

blade or another suitable scraping tool.

At this point Rubens usually applied an imprimatura coat containing chalk and white lead powder, ground in an oil medium. Often some color, usually gray or brown, was mixed with these ingredients. (For a gray mixture, you might try ivory black and yellow ochre; for a warm brown, ochre, sienna, and umber.) Rubens applied this semi-transparent base coat in single strokes—brushed on once and left alone. The result was a luminous middle tone, which often shows through in his work.

CANVAS SURFACES. The linen Rubens used was usually medium to rough. After the grounds were applied, the surface was smooth, but the bold weave of the linen was still visible, lending vitality to the painting. As with his panels, Rubens at times added pieces of linen to preexisting canvases to adjust them to whatever size was most suitable.

To prepare his canvases, Rubens first applied animal glue. Following the Venetian method, he was careful to apply this sizing as thinly as possible, so there would be no danger of cracking or flaking. Next, gesso was applied in layers. This gesso consisted of chalk, white lead, animal glue, and sometimes yellow ochre (the chalk made it an absorbent ground). If you use this kind of gesso, take proper precautions. White lead in its powder form is easily inhaled and is cumulatively toxic, building up in your body over time. Wear a protective mask and apply it outdoors, if possible, to avoid breathing in or swallowing the dust.

For his canvases, Rubens usually did not use the striated imprimatura found in his panels. Instead, he gave his canvases a more even coat of gray (probably chalk, white lead, ivory black, and yellow ochre), possibly ground in linseed oil. As a final step, Rubens applied an isolation coat with a shellac base. Again, the overall result was a highly luminous surface, of which Rubens took full advantage in his painting.

PAINTING MEDIUM. Rubens' painting medium is a highly debated subject; what we do know about it comes primarily from the writings of Dr. Theodore de Mayerne, a personal friend of Rubens. Rubens' medium is described as rich and thick, in contrast to van Dyck's thinner medium. According to Sir Charles Eastlake, an art historian who has studied de Mayerne's writings, Rubens' pigments were probably ground each morning with turpentine, although his white may have been ground in oil. After being placed on the palette, each color was mixed with some medium (linseed oil and mastic).

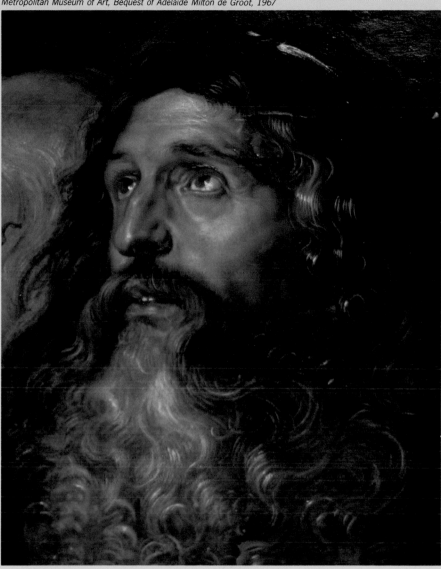

Peter Paul Rubens
STUDY OF TWO HEADS (detail)
oil on wood, 27½" × 20½" (70 × 52 cm)
Metropolitan Museum of Art, Bequest of Adelaide Milton de Groot, 1967

For fine details, like those in the beard here, Rubens may have dipped his loaded brush in turpentine and then have applied only one or two strokes before reloading his brush.

To purify the linseed oil and lessen its yellowing effect, Rubens may have used the following cleaning process: (1) Fill a glass container, half with rain water and half with oil, some cleaned sand, and some common salt. (2) Close the container, shake it for fifteen minutes, and then let it settle. (3) After the oil separates, shake the ingredients and repeat this until the oil has lost its dark color. (4) Now siphon the oil or separate it in some manner and pour it into a new container. (5) Add fresh sand, salt, and water, as before, and repeat the process two times. (6) Repeat the process yet again, but omit the salt in this last washing. (7) If these steps are not enough, bleach the linseed oil in the sun to dissolve any superfluous elements.

After cleaning the linseed oil, Rubens probably thickened it in the sun at length and combined it with litharge to make it a drying oil. Boiling was intentionally omitted.

The mastic in Rubens' painting medium may have been mixed with a turpentine of high quality. A useful proportion, according to Jacques Maroger, is two fluid ounces of turpentine to one ounce of mastic. This mixture is placed in a container and allowed to sit in the sun for at least two weeks.

As he painted, Rubens probably used small amounts of Venice turpentine with his colors to make them more fluid and to achieve an enamellike appearance. This turpentine was of the purest quality, and it was probably distilled in a water bath.

Materials:
Carb-Othello pencils
rag paper

Demonstration: Figure Drawing

Although the original is not shown here, Rubens' drawing clearly reveals why Rubens is considered one of the greatest draftsmen of all time. In addition to showing infinitely diverse contours, Rubens captures the anatomical expression of the pose. At the same time, even with so much information included, there is no feeling of heaviness.

Copying this drawing taught me a lot about the rendering of three-dimensional form. In his drawing, Rubens used a few spots of white, placed only where the highlights were brightest, to add depth and character to the forms. Yet using white highlights in a drawing mainly executed in black or dark tones is deceptively difficult. The spots of white can add a sparkling finishing touch, or they can kill any appearance of life in the figure.

Another way Rubens made the figure look three-dimensional was to include a slight indication of the background. Look at the lower right side of my copy. Here the lines extending outward from the contour create a foil for the figure, so it appears as if there were space behind and around the figure.

METHOD. In doing a copy of an old master drawing, begin by using calipers to duplicate the exact dimensions of the drawing. Then locate guidepoints within the drawing, such as the corner of the mouth or the outside point of an elbow. Once all the guidepoints are positioned (depending on the complexity of the work, around ten to twenty points), you can begin the actual drawing. As you work, keep your pencil point sharp. Hold the pencil between the tips of your fingers and thumb, below the palm of your hand. This position allows for a softer, more sensitive touch and also keeps the pencil point sharper longer. As the drawing takes shape, take care to observe the subtle shading and to attain the "spirit" of the picture.

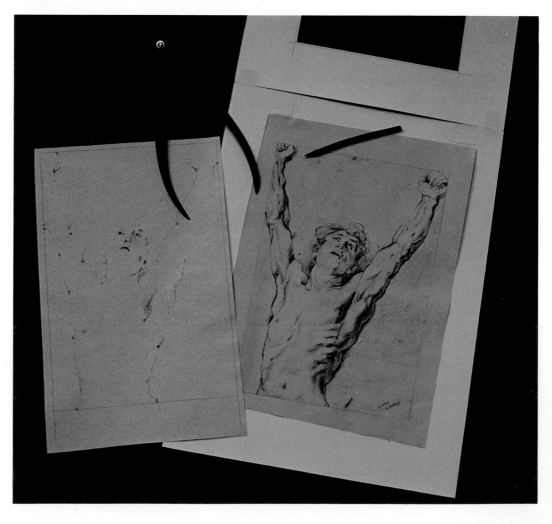

Copy after Peter Paul Rubens
STUDY FOR THE FIGURE OF CHRIST ON THE CROSS
*c. 1614–15, black and white chalk on paper, 21⅓" × 14⅘"
(54 × 38 cm), British Museum, London*

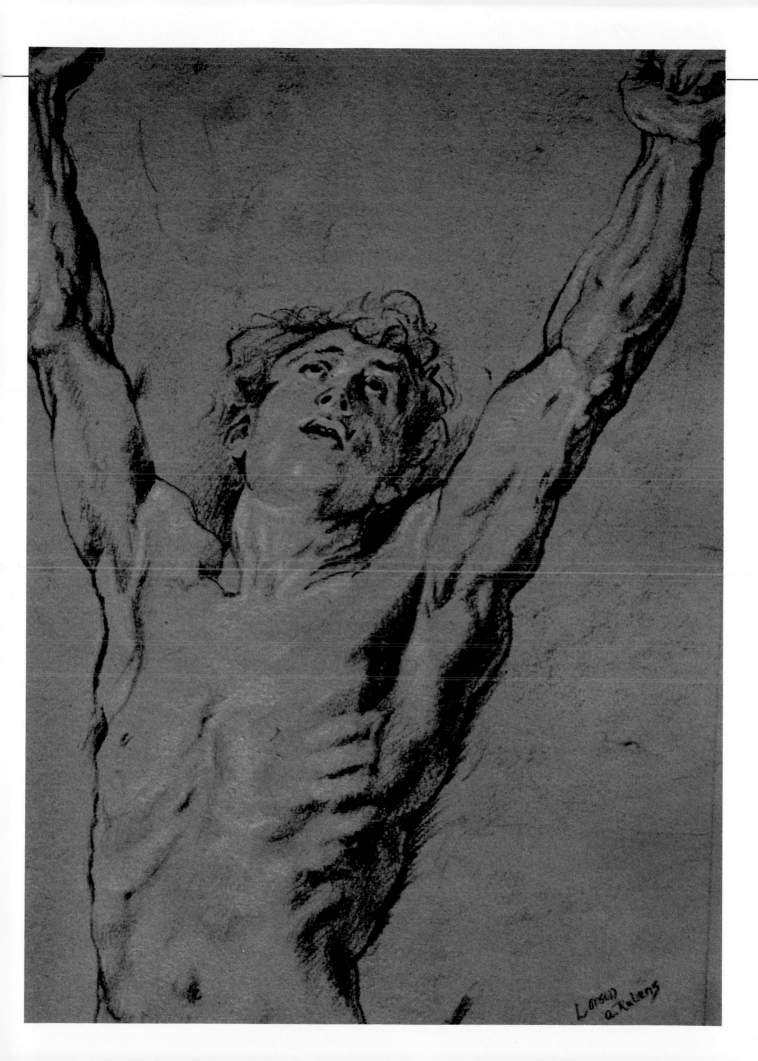

Palette:
Naples yellow light
yellow ochre
van Dyck brown
burnt umber
red ochre
cadmium red light
cobalt blue
ultramarine blue
ivory black
flake white

Brushes:
filbert bristles (no. 3)
round sables (no. 6)

Demonstration: Portrait Painting

Rubens created such a convincingly lifelike appearance in this painting that I am still amazed and inspired after viewing it for long periods of time. When I first saw this painting, I had to know how Rubens was able to achieve this level of suggestive power. I copied the painting with this in mind, trying carefully to observe how Rubens handled flesh differently from other artists. As the copy progressed, I discovered many simple techniques that together create this amazing illusion.

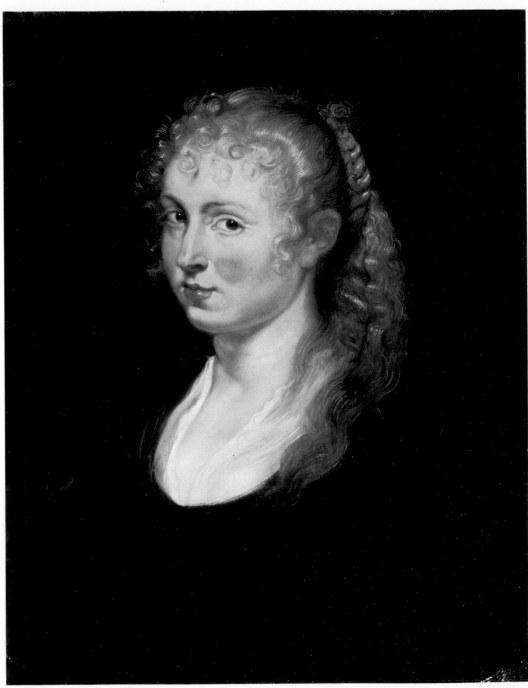

Peter Paul Rubens
YOUNG WOMAN WITH CURLY HAIR
c. 1618–20, oil on wood, 28" × 20½" (71 × 52 cm),
The Armand Hammer Collection

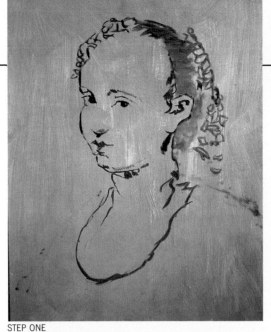

STEP ONE

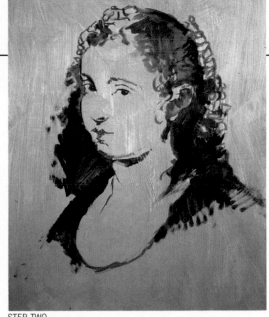

STEP TWO

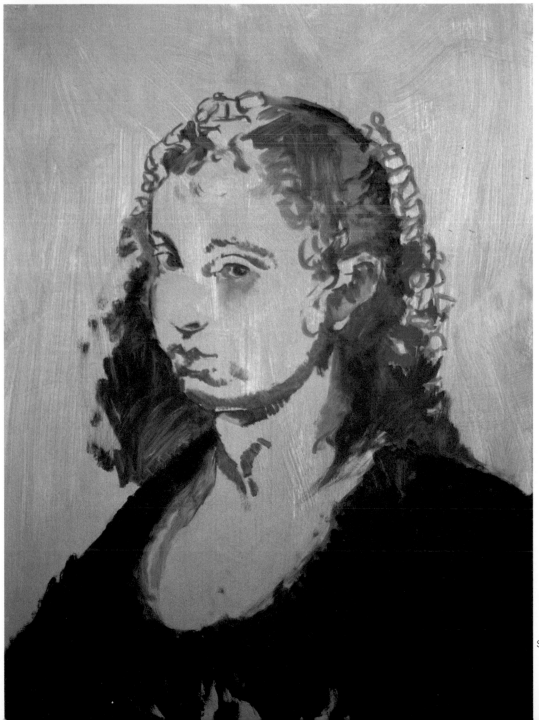

STEP ONE. Before beginning to paint, I draw the head, noting the major forms, in charcoal. Then I go over my drawing using Van Dyck brown or burnt umber, thinned with turpentine. The forms are slightly exaggerated here because during the painting process they will automatically round down. In other words, by exaggerating initially, I ensure that the finished product will have the correct proportions.

STEP TWO. Using ivory black, red ochre, and yellow ochre, I lay in transparent darks. For the background, Rubens probably used charcoal black and red lead; here, however, I substitute ivory black, red ochre, and yellow ochre, with a touch of ultramarine to indicate the tone on the left. At this stage you should apply paint rapidly. Try to enjoy the sensation of seeing your strokes register on the painting surface.

STEP THREE. Keeping the colors thin and transparent, I put in more shadow tones, followed by subtle grays, made of ivory black, flake white, and at times cobalt or ultramarine blue. The hair is painted with yellow ochre, red ochre, Naples yellow light, and touches of brown and ivory black. Again, at this stage you should attempt to paint quickly. Don't worry if tones overlap; let the paint do the work in creating subtle variations of edges and tones.

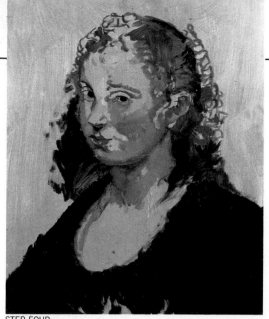
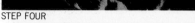

STEP FOUR

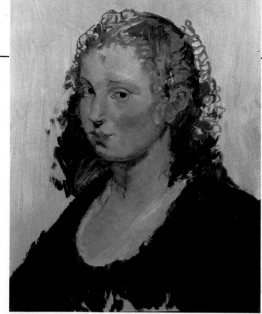

STEP FIVE

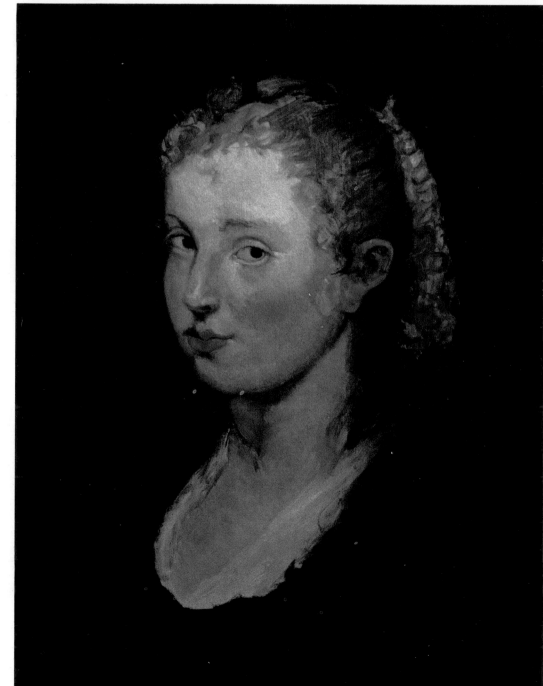

STEP SIX

STEP FOUR. Next I add the middle-tone flesh colors. Rubens used mainly vermilion, white lead, yellow ochre, and lead tin yellow for flesh. A suitable substitute is cadmium red light, flake white, yellow ochre, and at times Naples yellow light.

STEP FIVE. As I continue to add middle tones, I alternate warm tones (usually containing lots of cadmium red light) and cool gray tones. Rubens at times added golden tones, which are distinct from his warm reddish tones. In this way he created a vibrating pattern of the three primary colors. Here I mix yellow ochre with a touch of red ochre to make a rich golden tone. Notice that the different tones are applied individually, without much blending.

STEP SIX. Now the entire panel is covered with the basic tones, without too much attention yet to details. By covering the panel completely, as soon as possible, you can see each tone and its true value without the distraction of a bright white ground. Then, when you stand back to view the painting from a distance and compare it to the original, you can more easily recognize any mistakes in the values or drawing and make the proper adjustments.

STEP SEVEN. Finally, I add such details as the highlights in the eyes and bright flecks of light in the hair, using a fine-pointed round sable. For the highlights in the hair, I use single strokes, reloading the brush with more paint after each stroke. I also add glazes to the lips and cheeks, using cadmium red light thinned with medium. Notice the softness throughout the painting; the only hardness is in the pinpoint highlights of the eyes—capturing your attention.

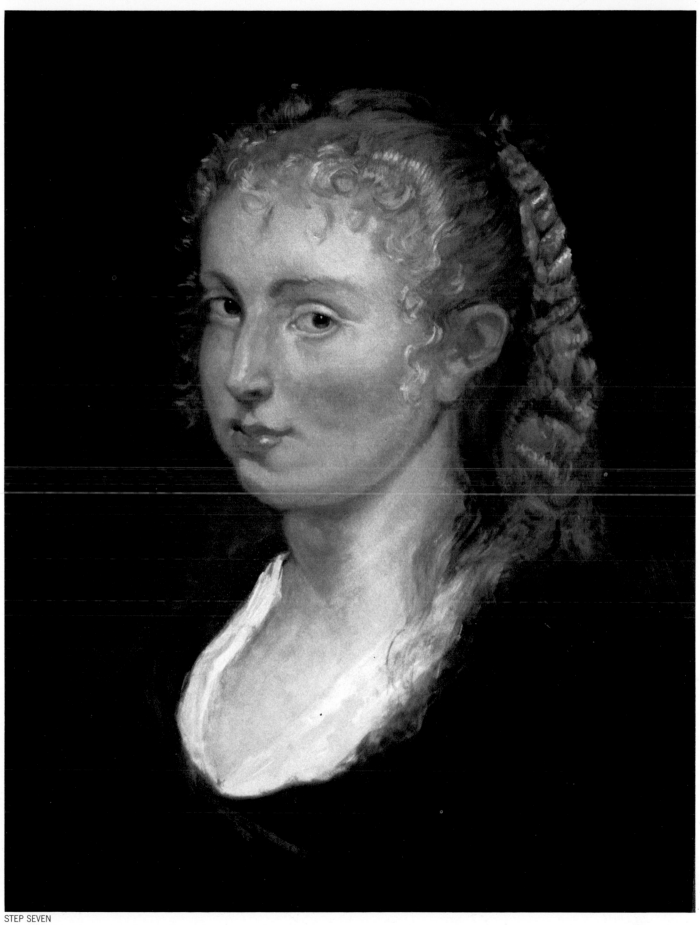

STEP SEVEN

Exemplar of
Pure Painting
VELÁZQUEZ

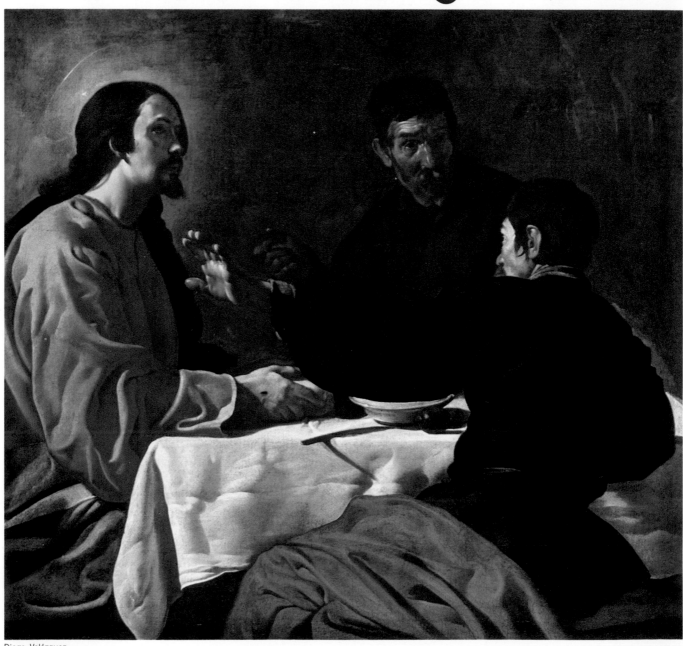

Diego Velázquez
CHRIST AT EMMAUS
c. 1622–23, oil on canvas, 48½″ × 52¼″ (123 × 133 cm), Metropolitan Museum of Art, Altman Collection

D

IEGO Rodriguez de Silva y Veláz-quez (1599–1660) has been described as the greatest portrait artist of all time. He is also known as a "painter's painter." When you look closely at his works, there is a sense of wonder at the open, painterly quality of the brushwork within a depiction that, from a distance, appears highly realistic. His loose brushwork and his portrayal of the shimmering qualities of light make Velázquez seem an artist far ahead of his time.

Although Velázquez did not really found a school of painting, his influence was tremendous. Bartolomé Estéban Murillo, another Spaniard, knew and studied with him. Much later, he was an inspiration to Francisco Goya and Edouard Manet, as well as John Singer Sargent (see page 97). His landscapes have been called impressionistic and, in their handling of light and atmosphere, can be seen as forerunners of Impressionism.

Life and Studies

Velázquez grew up in southern Spain, in the thriving community of Seville. At age twelve he was apprenticed to the leading teacher of painting in Seville, Francisco Pacheco. Although Pacheco himself was a mediocre painter, he was a learned man, whose house was a meeting place for many of Seville's most brilliant and talented citizens. He was also a personal friend of El Greco, whose work the young Velázquez admired and from whom Velázquez learned about using delicate grays in coloring flesh.

During the six years Velázquez studied in Pacheco's workshop, he developed a keen understanding of drawing and painting techniques. Pacheco's students began by copying engravings and drawings from antique sculpture. For Pacheco, drawing was the starting point for all art. He also insisted that his students draw from life, and Velázquez spent much time refining his life drawing. Velázquez's ability to capture various expressions in a model—from crying to laughing—was central to some of his early genre scenes.

At age eighteen Velázquez was admitted to the Guild of St. Luke, which meant he could set up his own studio and workshop. A year

later, in 1618, he married Pacheco's daughter Juana. Then, in 1623 Velázquez and his family moved to Madrid, where he became court painter to King Philip IV. By this time his wife had given birth to two daughters.

Velázquez remained in the service of the court, at least to some extent, throughout his life. It was in this way that he met Peter Paul Rubens, who visited Philip IV in 1628 to help negotiate a peace with England. The much older Rubens befriended Velázquez, and the two even shared the same studio. Although this association with Rubens probably inspired Velázquez in many ways, no direct influence can be seen in Velázquez's paintings. Mutual admiration probably best describes the relationship between the two great artists, who corresponded regularly after Rubens departed. At one point Rubens described Velázquez as the greatest living painter.

Between 1629 and 1631, Velázquez traveled in Italy, where he copied several great paintings, including works by Michelangelo, Raphael, and Tintoretto. Twenty years later he was to return to Italy to buy paintings and sculpture for an academy of art in Spain. It was during this second visit that he painted the portrait of Pope Innocent X shown on page 38.

In 1659, after many years of service to the

Although Velázquez is best known for his portraits, he also painted a number of religious subjects. In this relatively early painting, you can see the influence of Caravaggio in the dramatic contrasts of light and dark.

Michelangelo Merisi da Caravaggio
THE MUSICIANS
1591–92, oil on canvas, 36¼" × 46⅝" (92 × 118.5 cm)
Metropolitan Museum of Art, Rogers Fund

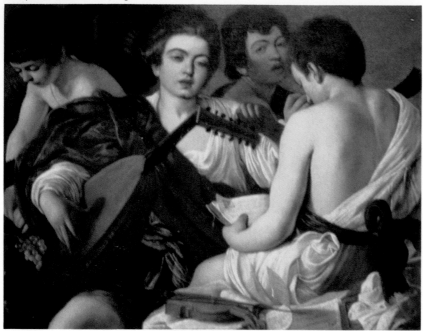

Velázquez was influenced by Caravaggio's use of chiaroscuro and by El Greco's use of subtle grays.

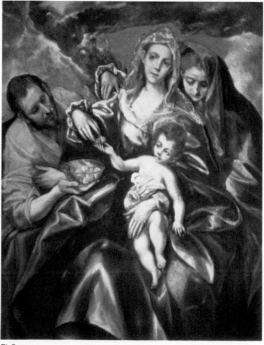

El Greco
THE HOLY FAMILY WITH MARY MAGDALENE
c. 1595–1600, oil on canvas, 51⅞" × 39½" (132 × 100 cm)
Cleveland Museum of Art, Gift of the Friends
of the Cleveland Museum of Art in memory of J. H. Wade

royal family, Velázquez was knighted by the king of Spain. He died a year later of fever.

Ideas on Painting

Velázquez's style evolved from the intense realism of his youth to the bold impressionism of his later years. Over the years he became a master at eliminating all but the most essential details. With only a few deliberate brushstrokes, Velázquez swiftly summed up whatever he was attempting to capture. Often—especially in the later work, where the modeling is only suggestive—the viewer is called upon to complete the painted image in his or her own mind. To do this, it helps to stand well back from the work.

One of the most characteristic elements in Velázquez's work is his use of realistic or naturalistic lighting. His early paintings, which were influenced by Caravaggio and his followers, are marked by strong chiaroscuro (light-dark contrast). In general, however, Velázquez preferred diffused light, which gave a cool, silvery effect. Especially in his late works it is the movement of light that creates the forms and colors we see and that gives unity to the whole.

Velázquez's subject matter included not only portraits, but also religious and mythological subjects, genre scenes, and landscapes. He rarely depended on any traditional source of composition. Instead, he created his compositions as he worked, continually adjusting the figures and objects until he achieved the desired effect. This process resulted in many *pentimenti*, or changes, which are still visible to the naked eye.

Velázquez disliked working without a model. His models generally posed for three hours, taking breaks when needed. Instead of painting what he "knew," Velázquez painted what he saw. In other words, he taught himself to really look at and put down whatever was before him without letting preconceived impressions intervene. In this respect, his work has been called pure painting.

Drawing Techniques

Most painters in the seventeenth century were expert draftsmen. Through Pacheco and other sources, it is known that Velázquez drew a great deal, especially in his early years. Unfortunately, few of his drawings have survived. The authentic drawings that do exist, however, reveal his extraordinary skills as a draftsman. They show a remarkable subtlety of shading and modeling. Like Velázquez's paintings, his drawings provide a

Diego Velázquez
THE NEEDLEWOMAN
c. 1640, oil on canvas, 29⅛" × 23⅝" (74 × 60 cm)
National Gallery of Art, Washington, D.C.,
Andrew W. Mellon Collection

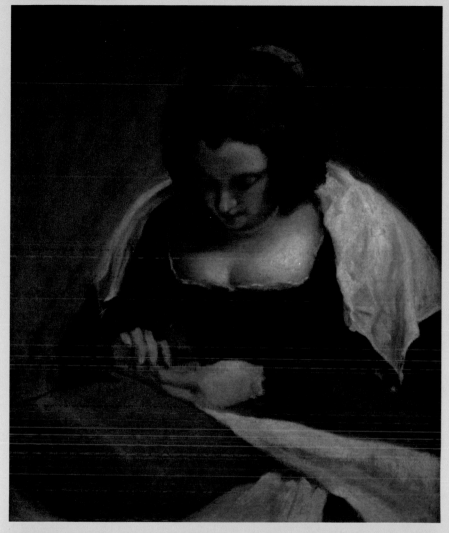

The Power of Simplicity

Velázquez's late paintings are far less detailed than his earlier works. *The Needlewoman* is a masterpiece of simplicity. Many areas of this picture are loosely, almost sketchily painted, yet the image as a whole seems incredibly lifelike, especially when it is viewed from a distance.

For the painter, this work offers a myriad of instructive lessons. First, there is Velázquez's skill in selecting the essential from what he saw. The pillow and the background on the left, for example, are actually painted in the same way, with only a few notes to suggest the pillow's form. In a sense we complete the image in our mind's eye. There is just enough for us to "see" the pillow's substance without being distracted from the main subject. The hands, too, are drawn with a minimum of detail, yet their gesture is clear—we can almost feel the woman sewing. This kind of simplification, however, isn't easy; it requires a lot of careful observation and practice.

Much of the beauty of this picture comes from Velázquez's skillful handling of the paint itself. Look closely at the detail of the left hand. Here Velázquez took advantage of the rough weave of the canvas and drybrushed the pigment in broad strokes, leaving deposits of broken color and creating the shimmering sensation of light.

In this painting you can also see the range of warm and cool tones Velázquez was able to achieve through a palette limited to yellows, reds, browns, black, and white. The restriction of hues is not a restriction on the feeling of color in this painting. The accent of red, in particular, is all the more powerful and colorful because of the subdued tones elsewhere in the painting. It is another example of Velázquez's ability to make something seemingly simple have a lot of impact.

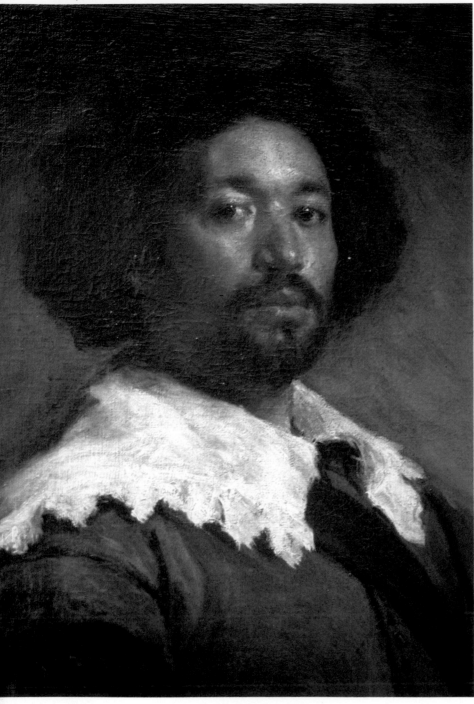

Diego Velázquez
PORTRAIT OF JUAN DE PAREJA (detail)
1649–50, oil on canvas, 30" × 25" (76 × 63 cm)
Metropolitan Museum of Art, Purchase 1971

This portrait of an assistant clearly reveals why Velázquez is often cited as one of the world's great portrait artists. Notice the looseness of the brushwork, particularly in the collar, and how the thick impasto areas appear to float over the surface. To heighten this effect and keep the edges soft, Velázquez often used blending brushes.

complete description of his subject; yet, at the same time, they are deceptively simple.

For the most part Velázquez used charcoal or pen and ink for his drawings, which were done on white, yellowish, buff, or blue paper. At times he used gouache with charcoal or included sepia washes. Velázquez also executed a number of engravings, of which only two survive.

It is interesting that Velázquez did not generally use drawings as preliminary studies for his paintings. Although there are a few drawings that translate closely or directly into paintings or sections of paintings, more often Velázquez worked out his composition directly on the canvas. Drawing, however, was still an important part of his working method: he first drew the major elements of the painting in chalk, then made changes with paint, and he continued to make further changes with chalk and then paint until the idea and composition had crystallized.

Painting Techniques

As just noted, Velázquez turned his canvas into a kind of sketchpad—perhaps because he wished to depict his true impression of the image, not a fixed preconception. After drawing the main outlines on the canvas with charcoal, black chalk, or dark gray or black paint, he began to block in the entire painting. He aimed immediately at getting the right proportions, values, and colors, but he was not afraid to make changes as he worked. After the initial block-in, Velázquez often worked wet-into-wet. Sometimes his paintings would dry before he had a chance to work wet into them again, resulting in a buildup of paint layers.

For his figures and portraits, Velázquez usually laid in the darker midtones first, followed by the lighter midtones. He simplified his modeling in the shadow areas and, to a lesser extent, in the halftones. It was in the light areas that he concentrated his modeling, and they were usually painted more thickly. As he worked, he took care to connect different areas of the painting through his tonal relationships.

Velázquez regularly stepped back to view his paintings from a distance. Using long brushes also helped him keep a distant view. In this way he was able to avoid understating or overstating his tones. In particular it helped him maintain the subtlety of his thick, impasto highlights, so they fit in with the rest of the painting. Usually these highlights are crisp in the center, with the paint dragged and softened at the edges. When viewed with raking (side) lighting, the highlights appear to

almost float on the surface of the painting.

An important factor in creating unity and color harmony in Velázquez's painting was his use of a limited palette (see page 32). With only a few basic colors—essentially red, yellow, brown, black, and white—he was able to create a range of warm and cool tones. If you work with a restricted palette, you'll discover how it can help you focus on tonal relationships—and tonal relationships are a key to the feeling of space and light in Velázquez's work.

GLAZING. Velázquez's painting technique relates to the methods of the sixteenth-century Venetians. Titian, among others, experimented with using different canvas textures with thick impastos as well as thin layers of transparent paint, or glazes. Velázquez, however, never used oil glazes to the extent the Venetians did. While the Venetians habitually accentuated underlying color by adding one or more (sometimes many more) layers of glazes, Velázquez used glazes mainly for drapery, and here and there for accents—adding, for example, a glaze of red organic lake over the lips. Sometimes Velázquez used simple glazing over a colored ground to create the tone in large areas of a painting. In these cases much of the ground shows through, and the effect is extremely luminous, with a transparency similar to watercolor.

LESSONS FROM PACHECO. Although Velázquez's technique evolved beyond what he learned from his teacher Pacheco, it is interesting to note how these early studies may have influenced him. For example, Pacheco had a specific formula for combining a figure study with a landscape background, and this may have affected Velázquez's approach to a painting like *St. John in the Wilderness* (see the demonstration on pages 34–37).

The first step, according to Pacheco, was to draw the scene in black chalk on the prepared canvas; the artist then divided this drawing into three or four planes going back in space. The figures and largest trees and rocks were generally placed in the first plane; additional trees and houses, in the second; smaller trees and buildings, in the third. The fourth plane might begin at the base of distant mountains and stretch into the sky.

After the drawing was completed, the colors were rapidly blocked in. The artist started with the sky at the horizon, where white and yellow ochre were used. He then moved up the canvas, continuing to paint the sky with a mixture of carmine (similar to alizarin crimson) and white, followed by smalt (which resembles cobalt blue) and white at the very top of the painting.

Once the sky was in, work began on the

Diego Velázquez
PORTRAIT OF THE JESTER CALABAZAS
c. 1633, oil on canvas, 68⅞" × 41¾" (175 × 106 cm)
Cleveland Museum of Art, Purchase: Leonard C. Hanna Jr. Bequest

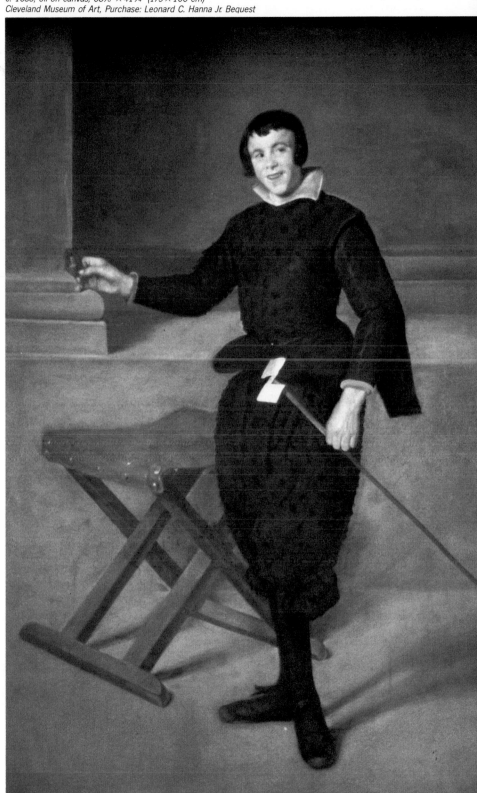

Velázquez often worked with a limited palette. Within this restriction, however, he achieved many subtle variations in his blacks, browns, and grays.

landscape, again starting from the horizon. The mountains, towns, and trees were laid in using a delicate brown tone, with touches of yellow ochre in spots. A little bone black or red ochre was sometimes added to the houses. Closer to the foreground, the trees were painted with blue ashes (for which ultramarine blue is a good substitute) and a few spots of ancorca and genuli (two obscure yellows, for which Naples yellow is an adequate substitute).

The immediate foreground, where the figure had been drawn, was the last part to be painted. Pacheco believed the trees in this plane should extend from the ground to the top of the sky, in order to dominate all the other distances. These trees were blocked in directly or underpainted with black and umber, with a little verdigris (similar to viridian) in the lights. Pacheco advised against any emphasis on the shapes of the leaves, lest they stand out too much and detract from the figure. At the same time he recommended making the grass on the ground look natural, as this section was closest to the viewer. Finally, for the figure, Pacheco instructed the artist to begin with the robes or clothing and paint the flesh areas last.

Diego Velázquez
CHRIST AT EMMAUS (detail)
*Metropolitan Museum of Art,
Altman Collection*

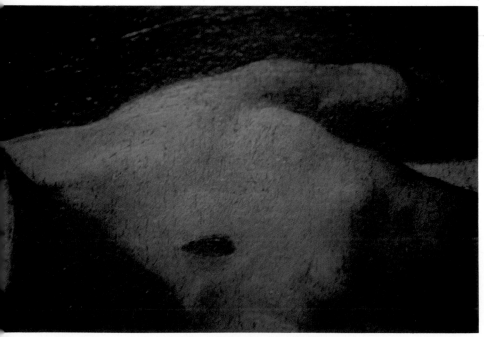

In this detail of Christ's hand (from the painting shown on page 26), you can see how important the actual texture of the paint is in Velazquez's work.

Materials

PIGMENTS. Velázquez is known for his restricted palette. His usual palette consisted of yellow ochre, red ochre, vermilion (similar to cadmium red light), red organic lake (alizarin crimson), umbers, white lead, and charcoal and bone black (ivory black), as well as chalk (which he mixed with different colors to give them more body). At times he may have also used smalt (substitute cobalt blue), verdigris (viridian), and blue ashes (ultramarine blue).

While Velázquez was in Italy, his palette was influenced by the artists there. During that time he used such colors as yellow lake (similar to cobalt yellow), orpiment (a brilliant yellow, now replaced by cadmium yellow), yellow iron oxide (substitute Mars yellow), lead tin yellow (Naples yellow light), lapis lazuli (ultramarine blue), azurite (cerulean), green earth, and manganese brown. Unlike the Venetian masters who preceded him, however,

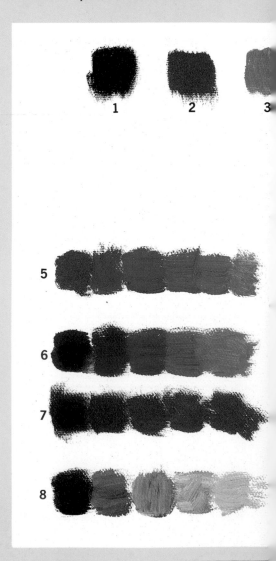

Velázquez used only oil paints. He never employed an egg medium followed by layers of glazes of oil pigments.

In working with his pigments, Velázquez used both "long" and "short" paint. The long paint was rich with an oil medium, while the short paint had little oil and was used mostly for impastos and scumbles. Variations in the liquidity of the paint are easily recognized in Velázquez's later works, where the canvas was rougher. In these he sometimes drybrushed the short paint over the canvas threads: the thicker paint was deposited where the threads were, but the spaces between the threads did not receive any paint, so the underpainting showed through, creating broken color and the appearance of shimmering light (see the detail on page 29).

BRUSHES. Velázquez probably used small, round, soft-haired brushes, which had long, slender handles. Details were added with fine-pointed brushes, probably of ermine or stoat.

He may have also employed blending brushes. Today, blenders are usually made from badger hair and resemble small shaving brushes. They are used to modify colors already on the canvas—to create soft edges and to rid the surface of excess runnels (grooves left by the brush when applying thick paint). If the runnels are not smoothed over, their textures may interfere with subsequent layers of paint.

CANVAS AND GROUNDS. Although for his early work Velázquez often used fine-grained, smooth-textured linen, for his late work he generally preferred a rougher canvas. Often he enlarged a painting by adding more canvas to the sides—a technique not often practiced today.

In many of his early paintings, Velázquez probably used Pacheco's method for preparing canvases. The process began with the application of a glue size (rabbit-skin glue may be used). After the glue had dried, clay, ground to a powder and mixed with linseed oil, was applied with a palette knife in an even layer. When the clay layer was dry, it was sanded with a pumice stone. Two more coats of the clay mixture were applied in the same way, resulting in a ground with a red-brown tone. Next, a mixture of glue and white lead was used. Finally, an imprimatura coat of red ochre, gray, or cream might be added, or the canvas might be left white. The gray grounds were generally of a warm shade, possibly black with a touch of yellow ochre.

Velázquez did a peculiar thing with the grounds of his *Rokeby Venus*, which is in the National Gallery in London. For the initial priming, he used a glue sizing, followed by a coat of white lead. Then, after drawing the Venus on the canvas, he experimented—applying an imprimatura of deep red everywhere except where the figure was to be painted.

VARNISHES. After completing a painting, Velázquez protected it with a transparent, natural resin varnish. Some of his varnishes have discolored over time, turning a deep yellowish brown.

4

9

10

1

1. IVORY BLACK (IB)
2. VENETIAN RED (VR)
3. YELLOW OCHRE (YO)
4. FLAKE WHITE (FW)
5. YO + VR
6. IB + YO
7. IB + VR
8. IB + FW
9. IB + VR + YO (+ FW)
10. IB + VR (+ FW)
11. IB + YO (+ FW)

A modern-day equivalent of Velázquez's palette includes flake white, yellow ochre, red ochre, cadmium red light, alizarin crimson, raw umber, and ivory black.

Here you can see some of the many mixtures possible with just four pigments: ivory black, Venetian red, yellow ochre, and flake white. You might experiment further on your own with these or different hues.

Demonstration: Figure in Landscape

Pacheco, Velázquez's teacher, left detailed descriptions of his instruction on painting. This painting suggests his influence on the younger artist. Notice, for example, how Velázquez created the illusion of distance behind the figure by painting a series of planes—the large trees, the smaller trees, the mountains—each relatively separate from the other. This approach was in keeping with Pacheco's advice (see page 31).

What especially intrigued me, however, was Velázquez's handling of the figure. There is a softness in the modeling of St. John that prefigures his mature style. I also admired the sense of "soul" in the facial expression and gesture of the hand—a quality that is difficult to capture and yet can make all the difference in a painting's impact.

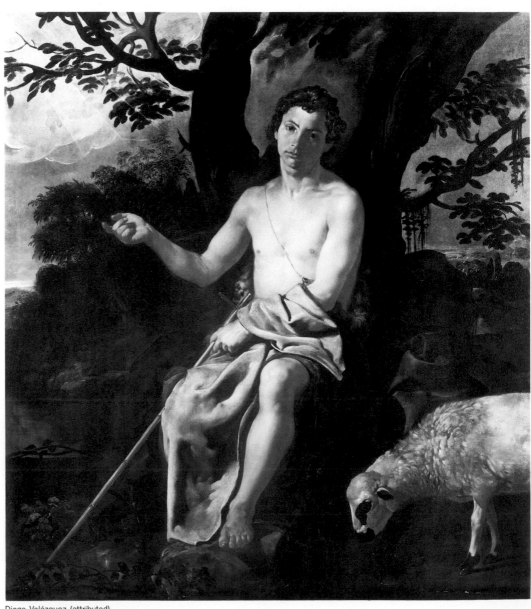

Diego Velázquez (attributed)
ST. JOHN IN THE WILDERNESS
17th century, oil on canvas, 69"×60" (175×152 cm)
Courtesy © The Art Institute of Chicago, All Rights Reserved, Charles Deering Collection

STEP ONE

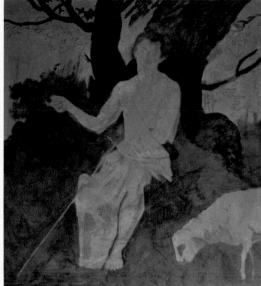

STEP TWO

STEP ONE. Adding red ochre to the final ground coat leaves a fiery-colored imprimatura. Here I use charcoal for the initial drawing of the composition. Often Velázquez alternated between charcoal and black paint in developing his compositions.

STEP TWO. To start, I do a simplified underpainting, blocking in the trees and rocks with ivory black and raw umber. Notice that the composition consists of three main planes: the immediate foreground, the middle ground with trees to the right, and the background mountains to the left (not yet painted).

STEP THREE. Beginning with the sky at the horizon, I rapidly lay in the colors. When painting the sky, I cover some areas where leaves will be added later. After the sky is finished, I move on to the background mountains and then to the darker darks in the middle ground and foreground. Next I put in the middle tones on the sheep and figure.

STEP THREE

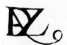

STEP FOUR

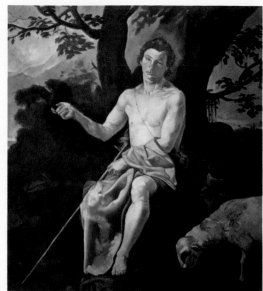

STEP FIVE

STEP FOUR. In this painting Velázquez followed Pacheco's formula and extended the trees from the ground to the top of the sky, thus giving the foreground dominance. Notice that the trees also create a backdrop, or foil, against which the figure is silhouetted. To define the trees and rocks, I lay on heavier pigment. Turning to the drapery, I pay careful attention to its shapes and forms. Next, I paint the flesh areas.

STEP FIVE. Now I develop details in the tree trunks, branches, and leaves. Because the sky is dry, I can lay in rich, pure darks to define the upper tree. I also repaint parts of the sky, once the darks are in, and fuse the edges to avoid any hardness. At this point I refine the shapes and values of the robe by exaggerating the lights (darker glazes will be added later). I also work on the figure, modeling the edges wet-into-wet. For the details in the face, I use a small, round brush instead of the larger rounds used elsewhere.

STEP SIX. After everything has dried, I glaze alizarin crimson over the robe and lips, as well different areas of the flesh, as a color accent. This glaze alters the value of the robe, making it darker and bringing it into proper relation with the figure. Notice in the first detail how the angularity of the robe contrasts with the subtle modeling in the figure. The brushwork is generally more controlled in the lights and looser and more spontaneous in the darks. Also notice in the detail of the sheep how spots of the red ochre ground show through. The sheep itself is painted mainly in cool colors, but when these are juxtaposed against the ground an interesting vibration occurs, adding excitement to the painting.

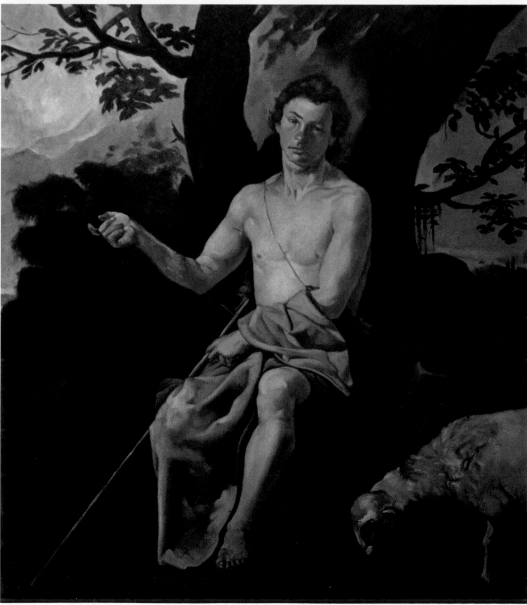

STEP SIX

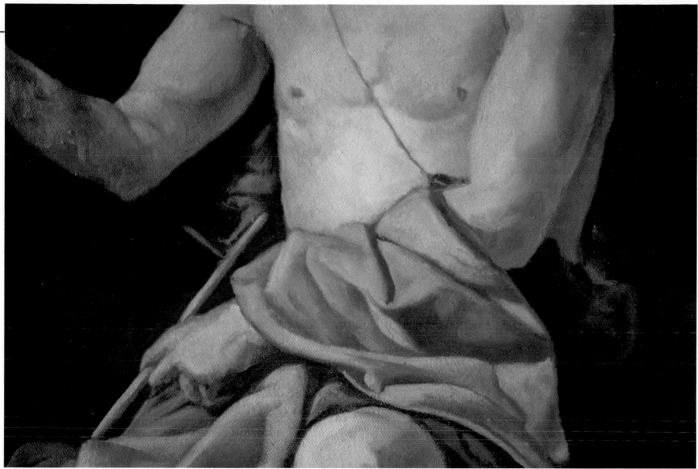

STEP SIX (DETAIL)

STEP SIX (DETAIL)

Palette:
yellow ochre
red ochre
raw umber
cadmium red light
alizarin crimson
ivory black
flake white

Brushes:
filbert bristles
(nos. 2, 3, 4, 6)
badger blender (no. 2)

Demonstration: Portrait

This painting is a preliminary work for a larger portrait, which contains almost the full figure of the pope. The final version has been described as one of the greatest portraits ever painted, although the pope found it "too truthful." To call this earlier work a "study," however, seems deceptive, for it is a striking painting in its own right. The modeling in the head is, in my opinion, more sensitive than in the larger work. And the power of the brushwork is astounding.

After making a few preliminary arrangements, I was able to paint my copy in front of the original. I spent a lot of time trying to understand and "see" the instinctive power of the strokes Velázquez used to model the face. I also paid attention to the twisted mouth and the seriousness of the pope's gaze, which add so much to the character of this forceful portrait.

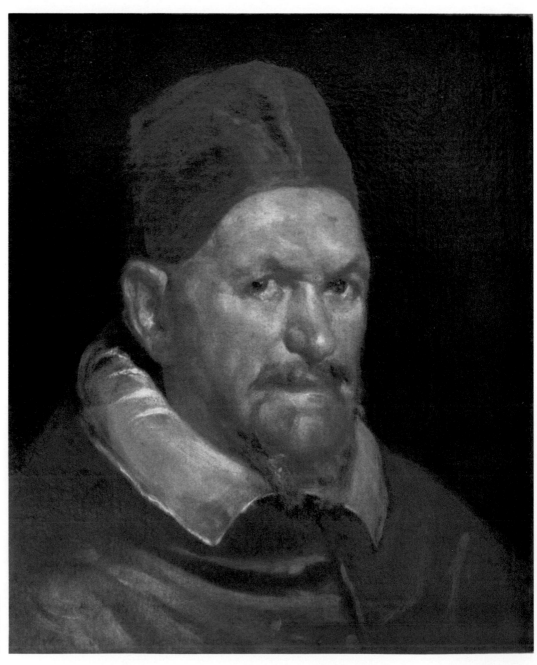

Diego Velázquez
POPE INNOCENT X
c. 1650, oil on canvas
19½" × 16¼" (49.5 × 41 cm)
National Gallery of Art, Washington, D.C.,
Andrew W. Mellon Collection

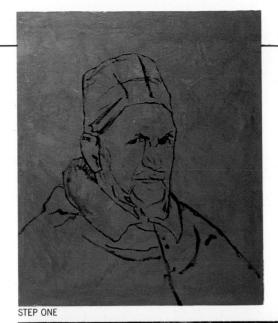

STEP ONE

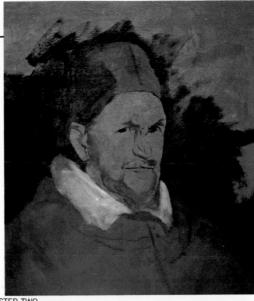

STEP TWO

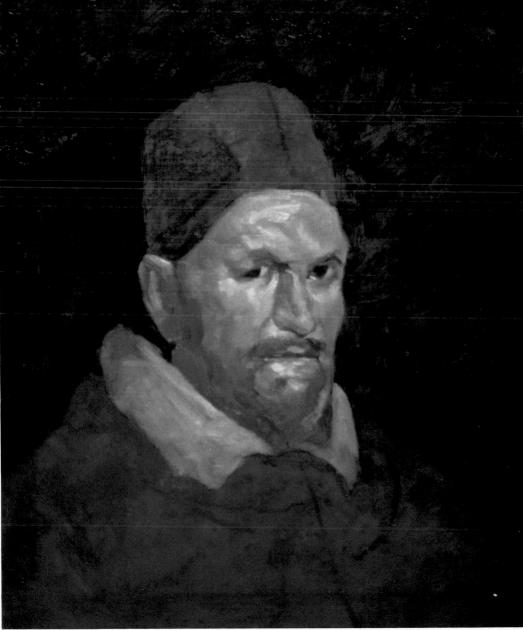

STEP THREE

STEP ONE. Velázquez used imprimatura coats of red, white, cream, or gray. Here I add red ochre to the final coat of white lead to provide a warm ground. Then I draw the head using ivory black thinned with turpentine and linseed oil. This underdrawing is very sketchy—giving only the basic placement of the forms. Most of the actual drawing will be done with the paint.

STEP TWO. Following Velázquez's general working method, I quickly block in the large color masses, using paint thinned with turpentine and linseed oil. The background is done with ivory black and raw umber; the robe and hat, with different mixtures of cadmium red light, alizarin crimson, black, and white; the collar, with ivory black and white. At this point the emphasis is on the middle tones, with the darkest darks and highlights left for later stages.

STEP THREE. After massing in the background tone, I concentrate on the middle tones in the face, using thicker paint and different combinations of white, yellow ochre, cadmium red light, alizarin crimson, and ivory black. As I work, I am continually drawing with the paint. Carefully rendering the shapes of the various tones helps in drawing the facial features. Remember that squinting and stepping back can help to clarify the values and their relationships.

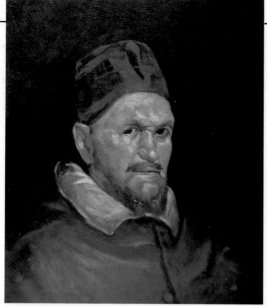

STEP FOUR

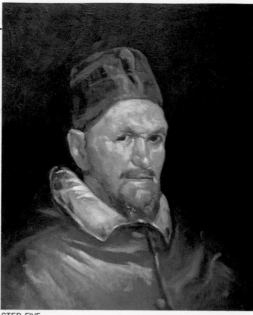

STEP FIVE

STEP FOUR. As I apply lighter and darker middle tones, I take care to soften the edges. I also try to include the color of the background in the shadow tones, as the color of the background denotes the color of the atmosphere or "space" in Velázquez's paintings. In contrast, the light areas tend to maintain the local color.

STEP FIVE. After placing the darkest darks in the face, robe, and hat, I paint the highlights using thick pigment and just a few strokes of the brush. To get the correct values, it's useful to look at pupils of the eyes, as they are often the darkest darks in a painting. Compare their value to surrounding values. If these values are too similar, then the value key in the portrait may be too dark and should be lightened. If the values contrast too much, then many tones may need to be darkened.

STEP SIX. At the very end I add a glaze of alizarin crimson to the robe and hat, as well as touches to the lips. Doing a painting like this one is a lesson in simplification. There are relatively few details; instead, the tones, simply but precisely rendered, are enough to capture the complete image.

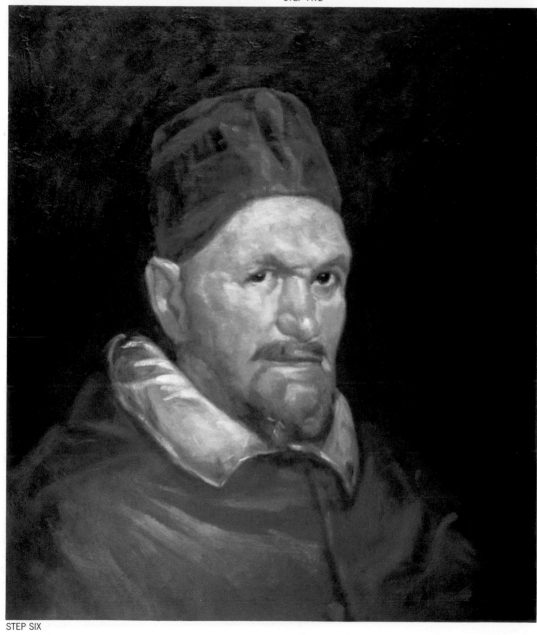

STEP SIX

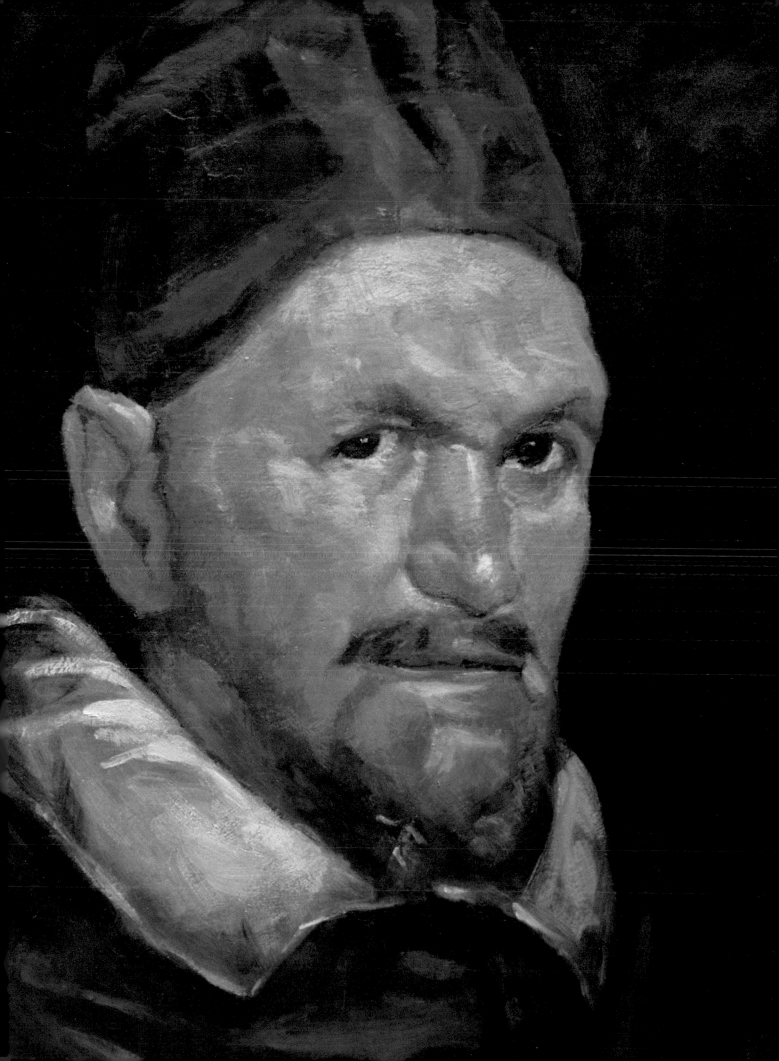

Brilliant Painter
of Light
TURNER

J. M. W. Turner
THE JUNCTION OF THE THAMES AND THE MIDWAY
1805–08, oil on canvas, 42¾" × 56½" (109 × 143.5 cm)
National Gallery of Art, Washington, D.C., Widener Collection

J

OSEPH Mallord William Turner (1775–1851) was a painter of the sublime and dramatic in nature. Dazzling sunsets, misty sunrises, menacing storms, and cataclysmic events filled his canvases and sketchbooks. Most important was the light in his paintings, with its piercing quality, which transformed all his subjects into glowing jewels.

Although his work was often viciously criticized, Turner produced an incredible number of paintings and drawings—perhaps the largest output of a single artist, without the help of assistants. His vision was a romantic one—part of the nineteenth-century Romantic movement, which was preoccupied with imagination and the exotic, with passions and at times the absurd. Along with Eugène Delacroix in France, Turner had a tremendous influence, and his work stands as a bridge between the classical style and what was to become the modern school.

Life and Studies

Born on April 23, 1775, in the Covent Garden section of London, Turner displayed a talent for drawing at a young age. Some of his earliest works were even shown in the window of his father's barbershop and sometimes sold to customers. At the age of twelve, he began working for John R. Smith, an engraver, who employed him to color prints. There he was exposed to the English school of topographical watercolorists, who followed the renewed interest at the time in medieval architectural remains and attempted to provide a true-to-life picture of the view at hand, while simultaneously reconstructing history. Two years later, in 1789, Turner began to study with Thomas Malton, an architectural watercolorist, who gave him lessons in perspective as well as further training in topographical draftsmanship. Later that year he entered the Royal Academy school, where he studied drawing from life and the antique.

Beginning in about 1794, Turner was employed for three years by Dr. Thomas Monro, for whom he produced copies of "colored" drawings by John R. Cozens and others. His co-worker in this task was Thomas Girtin, who later became an accomplished watercolorist. Girtin would draw in the outlines and Turner would color them. The two became close friends, and Turner once remarked, after Girtin's untimely death at age twenty-seven, "If Girtin had lived, I should have starved."

Cozens' poetic landscapes and other paintings in Dr. Monro's collection were influential on Turner's style. The chance to study and copy these works initiated a habit that soon became his most important tool for learning the craft of painting—copying. Indeed, in 1802, when Turner went to the Continent and first visited the Louvre, he spent hours making drawings of works by the great masters. He studied their systems of perspective, analyzed the paint application, and wrote notes in his sketchbooks, for future reference, about the grounds, imprimaturas, and colors used. He was especially impressed by the works of Claude Lorrain, as well as those of Nicolas Poussin, Rembrandt, Titian, Raphael, and others. Within England, he was also influenced by Sir Joshua Reynolds, with whom he may have even studied, and by Sir Thomas Lawrence, his contemporary and a close companion.

In 1802 Turner was elected to full membership in the Royal Academy and, a year later, to the council, or ruling body, of the institution. The Royal Academy, founded in 1768 by King George III, consisted of forty-

This painting reveals Turner's romantic vision and his emphasis on dramatic elements in nature. It also shows the influence of the great seventeenth-century Dutch seascapes.

Claude Lorrain
ITALIAN LANDSCAPE
163(?), oil on canvas, 40" × 53¹⁵⁄₁₆" (101.5 × 137 cm)
Cleveland Museum of Art, Mr. and Mrs. William H. Marlatt Fund

Turner was inspired by Claude's naturalistic landscapes and by the luminous light in Rembrandt's works. He saw Rembrandt as a model of the profound seriousness of art and claimed that, although certain gimmicks might initially attract the eye, it was the presence of soul that constituted the foremost quality in art.

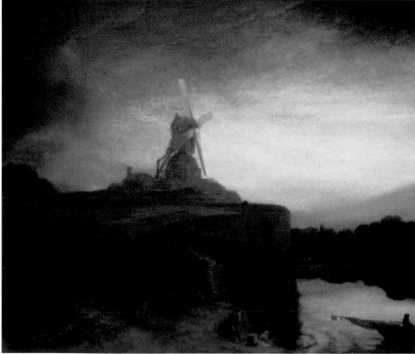

Rembrandt van Rijn
THE MILL
c. 1650, oil on canvas, 34½" × 41½" (88 × 105 cm)
National Gallery of Art, Washington, D.C., Widener Collection

five members who, once elected, were members for life. Its yearly exhibition was highly prestigious and provided for exposure that extended well beyond the English borders. Even after 1804, when he opened his own gallery on the first floor of his Harley Street house in London, Turner continued to send paintings to the Academy exhibition. He also later filled the Academy position of professor of perspective, a post he held for almost thirty years.

In 1805, when Turner was twenty-eight, his mother died. She had been subject to furious tantrums and eventually had been institutionalized. Turner and his father, however, enjoyed a close companionship and working arrangement. William prepared canvases and applied final varnishes. Turner would exclaim that his father would "begin and finish" his paintings. When Turner opened his own gallery, it was his father who watched over it each day.

Turner enjoyed two extremely supportive patrons during his career. The first was Walter Fawkes, who resided at Farnley Hall in Yorkshire. Between 1810 and 1824 Turner visited him there at least once a year. Fawkes had a predilection for Turner's watercolors and over the years purchased more than two hundred of them. George Wyndham, the earl of Egremont and master of Petworth House, also became one of Turner's dearest friends. Shortly after his father's death in 1829, Turner began visiting Petworth regularly. There he enjoyed the company of many of the great minds of his time. Lord Egremont gave Turner a studio in a remote section of the house, where he could work without interruption. The hills and streams around Petworth provided Turner with both recreation and inspiration. Turner was always sensitive to nature and what could be learned from persistent study and observation of its many moods. Often he would hike to a stream or lake, throw in three or four fishing lines, and then work on a sketch or watercolor. Many oils were also produced at Petworth, and some remain there today.

Turner was known as an intellectual and eccentric. He was a short, stocky man with a competitive nature, most evident in his fear of poverty. He continually worked at a frenetic pace to maintain a suitable income. His wish to be elusive at times led him to adopt assumed names and reside in secret places, where his true identity was unknown to his neighbors. Turner was said to be disposed to melancholy, which he often tried to hide with jovial conduct. He never married, but did have at least two mistresses, both widows. His first mistress, Sarah Danby, probably gave him two daughters. His second, Sophia

Booth, cared for him in his later years.

Turner's poor health started with bad teeth; because he could not chew properly, he depended increasingly on liquids. He died on December 1, 1851, of what doctors described as "natural decay." On December 30, he was buried in Saint Paul's Cathedral in London, beside Reynolds and Lawrence.

During his lifetime Turner amassed quite a fortune, although thousands of artworks remained in his studio at his death. In his will Turner specified that his money should be distributed to young British artists, but, due to a minor technicality, the majority of his fortune went to distant relatives instead. He wanted his unfinished paintings and drawings to remain in his Queen Anne Street residence, which was to be made into a museum, and the finished pieces to go to the nation. Instead, all 300 paintings and 1,900 drawings went to the National Gallery in London, where they were relegated to a storage room after a complete inventory had been made. Although Turner had requested in his will that the National Gallery build a special gallery to house his works, the museum never complied. Today many of the oils are in the Tate Gallery in London, while many of the watercolors and drawings are in the British Museum, with a few of the most important oils remaining in the National Gallery.

Ideas on Art

Although Turner's work was often criticized (especially some of his late paintings), he was never critical of other artists' or students' work, and he was always prepared to offer advice and encouragement. He himself was continually obsessed with the improvement of his work. Stressing the value of hard work, he explained to his students: "I know of no genius, but the genius of hard work," or "The only secret I have is damned hard work." His prolific output indicates how well he put this into practice.

Turner advised his students to make copies from the masters of the past, as he had done as a student. He asserted that this was the only reliable way of learning about and understanding color in painting. At the same time he continually encouraged students to develop their powers of observation. "Every glance is a glance for study," he would say. He insisted that nature and its structure must be the final appeal in art.

Although Turner's late paintings seem to foreshadow certain abstract styles, his work was always firmly grounded in naturalistic observation. He was capable of spending hours at a time staring at the sky or clouds or

J. M. W. Turner
KEELMEN HEAVING IN COALS BY MOONLIGHT
c. 1835, oil on canvas, 36¼" × 48¼" (92 × 123 cm)
National Gallery of Art, Washington, D.C., Widener Collection

Turner manipulated his use of light in his paintings to capture the spirit of his subject. Often, as you can see in the detail here, he emphasized the differences between thin glazes of color and thick impasto highlights.

Memory Training

Turner believed that memory played an important role in the creative process. Often, as he worked in his studio, he called upon his visual memory, with or without the help of a few pencil sketches, to re-create a scene he had carefully observed. His "portrait" of *Raby Castle* clearly reveals his ability to draw on memory, or stored observation, in adding the details that contribute to the life and interest of this painting.

Doing a drawing or painting from memory can help you concentrate on the most important forms and omit the unimportant ones. It can also free you from the restraints direct confrontation with a model or nature may impose. It is important, however, to begin by "training" your memory. In the same way that someone memorizes a poem—by starting with a single line and adding more lines until the entire work is learned—memory of form and color can be developed.

Start by trying to draw simple shapes from memory. Take a drawing like a simple profile of a nose. Study it for two or three days—learn the proportions, unique characteristics, and so on, then put the image away, get out a clean sheet of paper, and draw it from memory. Continue the process with more and more difficult forms. Train your color memory in a similar way. Paint two solid tones on a sheet of paper or canvas. Analyze the contrast of values and hues, then try to duplicate this. Later try three colors, and then go on to more.

It has been asserted that memory and imagination are closely linked. Like chemistry, in which new creations result from known elements, imagination uses only what memory can offer. A richer memory results in more information with which to work. Moreover, once the memory has been trained, then the eye, when observing something, will immediately see its distinct form.

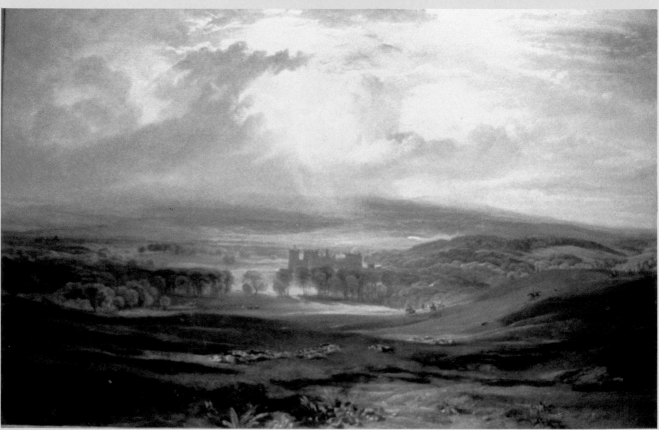

J. M. W. Turner
RABY CASTLE, SEAT OF THE EARL OF DARLINGTON
1817, oil on canvas, 46⅞" × 71⅛" (119 × 181 cm), Walters Art Gallery, Baltimore

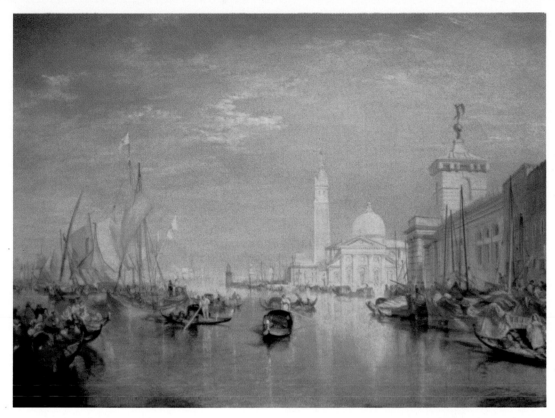

Turner did many paintings of Venice and its canals. He was particularly impressed by the light that enveloped the views there and later used this effect with other subjects.

whatever subject fascinated him. One of the most noteworthy moments in Turner's life came when he was sixty-seven. To paint the picture *Snowstorm at Sea*, he had himself tied to the mast of a ship, which set out into stormy waters. He did not expect to escape, but said he was bound to record it if he did. He survived the four-hour ordeal and painted a realistic account of what he saw.

DRAWING AND PERSPECTIVE. Turner insisted that drawing was the most important aspect of an art student's education. Often he would do a sketch in the presence of a student and then leave it for him to study and copy. This seems to be the only time he allowed others to watch him work. (He was in the habit of tearing into his own work furiously, and any distractions were strictly avoided.)

As professor of perspective, Turner lectured on many aspects of perspective, both aerial (with the gradation of light, shade, and color as objects recede) and linear (with parallel lines meeting at vanishing points). He emphasized the interaction of perspective and vision by showing how a knowledge of perspective could clarify one's vision and, at the same time, how the eye could correct and compensate for geometric perspective.

COMPOSITION. Turner had a general distrust of set rules, especially concerning composition. He did, however, assert a few guidelines. He recommended keeping the corners of a painting simple and centering the inter-

est. If possible, he advised, place your darkest darks next to your lightest lights in the middle of the painting, but never in the corners.

Many of Turner's own works have a circular composition, with a smaller inner circle near the center and a larger outer circle approaching the perimeter. This system, not unlike a vortex, resembles the one used by Peter Brueghel the Younger, almost two hundred years earlier.

At times Turner's predilection for detail led him to cram dissimilar subject matter onto the canvas. This detail, both observed and imagined, turned his simple "color beginnings" (see page 49) into complicated compositions. His late works, however, took on an almost abstract quality, depicting an impression of the moment. At the time some considered him mad, and it was not until later—when Edgar Degas and Claude Monet, among others, looked to Turner for a solution to rendering form in movement and capturing fleeting effects of sunlight—that his work was fully appreciated.

Turner always insisted that painters' most important duty was to their own paintings, more than to their subjects or to contemporary painting styles. He contended, for example, that landscape scenes were to be used as a guide, but were not to be copied exactly. Compositional changes were always necessary in the painting process, even when specific scenes or places were depicted. He also believed that accidents should never be lost.

J. M. W. Turner
BURNING OF THE HOUSES OF PARLIAMENT
1834–35, oil on canvas, 36½″ × 48½″ (93 × 123 cm)
Cleveland Museum of Art, John L. Severance Collection

This dramatic scene seems ideally suited to Turner's interest in color and light. In the detail, observe how he has combined scumbling and glazing to create a rich, luminous surface.

To him, chance could often help in the success of a painting, although it should never be sought intentionally.

COLOR AND LIGHT. Turner often called on color and light not only to define the subject being depicted, but also to capture its spirit. In his later work he moved beyond the traditional technique of working from dark to light to a close relationship of light and color, so they were no longer separate qualities. Although he never completely abandoned traditional subject matter, light and color increasingly became the focus and thus the real subject of his pictures.

Turner was particularly fascinated with white. In its undiluted state, it can bring things forward or push them back, whereas other unmixed pigments usually only advance. It also has the dual ability to imbue color with light or to muddy and destroy color (something Turner avoided). As he painted, Turner continually contrasted the soft effects of glazing and scumbling with thick, coarse, and broad applications of white. He would build up areas using impastos, tone down sections with thin color, and then build up again with more white, continuing this process until he achieved an effect of luminous light. This light, reflected off the white ground through numerous broken layers of transparent color, gave his work a magnificent radiance.

Turner was aware that while, in a prism, white is the union of colors, in pigments, all the colors combine to make black. To avoid the muddying effect of too many colors, he eventually eliminated dark pigments from his palette and concentrated on achieving contrast through warm and cool tones. Often he laid in pale washes of the three primary colors in the initial stages, with blue suggesting the distance, yellow the middle ground, and red the foreground. He may have thought that by including the three primary colors in this way, he was providing the basic components of light.

Turner showed a special preference for red and yellow in his paintings. Yellow, he believed, was the color closest to the production of light, while red had the greatest power (next to yellow) to call the eye to wherever it was positioned and hold it there.

For Turner, color was more than a reflection of the real things around him. It was a means by which a painting could achieve artistic harmony and produce expression or sentiment. The light in nature controlled the colors Turner used. Essentially, he believed that light was color and that shadow was its absence.

Painting Techniques

J. M. W. Turner
BURNING OF THE HOUSES OF LORDS
AND COMMONS, 16TH OF OCTOBER, 1834
c. 1835, oil on canvas, 36¼" × 48½" (92 × 123 cm)
Philadelphia Museum of Art, John H. McFadden Collection

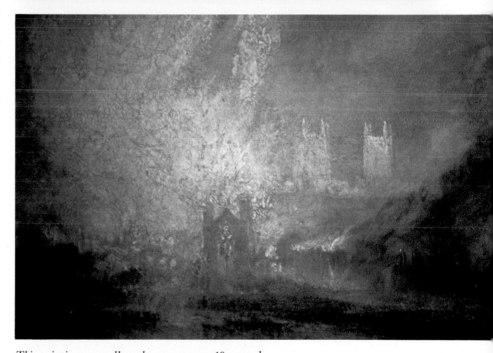

WATERCOLOR. Turner's watercolors demonstrate his ability to condense the important characteristics of a scene into a few rapid strokes. He worked at a furious pace, sometimes on several sheets at once. This speed, accompanied by a disciplined hand, enabled him to capture transitory effects.

Although on some occasions Turner painted watercolors outdoors, he usually preferred to work in his studio if color was involved, as he distrusted his coloring in the bright daylight. Often he worked from sketches, ranging from a few lines and color notations to jog his memory, to minutely detailed drawings, which took days to complete. On his watercolor paper he might begin with an underdrawing, but he then wet the paper and "floated in" pale washes of red, blue, and yellow. These "color beginnings," as he called them, were essential to his ability to capture fleeting visual effects. Eventually he evolved a technique in which he laid in the washes and then hung up the sheets on cords across his studio, much as a washerwoman might do. His drawing board even had a handle on the back, which he probably used to plunge the paper into water before applying the washes.

Turner used a variety of techniques in developing his watercolors, but he always respected the white of the paper and tried to avoid losing its brilliance through overpainting. Sometimes he wet already-dry areas and then rubbed them out to create halflights. He also used blotting paper on wet areas to lift paint and then sprinkled on breadcrumbs to absorb the excess water. Sometimes he dry-brushed areas by dragging paint over the tooth of the paper, creating a broken light effect. To establish highlights, he might leave areas unpainted or scrape out with his thumbnail. At times he masked the highlights with paper and glue, which was pulled off after the initial wash was laid in. Chalk and white paint were also used for lights, while at times black and colored inks were used to reinforce dark tones.

Turner always insisted on clean, unmuddied colors and generally preferred simple mixtures. Although in his early paintings he used variations in tone to create a feeling of recession, in later works he depended more on subtle variations in hues. After laying in most of the color, if he desired fine details, he sometimes drew them in with pen and ink.

From his early work in engraving, Turner learned two techniques that he applied to watercolor: hatching and stippling. Hatching, as

This painting, as well as the one on page 48, reveals Turner's excellent visual memory, as well as his fascination with light. Both were painted with the aid of only a few notes and some watercolor sketches that he quickly executed while watching the blazing fire. Yet he was able to use details like the buildings shown here to augment the effect of the whole.

J. M. W. Turner
VENICE, THE GUIDECCA
1841 or earlier, oil on canvas
24¾" × 36¾" (63 × 93.5 cm)
The Art Institute of Chicago
Gift of Mr. and Mrs. William-Prince

Many of Turner's works reflect poetic scenes. Often he wrote poems to accompany his paintings: in his mind the two had a symbolic relationship.

we saw with Rubens, entails shading with parallel lines, and usually the lines follow the form. Stippling suggests light and shade with hundreds of tiny dots.

OIL PAINTING. Turner's oil techniques were adapted from his watercolor methods, but, due to inherent differences in the media, they were more complicated. On a prepared linen canvas, he began with an imprimatura—usually in red (pink), yellow, and blue, diluted with turpentine. These washes served as his beginning concept, his plan for solving the problems the subject presented.

For Turner, the true subject of a painting was often the movement and radiance of light, so the problem became one of achieving light only through paint. After making some quick compositional notes, he laid in the large masses of the painting with white lead, possibly using linseed oil as his painting medium. This mixture was often applied in heavy layers, creating bold, swirling, and jagged textures. The white lead was especially thick in the highlights.

After allowing the painting to dry, Turner drew in the forms, often with burnt sienna. Next he added color, using glazes and scumbles. He built thin layers of color on top of each other, maintaining a luminous transparency to the textured white paint below. At times he applied scumbles of color containing large amounts of white over darker tones, creating a broken light effect. By eliminating

dark colors from his palette and through his subtle handling of the paint, he was able to attain a glowing radiance in his work.

In the last stage Turner put in accents and details. At times the accents included dark local colors, but more often the finishing touches were impasto white highlights, strategically placed to give the effect of glimmering light. Actually Turner often finished his paintings in the frame, especially when predominantly yellow or golden tones were used. This allowed him to study and alter the painting slightly, so that its tones would complement those of the frame. He is also known to have made use of "varnishing days" to complete his works—a time immediately before the annual Royal Academy exhibition, when members were allowed to touch up their paintings and add fresh varnish, even though the exhibit had already been hung. Turner spent these varnishing days standing very close to the canvas, painting with hog's-hair brushes and a large palette, which sometimes had only lead white on it. With his brushes he would drive paint into the grooves and other areas of the painting to add the finishing touches. For this, he and his followers earned the nickname "white painters."

Turner's late technique was, generally, a rapid one. The slow part of his method was allowing the white lead to dry in between layers. Otherwise, the work proceeded quickly, in a way not dissimilar to his watercolor process.

Materials

DRAWING.
Turner often drew with fine-tipped black lead pencils; he also used chalk or pen and ink. After completing a drawing, he might color it, using an ink wash or watercolor. His highly developed eye for observing and recording fine detail in drawings made his work easily transferable into etchings, aquatints, and mezzotints. When he wanted a drawing to be made into a print, he usually sent it to engravers, but at times did it himself.

WATERCOLOR.
Turner's watercolor palette probably included:

Yellows: yellow ochre, raw sienna, yellow lake, gamboge (the last two can be replaced by cobalt yellow).

Orange: chrome yellow deep.

Browns: burnt sienna, burnt umber, sepia, van Dyck brown, brown madder, brown-pink (a fugitive color).

Reds: vermilion, crimson lake, lac lake (the last two can be replaced by alizarin crimson).

Greens: chrome green, emerald green (not to be confused with viridian, which is frequently sold under the French name *vert emeraude*).

Blues: Prussian blue, cobalt blue, permanent blue.

Purple: carmine (a fugitive color).

Black: ivory black.

White: zinc white.

In addition to using transparent watercolor on paper, Turner sometimes mixed his paint with white, or body color, making the colors opaque and similar to gouache. He often alternated between transparent colors and body color for effects not achievable with one or the other alone. For mixing, he used a white china palette (known today as a Chinese porcelain butcher tray). He often used a medium-surface watercolor paper, of which some show the Whatman watermark. At times he worked on colored paper, usually blue-gray or brown.

OIL PAINTING.
Turner's oil painting palette probably included:

Yellows: yellow ochre, raw sienna, chrome yellow, gamboge (substitute cobalt yellow), Naples yellow, Turner's yellow (obsolete), barium yellow (zinc yellow), quercitron lake (zinc yellow), yellow lake (cobalt yellow).

Orange: orange lead (a variety of red lead).

Browns: burnt sienna, burnt umber, brown ochre.

Reds: Venetian red, vermilion, madder lake (substitute alizarin crimson), red lead (obsolete), Indian red, organic red (obsolete).

Green: terra verte.

Blues: Prussian blue, ultramarine blue, cobalt blue, blue verditer (similar to ultramarine).

Purple: carmine lake (fugitive).

Blacks: bone black, carbon, lamp black, blue-black (substitute vine black).

White: white lead. (Turner also used chalk and heavy magnesium carbonate to add bulk to his colors and also tooth, or texture, which facilitated the bonding between layers of paint.)

Turner didn't use all these colors at once; usually he restricted his colors to yellow ochre, raw sienna, burnt sienna, burnt umber, Venetian red, vermilion, Prussian blue, ultramarine blue, vine black, and white lead. As was the custom of the day, after grinding his pigments, Turner tied them up in "bladders"—pouches punctured so that the paint could be squeezed out onto the palette, much as one does today with a tube of paint.

It is suspected that Turner mixed a natural resin, either dammar or mastic, dissolved in turpentine, with linseed oil in grinding his pigments. He may also have used wax at times. As he painted, he may have used a medium of linseed oil or linseed oil and turpentine. For the most part, he applied the paint with short hog's-hair brushes, although at times he used a palette knife, especially for the bold, slashing strokes in his late paintings.

Turner painted on canvas and occasionally mahogany panels. He prepared his canvas with a base of white lead, sometimes with the addition of chalk. He covered the canvas fairly evenly but left a slight texture. Then he probably used a pumice lump or block to give the surface an ivorylike, smooth finish. Even though Turner sometimes applied three or four ground coats, the surface remained so absorbent that the paint would still sink into the canvas.

Early in his career Turner used dark imprimaturas, but these became paler in his middle period. In his final years he abandoned imprimaturas and painted directly on the white surface, which enhanced the brilliant light effects he desired. For the early, dark imprimaturas, Turner used combinations of burnt umber, vermilion, and golden ochre, applied with turpentine and possibly linseed oil. The later, pale washes were often applied while the canvas was lying flat, to avoid dripping and spreading.

A modern equivalent of Turner's oil palette includes flake white, yellow ochre, raw sienna, burnt sienna, Venetian red, cadmium red light, burnt umber, Prussian blue, ultramarine blue, and ivory black.

Palette:
yellow ochre
alizarin crimson
Prussian blue
burnt umber
ivory black

Brushes:
flat oxhair (1½-inch)
round red sable (no. 6)

Demonstration: Watercolor Landscape

After reading about Turner and his working methods, I concluded that he probably painted this watercolor from memory, with the aid of a few pencil sketches made on the spot. By clearing his mind of unessential details, he was able to focus on the tranquil appearance of the boats and buildings and their reflections in the water.

Particularly striking in this work is the alluring, radiant light, which transforms the scene into a sublime vision. As I discovered in copying this work, Turner used just a few simple techniques to solve the complex problem of making the illusion of light seem real.

J. M. W. Turner
VENICE: PUNTA DELLA SALUTE
1819, watercolor, 9" × 11⅗" (23 × 29.5 cm)
British Museum, London

STEP ONE. For this painting I attach my paper with heavy masking tape to a plywood board. My paper is Arches 140 lb. hot-pressed, although Whatman or Bockingford would be a suitable alternative. After sketching the subject, I apply the "color beginning," as Turner often did. For this I use an oxhair rather than a sable brush (as long as your oxhair brush has a good spring and bounces back into shape, it is perfectly suitable). After brushing the entire surface with clear water, I lay in pale washes of color, starting with Prussian blue at the top (and a touch of ivory black at the very top), then some alizarin crimson, followed by yellow ochre. In doing this, remember not to touch a wash once it has been laid down—let it dry thoroughly, then begin painting again.

STEP TWO. The basic working formula here is to paint from light to dark. I mix Prussian blue and alizarin crimson for the pale background buildings and use the same combination, with yellow ochre in places, for the foreground buildings. During this stage I work with my no. 6 round sable.

STEP THREE. To develop the building, I apply darker values. I also use burnt umber to establish the lighter values in some of the boats, and Prussian blue and alizarin crimson to show some reflections.

STEP FOUR. Once everything has dried, I go on to the next-darker tones. Depending on the subject, the majority of time spent painting a watercolor is taken up waiting for each layer to dry before proceeding to the next. This is why Turner liked to work on a few paintings at the same time.

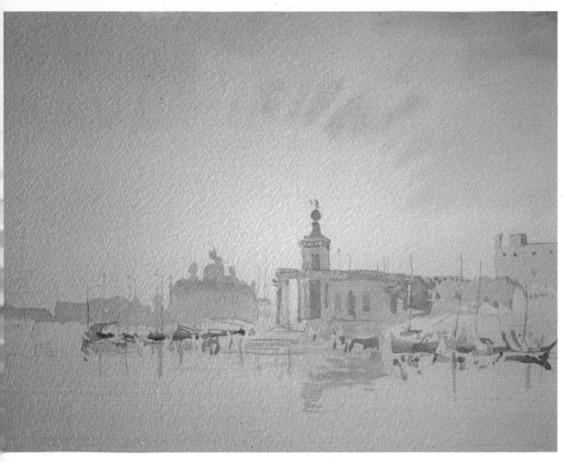

STEP FIVE. Still using my no. 6 round sable, I add further details, keeping in mind that colors dry lighter than they initially appear. Certain colors, like Payne's gray (not used here), dry much lighter.

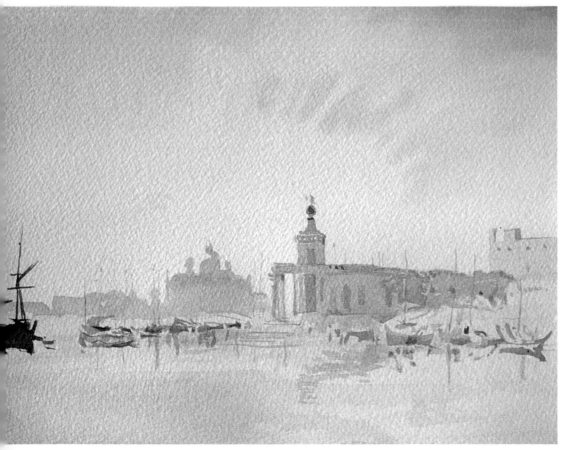

STEP SIX. In the final stages I apply the darkest values quickly and directly, often dipping the brush in paint after one or two strokes. Remember that the more directly the paint is applied, the more sparkle it will have—but keep it simple, as too much often results in mud. At this point I also add the calligraphy and the details of the boats. Once the details are done, the painting is complete.

Let's review a couple of watercolor rules. First, a pale or weaker wash should never be painted over a stronger one. Also, try not to place more than three washes in any one spot. If an area is to be very dark, then make the initial wash dark. Too many layers destroy the transparent quality of watercolor, which is one of its most appealing attributes.

Palette:
Naples yellow
yellow ochre
raw sienna
burnt sienna
Venetian red
alizarin crimson
burnt umber
terre verte (green earth)
Prussian blue
ultramarine blue
ivory black
flake white

Brushes:
filbert bristles
(nos. 3, 6, 8)
round sables (no. 6)

Demonstration: Oil Landscape

In his early works Turner tended to follow the traditional techniques of his time, but in later works like this one he incorporated a more personal vision. What particularly appealed to me was the complexity of movement, space, light, and atmosphere. I was especially interested in how Turner handled the white areas. Often, in painting, the use of a lot of white muddies and dulls the colors. Turner, however, is an exception. His use of white gives his colors the feeling of light.

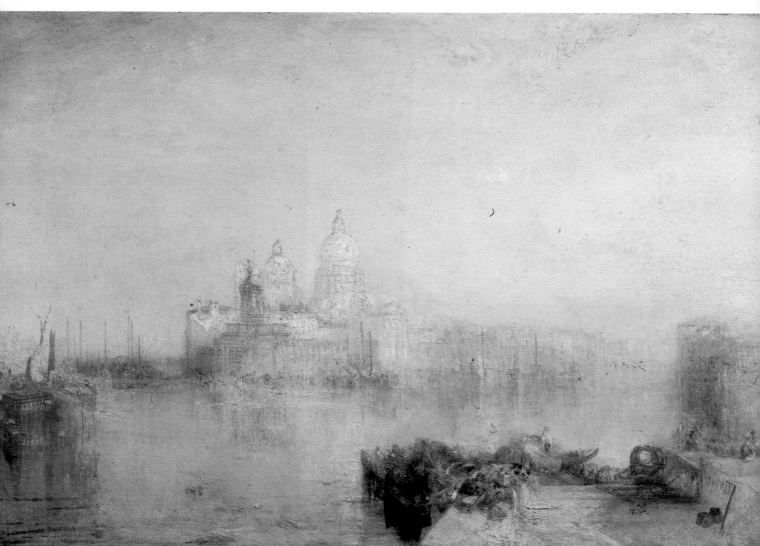

J. M. W. Turner
THE DOGANA AND SANTA MARIA DELLA SALUTE, VENICE
c. 1843, oil on canvas, 24⅜" × 36⅝" (62 × 93 cm)
National Gallery of Art, Washington, D.C., given in memory
of Governor Alvan T. Fuller by the Fuller Foundation

STEP ONE

STEP TWO

STEP THREE

STEP ONE. After drawing in the subject with charcoal, Turner usually applied a thin turpentine wash over the entire canvas, similar to a watercolor wash. Instead of toning his canvas in a single color, Turner liked to use a number of colors, specifically related to different compositional sections that were to follow. With this in mind, I begin with Naples yellow, alizarin crimson, and ultramarine blue.

STEP TWO. Into the thin washes I paint the large masses of the composition, mainly with flake white. I make the paint especially thick where the highlights are eventually to be placed. With the whites I use a medium containing wax, which adds body and thickness to the colors and is useful in building up thick textures.

STEP THREE. Once the initial layer has dried, I begin carefully drawing the objects with sable brushes, using burnt sienna in some sections and a gray mixture of ivory black and white in others. I thin my paints well with turpentine. Then, after this is completed, I strengthen the white areas with more of the white and wax medium mixture.

STEP FOUR

STEP FIVE

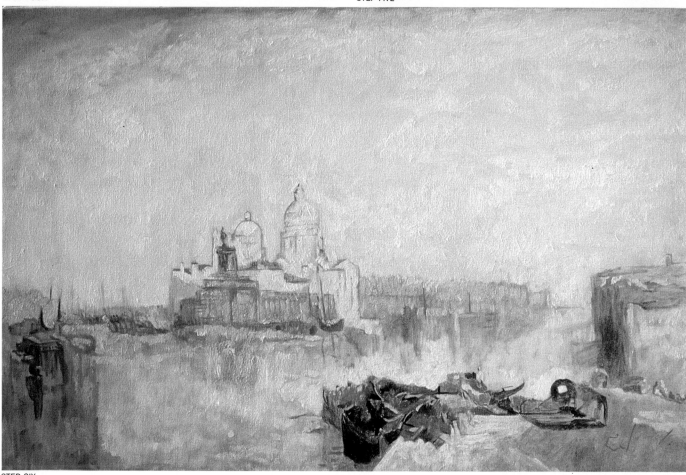

STEP SIX

STEP FOUR. The next two stages form pattern that I repeat several times in copying this painting. Here, in the first step, I apply additional washes—similar to the one applied at the very start, but using mainly Naples yellow and burnt sienna. As I work, I scrub colors into the textured white areas and then lightly wipe them away, leaving greater deposits of pigment in the paint runnels. This process increases the dramatic texture of the whites, as they appear to float above the canvas surface.

Note that I add touches of medium to the paint and turpentine for the washes, to strengthen the mixture and make the

washes tell against the heavy white impastos. A mixture of paint and turpentine alone is easily stained when you add other colors to that area. Adding medium to the glaze gives it enough body to keep its original brilliance when adjoining tones are painted.

STEP FIVE. The second step of the pattern is to work additional heavy white areas and darker local colors into the freshly applied glaze-washes. For the pinkish mixture, I use white, black, and alizarin crimson; for the golden tones, Naples yellow and burnt sienna.

STEP SIX. Now I place glazes of Naples yellow with touches of burnt sienna in the foreground, Naples yellow in the sky, ultramarine blue in the upper left sky, and burnt sienna and Naples yellow with alizarin crimson and ivory black in the reflections of the buildings and boats on the left. In the buildings to the right of the center, I alternate spots of alizarin crimson and blue, as it is difficult, if not impossible, to mix a pleasing violet from red and blue. When your painting calls for violet, either use a pure violet, such as ultramarine or cobalt violet, or use spots of deep red next to spots of blue. If the spots are intermingled well, the eye

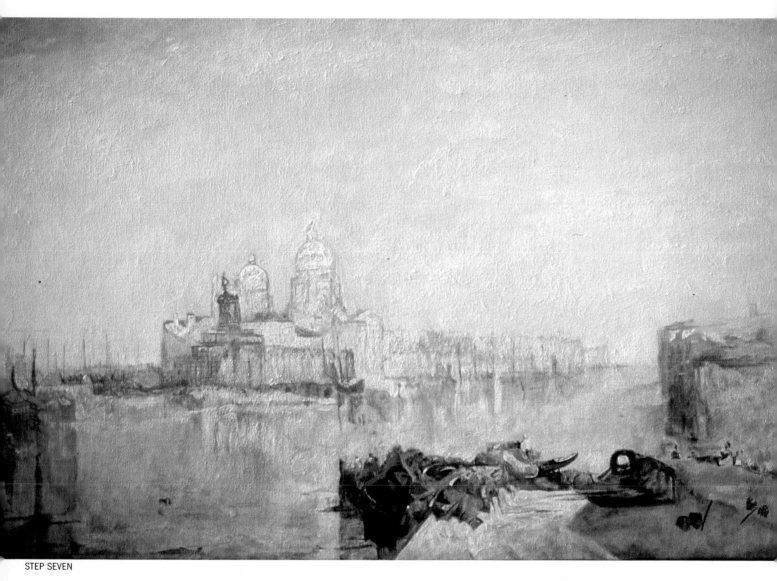

STEP SEVEN

will naturally do the mixing and will read violet.

In painting these spots of red and blue, I often add white, using a scumble rather than a glaze. The term *scumble* refers to transparent color to which opaque color, often white, has been added. When this mixture is applied in a thin coat, the undercolors remain visible.

STEP SEVEN. Into the glazes and scumbles, I add darker tones to further establish the details of the foreground and various other spots in the painting. For the final step, I add more details to the foreground and lay a warm wash over the sky. I also add a touch of Prussian blue and some pink and yellow clouds to the upper left corner. For the ripples in the water, I use terre verte; for the people and boats in the foreground, spots of Venetian red.

When you are doing a copy, keep in mind that it is possible to take some paintings only so far. There are certain aspects about paintings that only the nat-

ural process of aging can provide. Age often lends the paint a certain richness not originally intended. Try to see beyond the layers of fine dust and varnish to what you know was actually applied by the artist. Learning the process the artist used is more important than having your copy appear exactly like the original.

Champion of Composition

DEGAS

H

ILAIRE Germain Edgar Degas (1834–1917) gave the world a new vision of composition and design. Influenced by two opposing tendencies in early-nineteenth-century French painting—the Neoclassicism of Jean-Auguste Dominique Ingres and the Romantic art of Eugène Delacroix—Degas went on to become one of the greatest transitional figures between the classical and modern periods.

Although he showed work in the early Impressionist exhibitions between 1874 and 1886, he resented the label "Impressionist" and his work stands somewhat apart from this movement. It is true that many of his works have an Impressionist flavor in their representation of the fleeting effects of light and brilliant color, but Degas' concern with line and two-dimensional design makes his art unique.

Success, to Degas, was the end of progress. Throughout his life he struggled with his art, continually experimenting with new ideas and often with new materials. His desire was to be "illustrious and unknown." He once compared himself to a racehorse who ran the long races but was satisfied with his bag of oats.

Life and Studies

Degas was born in Paris, on July 19, 1834, to an affluent banking family. His father, Auguste, was half-French and half-Italian; his mother, Célestine, was a Creole from Louisiana. In 1845, at age eleven, Degas entered an all-boys school, the Lycée Louis-le-Grand. There he received a classical education, with study of Greek and Latin. He also had his first drawing lessons from Léon Cogiet.

While he was still in school, at age thirteen, Degas' mother died and his father, a connoisseur of both art and music, took over his upbringing. Degas and his father often visited the museums in Paris, as well as private collections, where Degas saw many works that later inspired him. In particular, Degas' father's circle of friends included Dr. Louis La Caze and Edouard Valpinçon, who both had extensive art collections. La Caze owned paintings by Frans Hals, Rembrandt, Peter Paul Rubens, Diego Velázquez, and Jean-Baptiste Siméon Chardin, among others, while Valpinçon's collection included Ingres' *Bather*, a painting that captured Degas' heart.

In March 1853, Degas graduated from the lycée, which enabled him to enroll in a university, a somewhat special opportunity at that time. After one semester in law school, however, he dropped out to pursue a career in painting. At this time, at age twenty, he began to study with Louis Lamothe, a former pupil of Ingres. Lamothe was an able draftsman, whose classes, among other things, introduced Degas to drawing from life. He also encouraged Degas to take classes at the École des Beaux-Arts.

More important than these classes perhaps was the time Degas spent in the afternoons, doing copies of the old masters in the Louvre. He regularly copied works by such Italian primitives as Mantegna, Perugino, Botticelli, and Ghirlandaio, as well as High Renaissance works by Raphael and Leonardo. Then, in 1856, he made one of several trips to Italy. There he continued his study of the early Italian masters, including Giotto, Cimabue, and Simone Martini; he also did copies of the Pompeii murals. What interested Degas in the Italians was their incisive draftsmanship and economical handling of color—qualities that were to become important in his own art.

Edgar Degas
DANCERS PRACTICING AT THE BAR
1876–77 (?), oil on canvas
29¾" × 32" (76 × 81 cm)
Metropolitan Museum of Art,
H. O. Havemeyer Collection, Bequest
of Mrs. H. O. Havemeyer, 1929

Degas' eye for composition and his wit are both evident in this painting. Compare the "gesture" of the watering can with that of the dancers. Also note how the can provides a visual balance for the figures on the right.

Jean-Auguste Dominique Ingres
ODALISQUE WITH SLAVE
1842, oil on fabric, 30" × 41½" (76 × 105 cm)
Walters Art Gallery, Baltimore

Degas was greatly influenced by Ingres, especially by his sensuous line. In the self-portrait shown here you can see a similar sensitivity to line in the handling of the silhouette.

Edgar Degas
SELF-PORTRAIT
1854 (?), oil on canvas,
16" × 13½" (41 × 34 cm)
Metropolitan Museum of Art, Bequest,
Steven C. Clark Collection, 1960

Another highly important early influence on Degas' work was Ingres. Degas actually met Ingres, and the older artist is reported to have told him, "Study line. . . . Draw lots of lines, either from memory or from nature." Degas cited other remarks by Ingres: "Form is not in the contour; it lies within the contour"; "Shadow is not an addition to the contour, but makes it"; and "Muscles I know; they are my friends. But I have forgotten their names." Many of Degas' portraits and nude figure studies reveal the influence of Ingres' handling of line and harmonious shapes. Ingres' paintings, however, are often sharp to the point of being cold, while Degas' lines seem "smoky," suggesting atmosphere.

Two other important influences on Degas' artistic education were Delacroix and Honoré Daumier. Delacroix's exuberant coloring, romantic subjects and compositions, and portrayals of horses in motion all intrigued Degas. With Daumier, it was the artist's unusual compositions, his keen sense of observation, and his depiction of urban life that fascinated the young Degas.

Degas was, of course, also influenced by his contemporaries and by the changes that were going on in French society at the time. Except for his studies in Italy and a few short trips, including one to the United States, Degas spent most of his life in and around Paris. As his paintings reveal, he frequented both the race courses and the theater and ballet world. Until it burned in 1873, he often visited the opera house in la rue Le Peletier, where he especially enjoyed the works of Carl Maria von Weber. As an opera subscription holder—an *abonné*—he was allowed backstage, where he observed the dancers rehearsing. He also spent time in various cafés, where he discussed ideas with his contemporaries Edouard Manet, Camille Pissarro, and Gustave Caillebotte, among others.

When his work began to sell well, Degas started to collect other artists' work, including pieces by El Greco, Tiepolo, Ingres, Delacroix, Daumier, Manet, Gustave Courbet, Paul Cézanne, Vincent Van Gogh, and Paul Gauguin. He also collected Japanese prints, which were popular in Paris at the time, and Oriental rugs, which captured his coloristic imagination.

Reports on Degas' character range from accusations of misogyny and rudeness to descriptions of sensitivity and warmth. He remained unmarried throughout his life and, despite his attendance at public gatherings, seems to have been something of a "loner." Already in 1871 he began having trouble with his eyes, and his vision gradually deteriorated. Until 1886 he kept notebooks, but then he stopped writing to preserve his eyesight.

He spent his last two decades virtually blind, turning to sculpture on days when he could not see at all.

Degas died in Paris on September 27, 1917. He is reported to have told his friend Jean-Louis Forain that he didn't want a funeral oration. "If there has to be one," he said, "you, Forain, get up and say, 'He greatly loved drawing. So do I.' And then go home."

Ideas on Art

Degas' notebooks are filled not only with sketches but also with his thoughts about drawing and painting. In a way he talked to himself in his notebooks, jotting down his reactions to different ideas about art and listing various "exercises" he might experiment with.

Degas looked on painting as a kind of science. He asserted that what he did was the result of reflection and study of the great masters, that he knew nothing of inspiration, spontaneity, and—especially—temperament. At the same time he declared that painting demands a certain mystery in which not everything is defined. "When you continually dot all the *i*'s," he wrote, "you end up being a bore." Even when you are painting from nature, he argued, you must select and compose, combining lines and tones in an original way.

For Degas, as for J. M. W. Turner, memory was an important aspect of the creative process. As a student, Degas probably read Lecoq de Boisbaudran's *The Training of the Memory in Art*. Following Boisbaudran's ideas, Degas recommended that art students pose the model on the ground floor but set their easels up on the upper floors to discipline themselves to remember values and forms. Degas himself often did quick sketches from models and then worked without models. In his notebooks he described the transformation that occurs when imagination collaborates with memory: recollection and fantasy are freed from the restraints of nature, and one draws or paints only what has made a strong impression—the essential.

Solitude was important to Degas, and he believed it necessary if the artist were to carve out his own little "niche." Talk and gossip, he contended, may falsify judgment and thwart originality and creativity. Degas specifically advised artists to stay away from art critics and claimed that in a single stroke an artist can say more than a critic can in a whole volume.

Throughout Degas' notebooks, there are pithy remarks, well worth quoting. At one point he asserted that everyone has talent at twenty-five—the difficulty is to have it at

Edgar Degas
AFTER THE BATH
c. 1895, pastel on paper, 30" × 32½" (76 × 83 cm)
The Phillips Collection, Washington, D.C.

These two works show Degas' skillful use of line to capture the figure's essential gesture. Note, however, the differences in the handling of the pastel medium. The work on top is built with many layers of color, creating varying textures.

Edgar Degas
BUST OF A WOMAN IN A PURPLE DRESS
c. 1885, pastel on brown paper mounted on paper board, 19¹⁵⁄₁₆" × 19¹⁵⁄₁₆" (51 × 51 cm)
Collection of Marion and Gustave Ring

Edgar Degas
SKETCH—BALLET DANCER
*Brush drawing with gouache
and ink on pink paper*
12¼″ × 16¹⁵⁄₁₆″ (31 × 43 cm)
*Metropolitan Museum of Art,
Lehman Collection*

*Degas drew continually
and experimented with both
different approaches and
different media.*

Edgar Degas
TWO DANCERS
*c. 1878–80, pastel and
charcoal on green paper
25⅛″ × 19¼″ (64 × 49 cm)
Metropolitan Museum of Art,
H. O. Havemeyer Collection*

fifty. In another place he remarked that "painting is not very difficult when you don't know how—but when you know—oh, then it's another matter." He also stated, "Art cannot be made with an intent to please." And he compared the knavery, trickery, and deceit involved in painting to the perpetration of a crime: "Make it untrue and add an accent of truth," he declared. Along similar lines, he asserted that one sees as one wishes to see, that everything is false, and it is falsity that constitutes art.

DRAWING. For Degas, getting the drawing right was the most important thing in painting—more important than good "paint quality" or even color. One of his biggest complaints about "modern art" was its lack of proper concern for drawing. In contrast, Degas drew constantly. He described himself as "born to draw." Certainly, he possessed a keen and ruthless power of observation, which enabled him to capture a telling idiosyncratic gesture or to depict form in motion with the utmost precision. But his incredible power of observation was built on a lot of practice. "It is necessary to do a subject ten times, a hundred times," he asserted. "Nothing in art must seem accidental, not even movement."

Degas' notebooks contain many drawing projects. "Draw a profile that will not move," he suggested, "while moving oneself, up or down." He also recommended, "Study from every perspective a figure or object, no matter what." In Degas' paintings one can see his fascination with unusual viewpoints, which jolt one's expectations and force one to look differently.

Throughout Degas' remarks there is an insistence that drawing is not a matter of copying nature but of transforming it. "Drawing," he claimed, "is not what one sees, but what one must make others see." On another occasion he explained, "Drawing is not the same as form; it is a way of seeing form." As the poet Paul Valéry commented in his study on Degas, here Degas was contrasting drawing with what he called *mise en place*, or the literal representation of the subject. For Degas, drawing was the way the artist saw the form rather than an exact duplication of the image, as one might obtain with a camera.

COMPOSITION. In addition to the drawing, one of the most striking aspects of Degas' work is the composition. His interest in Japanese prints led him to explore asymmetrical arrangements and bird's-eye viewpoints. As already noted, Degas specifically recommended viewing a subject from an unusual angle, from above or below. Often, in his paintings of dancers and women bathing, he

Edgar Degas
FRIEZE OF DANCERS
c. 1895, oil on canvas, 28" × 80" (71 × 203 cm)
Cleveland Museum of Art, Gift of the Hanna Fund .

Edgar Degas
BEFORE THE BALLET
c. 1885, oil on canvas, 15¾" × 35" (40 × 89 cm)
National Gallery of Art. Washington. D.C.. Widener Collection

Degas often used the same model and showed the same pose from different angles, as you can see in the painting on top here. He was also intrigued by the negative spaces, or shapes between the forms. Look at the second painting here and observe how the shapes between the dancers' legs contribute to the rhythm of the whole.

chose a perspective that directly engages the spectator as a voyeur, with an exciting interaction between the space of the picture and that of the viewer. Another device Degas used was to show figures pushed up against the picture's edge and even partially cut off—creating a "snapshot" effect (this may have been influenced by photography as well as Japanese prints). For Degas, such an "off-balance" arrangement seemed more natural than a "posed" painting, in which all the figures are safely included—something that may look contrived and even boring.

The two-dimensional design was important to Degas. From Japanese prints he learned to observe the spaces between things. By filling these intervals with a relationship between the two things, he brought out the decorative pattern of a painting. Often he repeated similar forms, with varied intervals between them, to create a rhythm across the surface. In Degas' late work the emphasis on the flat, decorative pattern becomes more pronounced and foreshadows abstract movements.

COLOR AND LIGHT. Degas maintained that line offered more opportunities for interesting innovation than color. Local color—the actual color of an object—mattered little; what did matter was correct drawing and a vital overall color scheme. Often he juxtaposed complementary colors to create tension and vibrancy. He also contrasted warm and cool tones to add brilliance. One specific piece of advice he gave was that orange colors, green neutralizes, and violet darkens. What was important was the visual effect of color. At one point he even defined painting as "the art of setting off a touch of Venetian red in such a way that it seems to be vermilion."

Degas' continual search for new ways of looking at things was reflected in his exploration of different kinds of lighting. In his notebooks he wrote, "Work a lot on night effects, lamp, candle, etc." He indicated that the exciting thing was not necessarily to depict the light source, but rather to show the effect of light on the subject.

Techniques

There is no simple way to describe Degas' techniques, for he was continually experimenting. At times he used mixed media, combining pastel with gouache or distemper. He also explored different printing forms, including aquatint, drypoint, etching, lithography, and especially monotype (see page 69). In his later years, when his eyesight deteriorated, he did many sculptures, although most of these were never cast. He sculpted in wax and clay, often with wire armatures.

Toward the end of his career Degas also developed an interest in photography, especially in how it could assist him in the study of motion. Although he was known to have taken many pictures, few have survived. He probably used photographs of dancers as studies for painting. At times he even painted with pastels directly on the photographs.

DEVELOPING COMPOSITIONS. Unlike most of the Impressionists, Degas nearly always painted indoors. In his dimly lit studio he could work surrounded by drawings, paintings, and props (such as a large spiral staircase) and not be disturbed by the changing elements outside. By working in his studio, he could also carefully compose his paintings, allowing for the important transformation brought about by the collaboration of imagination and memory.

There was no set way in which Degas developed a composition. Sometimes he completed detailed preparatory drawings for specific figures in a painting after his idea was set. Or he might have models come to his studio and move them around in different poses to decide on the composition. After the composition was determined, he might ask one of the models to remain in a pose while he did a pastel and then ask another model to pose while he did another pastel. The models would then leave, and he would execute the painting from the pastels and from memory. At other times Degas used details from previous drawings and reorganized them to form a new composition. He found it a challenge to work with only a limited number of poses and to come up with widely varying compositions. A few stock poses, together with his imaginative memory, constituted a lifetime of working material.

Degas often changed his mind as he worked. He might even redraw a figure in the final stages of a painting. In some works multiple contour lines are visible, augmenting the feeling of movement. It is as if successive frames of a motion picture were shown in one image.

Degas even made revisions in supposedly finished paintings. Unfortunately, at times these revisions were done in different media, causing the paint to crack. At other times when he redid a painting, he ruined it. This happened even with paintings that had already been sold—Degas would plead with the owner to give him the painting to take home and work on again. There is even a report of how one owner of a number of Degas' paintings always chained the works to the walls when the artist came to visit.

Using a Limited Palette

Degas explored different palettes for different subjects. Certain subjects demand the brilliance of tones that only a full palette of twelve or more colors can provide, while other subjects may require significantly fewer colors. In the painting of a bather shown here, he completed the picture with only four pigments: zinc oxide white, red ochre, burnt sienna, and charcoal black. Even four hues, however, can suggest a range of color. Notice how in this painting Degas has achieved varied warm tones by mixing zinc oxide white and charcoal black with burnt sienna and red ochre both separately and together. The cool tones in Degas' painting are mixed with zinc oxide white and charcoal black alone. When the warm tones are juxtaposed against the cool tones, they make each other tell.

Using a limited palette like this one also helps ensure a certain harmony of color. Especially when you are doing an underpainting, it pays to keep things simple. Then, if you want more color, you can add spots of intense color here and there and watch the painting come to life—something Degas himself noted (see page 68).

Here you can see various mixtures made with zinc oxide white, red ochre, burnt sienna, and ivory black (substituted for charcoal black).

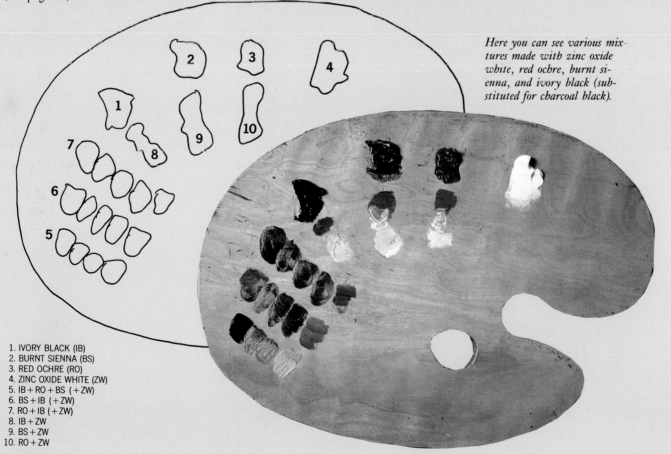

1. IVORY BLACK (IB)
2. BURNT SIENNA (BS)
3. RED OCHRE (RO)
4. ZINC OXIDE WHITE (ZW)
5. IB + RO + BS (+ZW)
6. BS + IB (+ZW)
7. RO + IB (+ZW)
8. IB + ZW
9. BS + ZW
10. RO + ZW

Edgar Degas
WOMAN WITH CHRYSANTHEMUMS
1865, oil on canvas, 29″ × 36½″ (74 × 93 cm)
Metropolitan Museum of Art, H. O. Havemeyer Collection,
Bequest of Mrs. H. O. Havemeyer

The composition in both these paintings is unusual. On top the flowers almost overwhelm the woman, heightening the mood of introspection; below most of the painting shows the sky but the strong colors focus attention on the racers.

Edgar Degas
THE RACES
1873, oil on panel, 10½″ × 13¾″ (27 × 35 cm)
National Gallery of Art, Washington, D.C., Widener Collection

OIL PAINTINGS. Especially in his early work, Degas followed the traditional "academic" technique. He generally began with a monochrome underpainting. Using a sable brush, he drew his subject in a single color on a toned ground. (Later in life he sometimes used his thumb to place this initial color on the canvas.) Taking a hog's-hair brush, he then applied uniformly thin, flat strokes over large areas, creating a smooth surface, which he called *le demi-plein mince*, or the thin half-full. As he worked, Degas built up the paint in separate but relatively even layers. Although at times he let the brushstrokes show, he did not use heavy, irregular impastos.

In his mature work Degas varied his technique, but he still often started with a monochrome underpainting. He asserted that this helped to unify the design so that, with the addition of only a little color—a touch here, a spot there—the image came to life. A painting was then finished whenever a harmonious effect was achieved.

Overall, Degas' oil paintings have a "lean" paint quality. A favorite technique of his was *peinture à l'essence*, in which oil paint was squeezed out of the tube onto blotting paper, which absorbed much of the oil. Degas then thinned the paint with turpentine before applying it to the canvas. This process reduced the drying time and allowed him to use many layers without building up excessive paint.

Degas did, however, create subtle textural variations in his mature works. He explored different kinds of brushstrokes, often using small strokes for delicate areas and large strokes to show movement or rhythm. At times he even applied paint directly with a rag or his fingers. Degas also liked to use a palette knife to manipulate the paint. One technique was to pull the paint up with the flat side of the palette knife. When the paint was wet, this technique helped to soften edges. It also created broken flecks of color by removing paint from the raised threads and leaving it in the hollows of the canvas. When the paint was partially dry, this technique gave a veiled quality to the subject.

PASTELS. During the last years of his life, Degas used pastel, almost exclusively, as a painting medium, in part because of his poor eyesight. Holding the pastel (mostly pigment), he could use it directly, as if it were an extension of his fingers.

With pastels, Degas could essentially draw with color. He usually began his pastels by setting up an all-over pattern of flecks, whirls, spots, parallel and crossing lines, often in vibrant reds, turquoises, yellows, and greens. Next he applied a fixative, probably of white shellac dissolved in pure methyl alcohol.

Then he might develop another layer of colors, allowing the first layer to show through. After applying fixative again, he completed successive layers in the same fashion.

From time to time Degas is thought to have blown steam over the first or second layer of a pastel work. With this technique, he could turn the pastel into a thin film that appeared to float on the surface. Or he could transform the pigment into a paste that could then be worked with a brush. Brushstrokes are visible in a number of his pastel works.

Degas sometimes passed his pastel pictures through a press, along with a damp sheet of paper, creating a reverse image. On this second version, he worked out alternative solutions to the same basic theme. Degas also reworked his ideas by using tracing paper. In this way he could quickly change a composition, combine figures from different drawings, or reverse an image. Sometimes he used tracing paper to enlarge his drawings, employing sheets as large as forty inches. These tracings were not just working sketches; some pastels were completed on tracing paper.

MONOTYPES. Around 1870 Degas began experimenting with monotypes as a tool for developing the lights and darks in a composition. Essentially, the process of monotype involves drawing or painting with greasy ink on a smooth zinc or copper plate and printing the image by placing a sheet of paper over it and running it through a press. As the term *monotype* implies, only one clear proof is possible—although, if there is enough ink left on the plate, a second, weaker impression can be obtained. There are two basic ways of working with the ink on the plate, and Degas used both in his work. In the first—the "light field" method—he drew directly with the ink on the surface. In the second, or "dark field," method, he covered the entire surface with ink and then wiped away the ink—using a rag, his fingers, or whatever—to create lighter areas. After pulling the monotype, Degas might retouch it with pastel. Sometimes, especially with the second, weaker impressions, he completely reworked the surface with pastel, using the monotype as a ground for the pastel.

Materials

Because Degas experimented so much, it's difficult to give a simple listing of his materials. What follows is only a brief summary of some of them.

DRAWING. Degas drew with graphite, chalk, charcoal, and crayon. He also did brush drawings in ink, watercolor, and oil paint. For his drawings he used several kinds of paper, including tracing, laid, wove, and China paper. (Laid pape has a rough texture, with lines running across the grain, whereas wove paper offers a smooth surface.) Often he worked on toned paper, which might be tan, buff, pink, blue, or gray.

PIGMENTS. Degas' oil painting palette probably consisted of the following colors:

Yellows: yellow ochre, lemon yellow, Naples yellow.

Browns: burnt sienna, raw umber.

Reds: red ochre, vermilion, alizarin crimson, pale madder pink.

Greens: chrome green, viridian, pale turquoise.

Blues: Prussian blue, cobalt blue, ultramarine blue.

Blacks: charcoal black, ivory black.

Whites: white lead, zinc oxide white.

Degas did not generally use all these colors at once, and at times he greatly restricted his palette (see page 67).

PAINTING SURFACES. Degas painted on various sizes of canvas; some unusually complex works are surprisingly small. For the small works, he used smooth linen or, occasionally, a panel, but generally he preferred medium to medium-rough canvas. To prepare the surface, he often primed it with coats of thin white lead, possibly on top of an animal glue size. He then frequently applied an umber imprimatura, although off-white, cool green, and burnt sienna imprimaturas are also found.

Degas did a number of paintings on cardboard. First he coated the cardboard with a glue size (possibly rabbit-skin glue) or varnish to make the surface less absorbent and facilitate brushing on the paint. A few of these works show an intense reddish-brown imprimatura, which may have been a separate oil layer or a mixture of pigment with the glue size. Degas also, at times, oiled sheets of paper and painted directly on them.

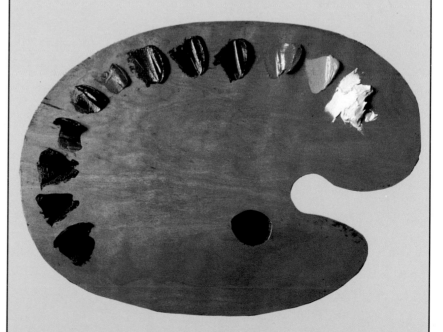

A modern-day equivalent of Degas' oil palette includes zinc white, Naples yellow medium, yellow ochre, burnt sienna, raw umber, red ochre, cadmium red light, alizarin crimson, viridian, phthalo green, Prussian blue, and ivory black.

Demonstration: Dancers

Both this demonstration and the one that follows clearly show how a colored ground can be used to great advantage in the painting process. With this technique, Degas could capture a full range of tones more quickly and more easily than if he had carefully rendered each section of the canvas. At times he let the ground color show through in the final painting in a way that adds to the painting's luminous quality and provides a contrast to areas built up with layers of paint.

One aspect of this painting that especially intrigued me was how Degas depicted the figures as a harmonious unit and yet preserved their individual character. Look closely and you can see that, in addition to the dancers, there is a sixth figure—a man in a top hat, who is partially hidden by the stage scenery.

Edgar Degas
DANCERS, PINK AND GREEN
1890, oil on canvas, 32⅜″ × 29¾″ (82 × 76 cm)
Metropolitan Museum of Art, H. O. Havemeyer Collection,
Bequest of Mrs. H. O. Havemeyer, 1929

STEP ONE. To prepare the linen canvas, I apply rabbit-skin glue, followed by a thin coat of white lead priming and finally an imprimatura coat of burnt sienna thinned with turpentine. After this has dried, I draw the composition with a no. 6 round sable in brown tones (ivory black mixed with burnt sienna and Venetian red).

Applying an imprimatura to tone the canvas is especially useful when your subject is in the medium to dark value range. The process is quite simple. First lay your canvas flat on the floor; then squeeze some burnt sienna onto the center of the canvas. Now take some turpentine (as pure and fresh as you can get it) and pour a little over the paint. Crumple a clean rag or paper towel and use it to spread the mixture evenly over the entire surface. After the entire canvas is covered, continue wiping until you get the tone you want (darker or lighter). You can create interesting striations by wiping across the canvas in single strokes, working your way from top to bottom.

STEP TWO. Using a no. 4 flat bristle, I now lay in flat, smooth areas of color. At this point these are mostly stains of brown.

STEP THREE. I continue to work on the monochrome underpainting—first the darks, then the lights. I also introduce some areas of green against the reddish ground to suggest the interaction of complements, so important to Degas' finished painting.

STEP FOUR. After adding a variety of brown tones above the heads of the dancers, I work on some of the bright reds in the dancers. I also check for any errors in the drawing. In Degas' work the drawing is critical—even more important than the color.

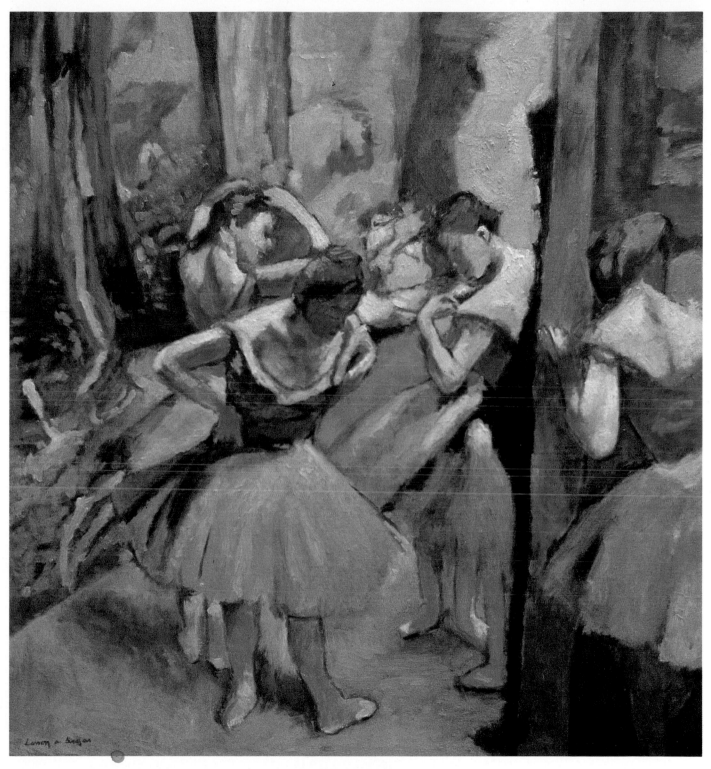

STEP FIVE. To finish the painting, I concentrate on the juxtaposition of complementary reds and greens, which add life and vibrancy to Degas' painting. For the highlights, I apply impastos full of white. I also add touches of pure Venetian red and pure vermilion. Remember that just a few spots of intense color can bring the painting to life.

Palette:
Naples yellow
yellow ochre
burnt sienna
raw umber
Venetian red
cadmium red light
Prussian blue
ivory black
zinc white

Brushes:
flat bristles (nos. 3, 4)
round sables (nos. 6, 8)

Demonstration: Single Figure

Once in a while an artist strikes on a perfect balance between a complex, mysterious mood and a simple, direct design. This small painting is one of the most "soulful" compositions I have ever seen. Its melancholic expression is so powerful that I decided that it must be included in my study of Degas.

What is the value of painting? What do your paintings communicate to others? Are they merely pretty pictures, or do they say something? These are questions artists ask again and again, and they continually search for new answers. Degas has made this seemingly simple painting say so much that a careful study of it would benefit any artist, no matter what style he or she prefers.

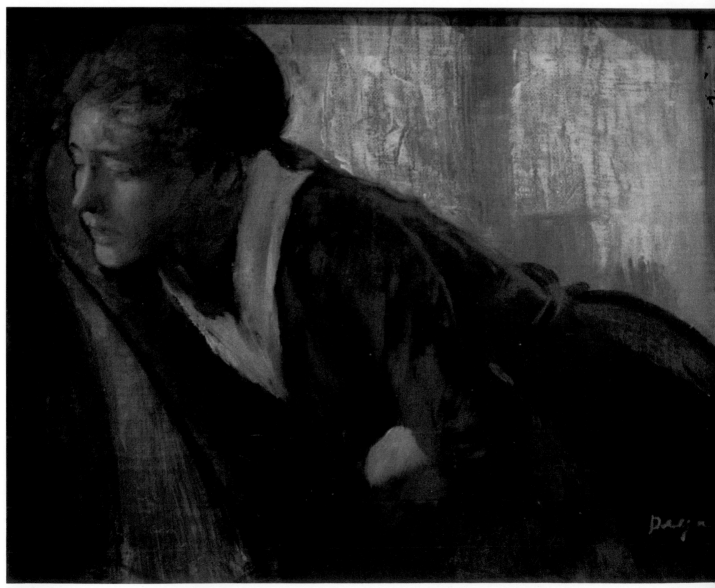

Edgar Degas
REFLECTION
c. 1874, oil on canvas, 7½" × 9¾" (19 × 25 cm)
The Phillips Collection, Washington, D.C.

74

STEP ONE. For this painting, Degas used a fairly dark imprimatura, and its orangish tone shows through the many thin layers of paint in the final work. To reproduce this effect, I apply a moderately dark imprimatura of burnt sienna, after first sizing the canvas with rabbit-skin glue and priming it with white lead. Then, using round sables, I draw the figure in ivory black.

STEP TWO. Degas intended this painting to be completed in one sitting. He began by painting the middle tones of the background to model the edges of the figure. Following this method, I paint tones of ivory black, cadmium red light, and burnt sienna on the left. On the right, I use mainly Naples yellow mixed with raw umber, white, and a little Prussian blue.

STEP THREE. The next step is to lay in the dark masses of the figure. For the darkest darks, I use ivory black combined with some raw umber and touches of cadmium red light; for the slightly ligher areas, raw umber and yellow ochre.

STEP FOUR. In small areas of this painting, Degas scrubbed the paint in, using a circular movement to create a soft fusion between adjoining areas. As he worked, he mixed his colors both on the palette and on the canvas. With this in mind, I lay in the middle tones. For the chair, I use cadmium red light and Naples yellow, as well as raw umber in parts; for the shadow tones of the face, yellow ochre, burnt sienna, and raw umber.

STEP FIVE. Turning to the light tones, I work on the collar with white, Prussian blue, raw umber, and some yellow ochre. The golden tones of the face are made up of yellow ochre, burnt sienna, and some white. To articulate the arm, I apply burnt sienna and Venetian red where the shadow areas turn into light areas; I then use undiluted cadmium red light for the brightest spots and a mixture of cadmium red light and yellow ochre for the light areas.

STEP SIX. Now I reinforce the drawing of the chair and develop the hair, using mainly yellow ochre with some burnt sienna and raw umber. I also apply the highlights on the collar, hand, and face. Finally, I place the bright lights in the background with a palette knife, stroking up and down and leaving some knife marks to add variations to the paint texture. Notice how these bright tones create a foil for the dark figure and make her stand out.

Master of Jewellike Textures

MONET

Claude Monet
PALAZZO DA MULA, VENICE
1908, oil on canvas, 24½" × 31⅞" (62 × 81 cm)
National Gallery of Art, Washington, D.C., Chester Dale Collection

THE WORK of Claude Oscar Monet (1840–1926) typifies the Impressionist style, and he is considered one of the founders of the movement. In 1874 he helped to organize the first of eight Impressionist exhibits. The artists, however, did not call themselves "Impressionists." Instead, the term came from the art critic Louis Leroy, who was struck by the title of Monet's painting *Impression: Sunrise* and used the word to ridicule the entire show. Along with most of the public at the time, Leroy thought the work oversimplified—an impression—without the refinement of good art.

Today it may be difficult to understand this negative reaction, but at the time the Impressionist vision was revolutionary. People were accustomed to viewing highly finished paintings, completed in the studio. Although outdoor sketches, carefully labeled, might be placed next to finished works in exhibitions, this was only for comparison. The Impressionists, however, often completed their landscapes on location and offered a suggestion—rather than a detailed description—of their subjects. In other paintings they depicted the modern urban life around them, without giving it any particular historical or allegorical significance. They aspired to record what they *saw*, and, in doing this, they emphasized the effects of light and atmosphere.

Life and Studies

Monet was born on November 14, 1840, in Paris—on the same day and in the same city that the sculptor Auguste Rodin was born. In 1845 Monet's family moved to the seaport Le Havre, where his father dealt in groceries and other goods. While in school there, Monet received his first art instruction from François-Charles Ochard, who had his students draw from plaster casts, with an emphasis on line and value over color. As a teenager, Monet earned a local reputation as a caricaturist and received several commissions for his caricatures.

In 1858 Monet met Eugène Boudin, whom he later credited with showing him what painting from nature could be. Boudin advised Monet that paintings done on location had a power and a vivacity of touch that could not be re-created in the studio. He also taught Monet about the use of color, especially where shadows were concerned.

Determined to become a painter, Monet set out for Paris in 1859. Within two years, however, he was conscripted into the army and sent to Algeria. Monet was reportedly delighted with the strong color and light there, but he soon became ill and returned to France to recuperate. His father then bought him out of his remaining military duty—under the condition that he study in a proper atelier with a "well-known master."

In the summer of 1862, before he returned to Paris, Monet met Johann Barthold Jongkind, a Dutch landscape painter. He spent some time painting with Jongkind on location and later credited the elder artist with "the final education of my eye." Then, in the fall of 1862, Monet entered the studio of Charles Gleyre, a Neoclassical painter. Gleyre had his students paint from live models, but he discouraged realistic depictions, which he considered ugly. Instead, he insisted on the addition of "style," in imitation of antique art. Although Monet rejected Gleyre's teachings, it was in Gleyre's studio that he

The magical quality of this painting comes from Monet's attention to light and atmosphere. Although there is a predominant bluish tone, there are many exciting color variations, in both the buildings and the reflections in the water. The thick, encrusted paint adds to the jewellike feeling of the whole.

Eugène Boudin
WASHERWOMEN ON THE BEACH OF ETRETAT
1894, oil on wood, 14⅝″ × 21⅝″ (37 × 55 cm)
National Gallery of Art, Washington, D.C., Ailsa Mellon Bruce Collection

Boudin was an important early influence on Monet and encouraged him to work outdoors. In the painting by Monet here, you can see on the right his floating studio, which allowed him to paint views on location along the river.

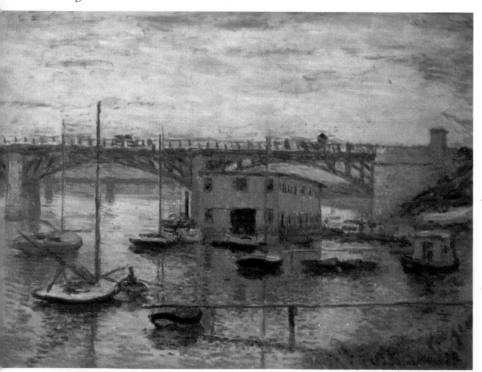

Claude Monet
THE BRIDGE AT ARGENTEUIL ON A GRAY DAY
1874–75, oil on canvas, 24″ × 31⅝″ (61 × 80 cm)
National Gallery of Art, Washington, D.C., Ailsa Mellon Bruce Collection

met and befriended Frédéric Bazille, Pierre Auguste Renoir, and Alfred Sisley.

Living in Paris brought Monet in contact with many other artists. In the cafés he discussed ideas with Camille Pissarro and Gustave Courbet, among others. Courbet encouraged him to paint subjects from contemporary life, rather than classical compositions, and to render the objects accurately. Monet was also influenced by the work of Eugène Delacroix, especially his use of contrasting colors. When Delacroix's journals were published posthumously, they became one of Monet's favorite books.

Although Monet showed paintings in the official French Salon in 1865 and 1866, his work was rejected in ensuing years. In 1870 he married his mistress Camille and later that year went to England. There he admired the work of John Constable and J. M. W. Turner, although he expressed dislike for Turner's excessive romanticism.

In 1871 Monet rented a house in Argenteuil, a village on the Seine famous for its boat races. There he acquired a studio boat and worked prodigiously, completing nearly two hundred canvases in seven years. Edouard Manet, Renoir, and other friends often joined him on painting trips there.

In 1875 Camille became ill with tuberculosis and four years later died. A year before her death the family moved to the secluded village of Vétheuil, where they were joined by Alice Hoschedé and her six children. (Her husband had experienced financial ruin and could no longer face his family.) After Camille's death, Alice took over the care of Monet and his two sons, as well as her own children.

In 1883 the family moved to Giverny, where they rented a house and its surrounding grounds. After many years of severe poverty, Monet began to earn money from his paintings, and by 1890 he was able to purchase the property. Although Monet had planned and constructed gardens at most of his previous residences, at Giverny they became much more complex and extensive. He visited his gardens many times a day and found them an important source of inspiration. The waterlilies, for example, were initially planted purely for pleasure, but one day he was struck by the beauty of his pool and set out to capture the vision on canvas.

Monet spent forty-three years in Giverny, although during that time he also took painting trips along the northern French coast and traveled to England and Venice. Many artists came to visit Monet in Giverny, including Paul Cézanne, Edgar Degas, John Singer Sargent, and Henri Matisse. A few other artists even settled there.

During the years at Giverny, Monet kept a regular schedule. He was usually up by four or five, when he would take a cold bath and eat a large breakfast. Then he and one of the children would load a wheelbarrow with painting equipment and set off to work. They returned home for a leisurely lunch, and then Monet usually retired to one of his studios to paint in the afternoon. Dinner was served at seven, and Monet was usually in bed by nine-thirty.

On some mornings, however, Monet refused to get out of bed. He was a moody character and suffered from bouts of depression and self-doubt throughout his life. At times he destroyed his work in frustration.

Monet had married Alice Hoschedé in 1892, and he was quite upset when she died in 1911. A few years later, Alice's daughter Blanche—who was also the widow of Monet's eldest son and an artist herself—became his guardian and helper.

In 1914, at age seventy-four, Monet embarked on a final ambitious project. His friend Georges Clemenceau, the statesman and newspaper owner, secured a government commission for him to decorate two oval rooms in the Orangerie in Paris. The plan involved about fifty canvases, each measuring about 6 × 12 feet (1.8 × 3.6 meters), and Monet built a special studio just to accommodate these large canvases.

While working on these large waterlily paintings, Monet suffered increasing difficulty with his eyesight, eventually becoming nearly blind. Finally, at Clemenceau's urging, he underwent two operations to remove cataracts in 1923. Although at first, when the patches were removed, everything appeared yellowish and then bluish, his vision eventually improved.

Monet lived to complete the Orangerie canvases, but he died before they were fully installed and dedicated. On December 5, 1926, at the age of eighty-six, he died of pulmonary sclerosis, which was probably brought on by his chain-smoking. The funeral in Giverny was simple, but among the pall-bearers were Clemenceau and the artists Pierre Bonnard and Edouard Vuillard. Many years later Monet's home and gardens at Giverny were restored; they are now open to the public.

Ideas on Art

Monet described his lifelong ambition as painting "directly from nature, trying to convey my impressions in the presence of the most fugitive effects." He distrusted artistic theories and insisted that pictures were not made by "following all the rules." For him, it

Claude Monet
WOMAN WITH A PARASOL—MADAME MONET AND HER SON
1875, oil on canvas, 39¼" × 32" (100 × 81 cm)
National Gallery of Art, Washington, D.C., Collection of Mr. and Mrs. Paul Mellon

In painting figures as well as landscapes, Monet looked for the effect of light and how this affected the color. Notice how his brushstrokes here create subtle rhythms across the canvas.

Claude Monet
THE BRIDGE AT ARGENTEUIL
1874, oil on canvas, 23⅝″ × 31⅜″ (60 × 80 cm)
National Gallery of Art, Washington, D.C.,
Collection of Mr. and Mrs. Paul Mellon

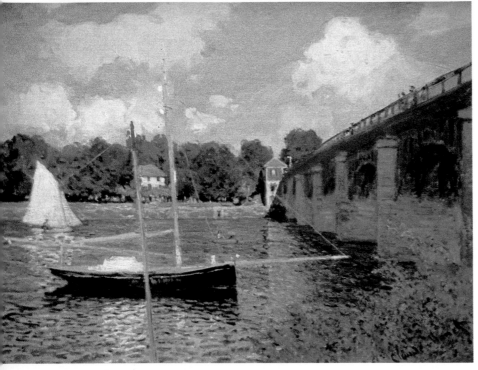

Monet was fascinated by water and its reflections, and
he returned to this subject throughout his career. The
painting on top is typical of the Impressionist period,
while the one below reveals Monet's later interest in
subtle, fleeting atmospheric effects.

Claude Monet
MORNING ON THE SEINE, FOG EFFECT
1897, oil on canvas, 26″ × 36″ (66 × 91 cm),
Metropolitan Museum of Art

was important to paint what one actually sees, instead of what one thinks one ought to see.

Monet contended that techniques may vary but the goal of art remains the same: "it is the transposition of nature, at once forceful and sensitive." While discussing his need to paint on location, without preestablished ideas, he remarked to Clemenceau: "When one is on the plane of concordant appearances, one cannot be far from reality, or at least from what we can know of it. . . . Your error is to wish to reduce the world to your measure, whereas, by enlarging your knowledge of things, you will find your knowledge of self enlarged."

COMPOSITION. Although Monet insisted on painting what he saw, that doesn't mean he ignored composition. His decisions about where to crop a scene or what to emphasize involved his sense of composition. One might describe his way of working as finding the natural order in the scene before him rather than imposing an abstract idea of order on nature.

In his feeling for design, Monet, like Degas, was greatly influenced by Japanese prints. He was intrigued by their emphasis on the flat, two-dimensional design and their "all-over" patterning, which lacked a specific focus. Another aspect of Japanese prints that Monet incorporated into his compositions was the use of asymmetrical arrangements, which created a sense of imbalance. In his paintings of the cliffs at Etretat, for example, he often placed a heavy mass of rocks on one side, with the open sky and sea on the other.

COLOR AND LIGHT. Monet's use of color evolved as he matured. In his early works, he tended to use contrasting values to render objects. By the 1870s, however, he began to vary colors, rather than light and shade, to create space and form. More and more, he concentrated on the effects of light and on the atmosphere that lay between the viewer and the subject being viewed. From the 1880s onward, his paintings became enveloped in light, and often the colors seem to flicker, like light, over the textured surface. In his late works Monet brought the subject up close to the picture plane and thus to the viewer, so one becomes immersed in the play of color, light, and texture.

To convey the effect of light, Monet concentrated on the colors that lie in the atmosphere that surrounds a subject. These colors change continually as the light changes. Generally light during the early and late hours of the day is warmer, while between the hours of ten in the morning to two in the afternoon, it is usually cool. Monet observed how the light

fell on objects and how it transformed the "local" color. Through this process, he came to analyze what he saw in terms of spots of color. "When you go out to paint," he once advised, "try to forget what objects you have before you—a tree, a house, a field, or whatever. Merely think, here is a little square of blue, here an oblong of pink, here a streak of yellow, and paint it just as it looks to you, the exact color and shape, until it gives your own naive impression of the scene before you."

Monet worked with touches of pure color, often placing unmixed paints side by side. Everything was imbued with color—not just the light areas. In the shadows, for example, he sometimes added a small amount of the complement of the surrounding color instead of painting a darker tone. He also used the vibration of complements in other places—playing bright reds against duller greens, for example. At times, especially in his later work, he allowed one hue to dominate a painting. This dominant hue then suggested an envelope of light, vibrating throughout the painting and transforming both attractive and unattractive objects into glowing gems.

Even in signing his paintings, Monet thought about the color and how it fit in with the rest of the painting. Sometimes, in landscapes in which green tones predominated, he signed his name in red. The signature provided an excuse to place red in an area where it might not otherwise have been appropriate, but where it added to the overall effect.

USE OF SERIES. Around 1890 Monet began painting the same subject in a series of works. Each painting showed an instant among many moments. He had already developed the idea of changing canvases as the light changed and working on each canvas during the same time period on successive days, and this now became common practice. Monet believed that this was the best way to get a true impression of the effect of light on nature—in contrast to a composite picture, which showed a number of effects. Individually, his serial paintings captured a brief moment in nature; together, they depicted a more complete view.

For his work in a series, Monet generally preferred one or two fixed viewpoints. He kept all the paintings in a series beside him in the studio and worked on them concurrently until they were all finished. Then, if possible, he tried to exhibit the works in a series together.

Monet's first major series included various paintings of haystacks, completed between 1889 and 1891. The haystacks are shown at different times of day, with the emphasis on the changing light and atmosphere. In these

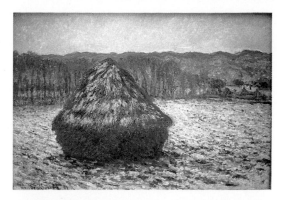

Claude Monet
LA MEULE (HAYSTACK)
1891, oil on canvas
25⁹⁄₁₆" × 36³⁄₁₆" (65 × 92 cm)
The Art Institute of Chicago,
Martin A. Ryerson Collection
and Potter Palmer Collection,
Bequest of Jerome Friedman,
Major Acquisition Centennial Fund,
and Searle Family Trust

Claude Monet
TWO HAYSTACKS
1891, oil on canvas
25½" × 39½" (65 × 100 cm)
The Art Institute of Chicago,
Mr. and Mrs. Lewis L. Coburn
Memorial Collection

Claude Monet
HAYSTACK—SETTING SUN
1891, oil on canvas
25½" × 39½" (65 × 100 cm)
The Art Institute of Chicago,
Potter Palmer Collection

Claude Monet
HAYSTACK IN THE SNOW,
OVERCAST DAY
1891, oil on canvas
25⁹⁄₁₆" × 36³⁄₁₆" (65 × 92 cm)
The Art Institute of Chicago,
Martin A. Ryerson Collection

Viewed together, these paintings from Monet's haystack series suggest the constant visual transformation of the world around us as the light and time change.

Claude Monet
POPLARS
1891, oil on canvas, 32¼" × 32⅛" (82 × 82 cm)
Metropolitan Museum of Art, H. O. Havemeyer Collection,
Bequest of Mrs. H. O. Havemeyer, 1929

This painting is from Monet's second major series—of poplar trees. This series has, at times, been described as a study in rectangles.

Experimenting with Texture

When Monet began a painting, he often employed a variety of brushstrokes, which created different textures. He might use smooth strokes for the sky, choppy strokes shaped like commas for greenery, and flat, straight strokes of varying lengths for water. As he worked, he built the various directional and irregular strokes in layers, setting up a rhythm in the painting and creating broken color. In the final stages he sometimes emphasized the underlying textures by placing dark tones along the bottoms of horizontal strokes and light tones along the tops. Highlights might be added with skip strokes or thin strokes that followed the tops of the textured strokes. Occasionally Monet scratched through paint with the wooden end of a brush to expose the canvas ground.

While working with lots of paint, Monet sometimes changed the way he held his brush. Instead of holding it as one would a pen, he held it as a house-painter would—with the brush flat in his palm. In this way he could apply more paint at a faster rate, while emphasizing the vertical strokes in his subject.

Texture became increasingly important in Monet's later work. In the Rouen Cathedral series, the paint surface is not unlike the rough surface of the actual cathedral. Here the ridges and valleys of paint add another dimension to the picture, and the viewer's eye is activated by both the surface and the more subtle tones that lie in the hollows. Similarly, in his waterlily series, Monet exploited textures to increase the paintings' impact. The local colors on top of the textured grounds suggest the water's surface while the rugged, textured grooves hint at the water's depths.

It is interesting to compare Monet's exploration of texture to experiments by Turner and Rembrandt. When Monet visited England in 1870 he studied Turner's paintings; many years before, Turner had looked to the works of Rembrandt for lessons on how to handle light and texture. The textures all three artists used were considered revolutionary in their day. What is important to realize is that Rembrandt, Turner, and Monet all took chances in their work. To succeed as an artist, you must be willing to take risks.

paintings the surface is strongly built up, almost encrusted with vibrant, broken color.

After the haystacks, Monet did a series of poplar trees, between 1891 and 1892. At one point he learned that the row of trees was to be cleared, but he was able to pay to keep them up long enough to finish his paintings. One of the particular effects depicted in this series lasted only seven minutes. To take full advantage of the limited time, Monet reportedly fitted a boat with grooves, presumably lined up along a side, to hold a number of canvases. He then worked on the canvases individually, moving down the row as the light changed.

Monet's other series include his paintings of the Rouen Cathedral (see page 85), the Houses of Parliament in London (page 92), and the waterlilies at Giverny (page 86). In all these works the real subject is light and atmosphere.

Claude Monet
ROUEN CATHEDRAL, WEST FACADE, SUNLIGHT
1894, oil on canvas, 39½" × 26" (100 × 66 cm)
National Gallery of Art, Washington, D.C., Chester Dale Collection

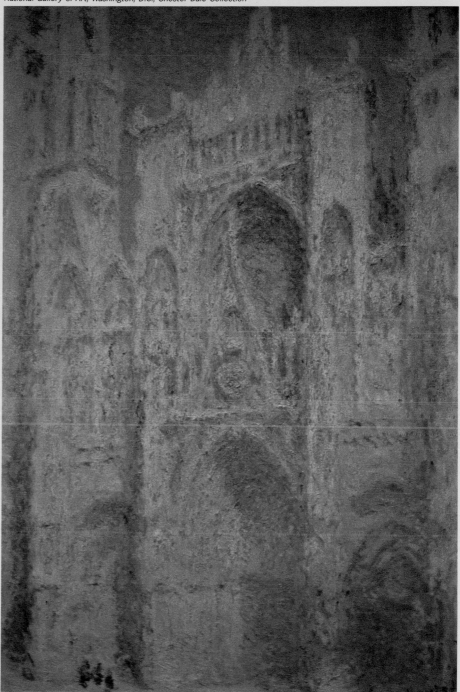

DETAILS:
Rembrandt van Rijn,
JOSEPH ACCUSED BY POTIPHAR'S WIFE,
1655, oil on canvas, National Gallery of Art,
Washington, D.C.

J.M.W. Turner,
THE DOGANA AND THE
SANTA MARIA DELLA SALUTE, VENICE
(see page 56)

Claude Monet,
ROUEN CATHEDRAL, WEST FACADE,
SUNLIGHT *(two details)*

Claude Monet
WATERLILIES (slightly cropped)
1919–22, oil on canvas, 78¾" × 167¾" (200 × 426 cm)
Cleveland Museum of Art, Purchase: John L. Severance Fund

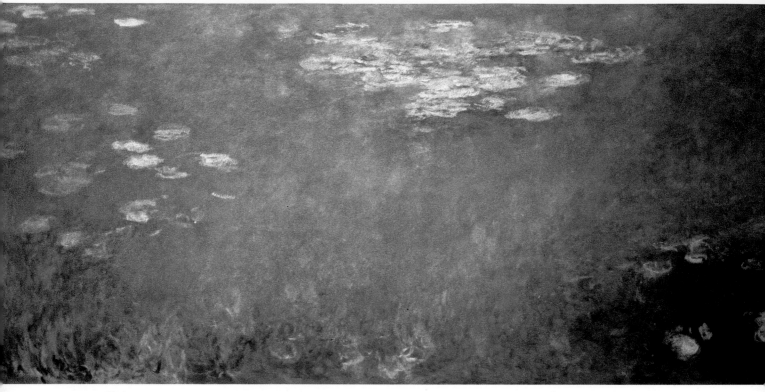

In Monet's late paintings of waterlilies everything is close to the picture plane, so the viewer becomes immersed in the play of color, light, and texture.

Painting Techniques

After selecting a view, Monet probably sketched in the basic composition using either charcoal or light blue paint. He then began working with rather thin paint and swiftly laid in the subject with strokes of color all over the canvas. Monet continued to add dabs of color, building the paint in uneven layers and allowing the ground to show through in parts. In the beginning he probably used paler colors because light tones were easier to cover if changes were desired later.

When painting a landscape, Monet worked on the canvas only as long as the effect he was attempting to capture remained. If the lighting or weather changed, he either began working on another painting or quit for the day. This method of working evolved naturally. One day when he was out painting with one of his stepchildren, he saw that the light had changed, so he asked the girl to go and bring out another canvas. She did, but a short time later the light changed again, so she went and collected another canvas, then another. Limiting his painting time to a brief moment's effect eventually became standard practice for Monet.

On a few occasions, Monet completed a painting after the first day's work. More often, however, he worked on a painting a number of times, sometimes with several days' drying time in between. Some paintings required as many as fifty or sixty separate sessions.

Monet would return to the same spot at the same time each day to continue painting. Gradually, he built up the layers of paint, creating thick, tactile textures. In the final stages he might drybrush spots of intense color and alter local colors. Often the final body colors of an object differed from the original color lay-in.

Although Monet insisted on observing nature directly, outdoors, he did sometimes retouch his paintings back in the studio. This was especially true when he was working on a series of paintings, such as the haystacks or poplars, which he intended to exhibit together. The entire group of paintings would be lined up in the studio and Monet would stand back to view the paintings as a whole from a distance. Sometimes he also looked at them through a mirror, which provided an entirely different perspective and often brought to light things that might otherwise have gone unnoticed. By working in his studio, where changing light effects were not a factor, he could add finishing touches that enhanced the definition of shapes and colors. In this way he was also able to make the group of paintings a cohesive unit of work.

Materials

DRAWING. Monet occasionally did quick, simple sketches of a subject. For these he did not use watercolor, as many of his contemporaries did—instead, he worked in pastel. He rarely did any actual drawing, however, as the Impressionists contended that line does not exist in nature. Yet Monet was a fine draftsman; his early caricatures and pencil and crayon drawings attest to his sensitive feel for line and model.

PIGMENTS. For his oil paintings, Monet used tube colors. His palette probably included the following colors:

Yellows: cadmium yellow light, cadmium yellow deep, cadmium yellow lemon, yellow ochre, strontium (a light, bright yellow with a greenish cast).

Orange: cadmium orange.

Reds: vermilion, deep madder (replaced by alizarin crimson).

Greens: viridian, sap green.

Blues: cobalt blue, ultramarine blue.

Violet: cobalt violet light.

White: white lead.

Although he used ivory black in his earlier paintings, during his Impressionist years he avoided it. For the Impressionists, black signified the absence of light—instead, if a dark was needed, they might mix ultramarine blue and alizarin crimson. The Impressionists also eliminated earthtones because they were thought not to transmit light.

Like most artists, Monet chose his specific colors according to the subject before him. For his late paintings of waterlilies, he probably simplified his palette to yellow ochre, orange, vermilion, viridian, possibly sap green, cobalt blue, ultramarine blue, cobalt violet light, and—in the center of his palette—mounds of white.

Monet laid out his pigments on an oblong or rectangular palette. He preferred a natural wood coloring, which allowed him to see the values of his mixtures properly—something that is more difficult with a light or dark palette. Before applying the paint, Monet, like Degas, blotted it to remove excess oil. He preferred a dry look to a shiny, smooth finish. For a painting medium,

he probably used turpentine and linseed oil.

PAINTING SURFACES. Monet generally worked on canvas, but there are a few examples of paintings on wood. Most often he used ready-prepared linen canvas with an unusually smooth texture, although for the very late paintings rougher canvas was employed. The grounds consisted of thin priming coats, brushed on rather than applied with a palette knife, so the canvas grain—or tooth, as it is sometimes called—remained exposed. For his early work, Monet added imprimaturas of pale gray, pinkish gray, cream, tan, or off-white. After 1881, however, he usually worked on a white ground.

OTHER TOOLS. Monet used both small and large hog's-hair brushes, often with long handles. He also employed sable brushes, which were sometimes wider than an inch.

One special device that Monet used was a floating studio, which he built in the 1870s. He worked from this boat quite often, taking it up and down the Seine. It allowed him to paint water scenes from different viewpoints.

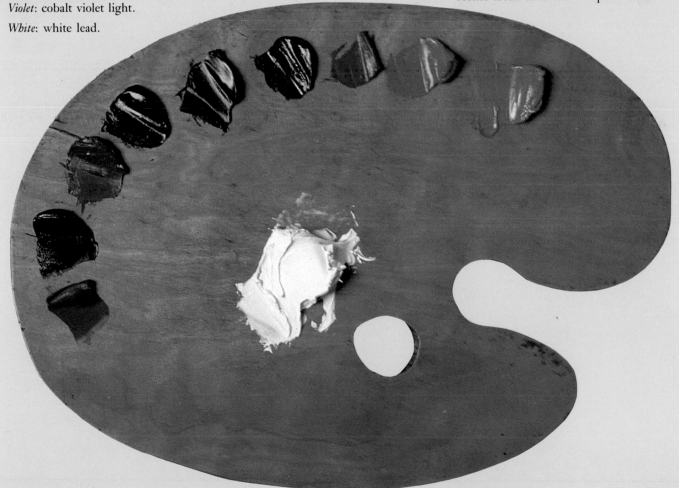

A modern-day equivalent of Monet's palette includes yellow ochre, cadmium orange, cadmium red light, alizarin crimson, viridian, sap green, cobalt blue, ultramarine blue, cobalt violet, and lots of flake white.

Palette:
cadmium yellow lemon
yellow ochre
cadmium red light
alizarin crimson
sap green
viridian
cobalt blue
cobalt violet
ivory black
flake white

Brushes:
filbert bristles
(nos. 3, 4, 6, 8)

Demonstration: Garden Landscape

Rarely did a guest to Monet's home leave without a visit to the garden. This view of Monet's garden at Vétheuil, where he lived before moving to Giverny, is a typical Impressionist scene, full of light and color.

In copying this painting I was interested in Monet's use of color in the darks as well as in the lights. Often painters today run into problems in the handling of lights and darks when they paint from photographs. The camera is not equipped to pick up all the detail in the darks, so an artist may leave out much of the color in these areas. Although I've found it a good general rule to paint less color and less contrast in the shadows than in the lights, there must be some interest in the shadows for a setting to be believable. Observing the color in Monet's shadows can teach you how to do this.

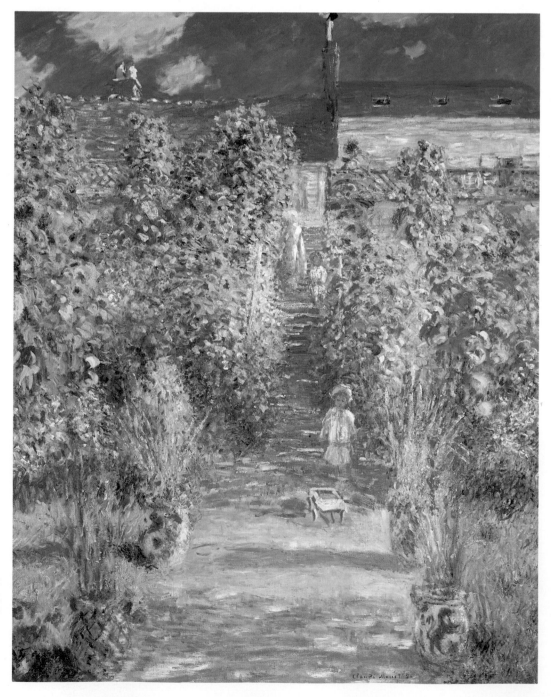

Claude Monet
THE ARTIST'S GARDEN AT VETHEUIL
1880, oil on canvas
59⅝" × 47⅝" (151 × 121 cm)
National Gallery of Art,
Washington, D.C.,
Ailsa Mellon Bruce Collection

STEP ONE. Using charcoal, I first draw in the main shapes of the plants, house, and figures. Because the composition is complex, I then go over my drawing with cobalt blue and flake white (thinned with a little turpentine) to refine the design. Notice that, although the shapes are simplified here, they retain their identity in the finished painting. One way to add life and interest to your own work is to emphasize the shapes in your composition and maintain their character throughout the painting process.

STEP TWO. At this point I work swiftly to cover the entire surface with pale tones. Using pale colors in the initial states gives you the flexibility to make tones lighter or darker as the painting progresses (remember that dark tones are harder to cover than lighter ones). If you later add more intense tones in separate layers, as Monet did, it will give the painting sparkle. Also, it's a good idea to use a clean brush for each of the basic colors to preserve the brilliance of the tones.

STEP THREE. With the basic tones laid in, I work on building up the forms with more intense colors. Often I apply the paint with commalike strokes, as Monet did, so there are many separate touches of color that mingle in the viewer's eye. Notice that even the shadows are filled with color. For the dark greens, for example, I use viridian and cobalt blue. In the foreground you can see the interplay of near-complements: the shadows are mainly cobalt blue, sap green, yellow ochre, and white, while light areas are built up with more white, yellow ochre, cadmium red light, and cobalt violet.

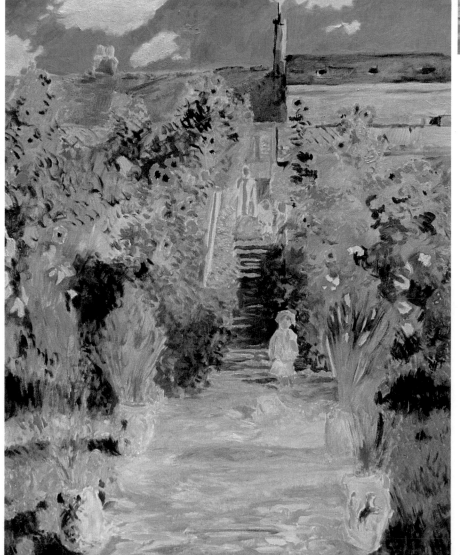

STEP FOUR. As the paint layers build up, the painting acquires atmosphere. One traditional rule for suggesting depth is to make the darks lighter and the lights darker as things recede (aerial perspective). Monet, however, did not follow this rule. Although he did employ linear perspective (the sides of the garden path appear to converge in the distance), even more important is the way the enveloping light creates a feeling of space. Notice again the use of intense colors in the shadow as well as the lights and the subtle contrast of complementary colors, which give the painting its light-filled quality.

STEP FIVE. After the forms are well built up and the layers dry, I add bright spots of color, carefully using a separate brush for each color. Touches of cadmium yellow lemon and viridian enliven the greens, while dabs of pure cadmium red light provide contrasting bright reds. At the very end I add details to sharpen the figures, wagon, and planters, and bring everything into focus.

STEP FIVE

Palette:
Naples yellow medium
yellow ochre
cadmium orange
sap green
cobalt blue
cobalt violet
flake white

Brushes:
filbert bristles
(nos. 2, 4, 6, 8)

Claude Monet
THE HOUSES OF
PARLIAMENT, SUNSET
*1903, oil on canvas, 32″ × 36⅜″
(81 × 92 cm) National Gallery
of Art, Washington, D.C.,
Chester Dale Collection*

Demonstration: Buildings and Water

Looking at this painting, I am continually impressed by how the viewer is thrust into the glowing scene. Everything contributes to the enveloping feeling of light. At the same time there is considerable variety in the vibrant colors and textures, so the viewer keeps on looking—beyond the immediate impact.

In this painting Monet has resolved several potential painting problems. Although, to me at least, the colors seem exaggerated compared with those he would have observed in the actual scene, he manages to portray a convincingly real setting. Also, instead of choosing a single focal point to unify the scene, he has created a delicate balance of heavy textures and vibrating colors within a somewhat circular composition, which keeps the eye moving around the picture. Finally, I was especially interested in how Monet made the different edges of the water, buildings, clouds, and sky all seem to flow smoothly into one another while maintaining their individual character.

STEP ONE. After lightly drawing the subject on the white canvas with charcoal, I elaborate on this with cobalt blue and white lead. The composition here follows a pattern that Monet often used—with the subject placed near the center of the canvas and reflected in water in the foreground. Notice how the lone oarsman adds interest to the lower portion of the painting and helps explain the surface of the water.

STEP TWO. Working swiftly, I lay in patches of color in different areas. To build the underpainting texture, I use a lot of white with my colors, in part because white is a fast dryer and because many pigments are prohibitively expensive to use in great quantity. More important, however, is that white lead creates a luminous base for the somewhat transparent local color that will be added later.

STEP THREE. Using darker but still pale colors, I continue to work swiftly, covering the canvas. Although at times the colors overlap, I do not paint one up to another—the sensation I'm aiming for is that "everything is everywhere." Notice how the touches of cadmium orange I add to the yellow ochre and cobalt violet in the sky begin to interact with the cobalt blue in the buildings.

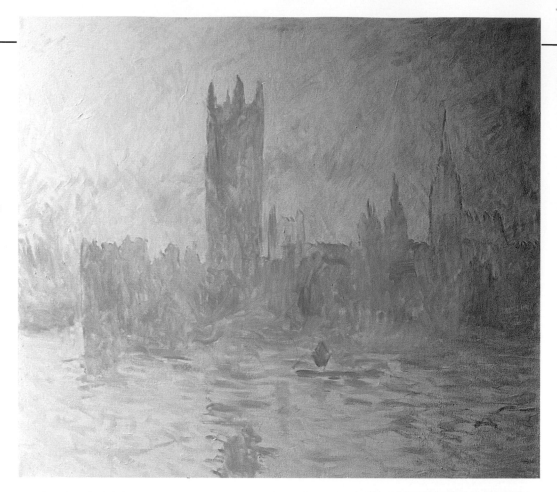

STEP FOUR. After letting the painting dry for a few days, I continue to apply darker tones and to build up texture. Here I use sap green extensively on the tops of the basically blue buildings to complement the pinkish tones of the sky. Later, these and other complementary colors will be heightened to create the sense of dazzling light and color.

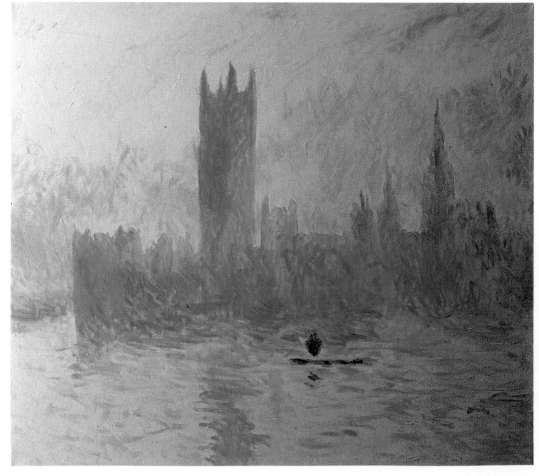

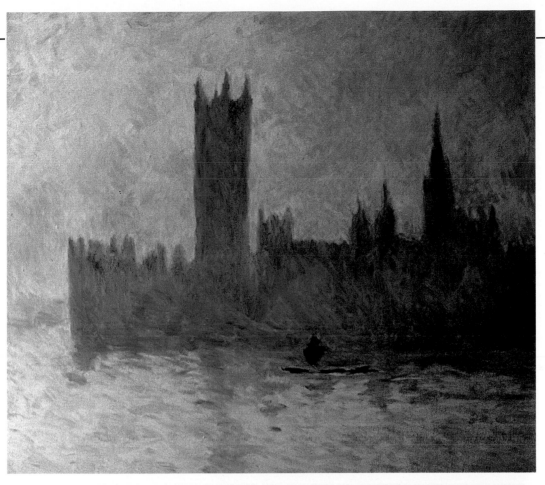

STEP FIVE. As I add more and more layers of color, I simultaneously darken everything. To create the glowing light in the sky, I use several different combinations: cobalt blue and white for the clouds; cobalt violet, cadmium orange, and white for the pinkish areas; yellow ochre, cobalt blue, and white for the yellowish haze; plus touches of Naples yellow medium and white for bright spots. In the buildings, the colors are sap green, cobalt blue, cobalt violet, and a little white, applied with mainly vertical strokes.

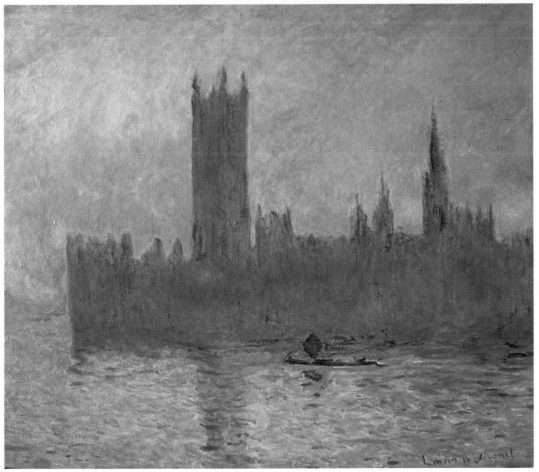

STEP SIX. At this point I add simple, clean color mixtures over the textured underpainting, with its white base, to create a luminous surface. The underlying texture contributes to an all-over patterning in which everything is important. As a final touch, I apply flecks of pure paint, especially in the lower area, where the water is closest. These dabs of intense color bring the water forward and—most important—add a sparkle that gives life to the entire canvas.

95

Painter of Lively Brushstrokes

SARGENT

J

OHN Singer Sargent (1856–1925) is often cited as one of America's greatest portrait painters, although he spent most of his life in Europe. His paintings were influenced by the work of two other artists discussed in this book: Diego Velázquez and Claude Monet. Sargent copied some of Velázquez's paintings in the Prado in Madrid, and he became friends with Monet, whom he visited and even painted at Giverny. From both these artists, Sargent learned about the bold, loose handling of paint, but the style he developed was very much his own.

Opinions on Sargent's work run the gamut from ardent admiration to vociferous criticism. Some of his portraits have been attacked for their lack of feeling and emphasis on surface appearances. Sargent himself became bored with his role as a society painter in his later years. Yet there are many magnificent portraits in his oeuvre, and there is much to learn from his spirited brushwork.

John Singer Sargent
CARMELA BERTAGNA
c. 1880, oil on canvas
23½" × 19½" (60 × 49.5 cm)
Columbus Museum of Art, Ohio,
Bequest of Frederick W. Schumacher

This charming portrait clearly shows how much Sargent's brushwork contributes to the liveliness of his paintings. Notice that, although Sargent used a lot of paint, there is never a feeling of heaviness.

Life and Studies

Sargent was born on January 12, 1856, in Florence, Italy. Both his parents were American, but his mother had persuaded her husband to take up permanent residence abroad. Sargent spent his entire childhood in Europe and did not even visit the United States until 1876, when he was twenty.

As a child, Sargent showed artistic talent and his mother strongly encouraged his efforts. In 1868, at age twelve, he received his first art instruction from Carl Welsch, a German-American landscape painter; two years later he enrolled in the Academia delle Belle Arti in Florence. His mother, however, wanted him to get the best art education available, so in 1874, at age eighteen, he moved with his family to Paris. There Sargent entered the atelier of Emile Carolus-Duran and simultaneously took classes at the Ecole des Beaux-Arts, with which Carolus-Duran was affiliated.

The curriculum at the Ecole des Beaux-Arts required students to begin by copying engravings and then move on to drawing from plaster casts, followed by studies in anatomy, perspective, and life drawing. In drawing from the nude, students were advised to start with a light sketch and then adjust the figure according to horizontal and vertical guidelines established with the aid of a plumb line. The initial emphasis was on accounting for the masses and, later, on the finishing details. Only when drawing had been firmly mastered were students allowed to paint the model.

The instruction Sargent received from Carolus-Duran, however, was even more important. It was Carolus who encouraged him to take up portrait painting and who constantly insisted on the greatness of Velázquez. In his classes Carolus emphasized direct painting, *alla prima*, with close attention to values. His students began a portrait with only a light charcoal sketch and then, without any underpainting, laid in the main planes of the head, working with a large brush. Blending of edges was not allowed; instead, his students proceeded to lay in planes at the junction of large planes and to break up the large planes with smaller planes, all the time carefully observing the change in tone. For Carolus, the secret of painting was in getting the halftone of each plane; dark accents and highlights were to be used only very economically. Carolus stressed that one should always look for the essentials—"all that is not indispensable is useless," he proclaimed.

John Singer Sargent
THE OYSTER GATHERERS OF CANCALE
1878, oil on canvas, 31″ × 48½″ (79 × 123 cm)
The Corcoran Gallery of Art, Washington, D.C.

The influence of the Impressionists' handling of light and emphasis on outdoor painting can be seen in Sargent's Oyster Gatherers of Cancale *(shown above). On the right is his famous portrait of* Madame X, *which caused a minor scandal. When it was originally shown the left shoulder strap had fallen down, but Sargent later repainted this. The reddish ear, which makes the generally pale flesh tones tell, was also decried at the time.*

While studying with Carolus, Sargent probably came in contact with the Impressionists. Their influence is evident in his painting *The Oyster Gatherers of Cancale* (page 98), which won an honorable mention at the Salon of 1878, when Sargent was only twenty-two.

During the next few years Sargent began to establish himself as a portrait artist. He traveled to Spain, where he copied Velázquez's masterpieces; he also visited the Netherlands and was impressed by the works of Frans Hals. Then, in 1884, he exhibited his *Portrait of Madame X* (this page) at the Salon. The subject of the portrait—Mme. Pierre Gautreau—was easily recognizable and the provocative pose of this notorious beauty was met with outrage. It was in part as a result of this scandal that Sargent moved to London.

Although Sargent maintained a studio in London for the rest of his life, he led a nomadic existence, traveling frequently in Europe, the United States, North Africa, and the Near East. During this time he painted hundreds of portraits, in both England and the United States. He also worked on a large set of murals for the Boston Public Library (done between 1890 and 1921).

Sargent was not only a highly skilled painter, he was also an accomplished pianist. During portrait sittings, he often took a break and played on the piano for a few moments. In later years he even played duets with Arthur Rubinstein.

Sargent died of degenerative heart disease on April 4, 1925. It is reported that he died quietly at home, while reading Voltaire. He was buried in Woking, near London.

Ideas on Art

Sargent stressed the importance of painting what you see, without preconceived ideas about how an object should look. As much as possible, he tried to clear his mind of any knowledge of the nature of a subject, to concentrate his energy on its visual appearance.

When he taught at the Royal Academy in London, Sargent encouraged his students to make lots of studies and quick sketches to develop their ability to seize a moment's impression. "Sketch everything," he advised, "and keep your curiosity fresh." He recommended painting flowers, for to do them properly you have to carefully study their forms and brilliant colors. He also suggested that it is a good idea to refresh your approach to indoor portraits by painting landscapes or figures outdoors, as well as by changing your medium from time to time. (He himself did many watercolors, in addition to oils.)

John Singer Sargent
MADAME X (MADAME PIERRE GAUTREAU)
1884, oil on canvas, 82½″ × 43½″ (210 × 110.5 cm)
Metropolitan Museum of Art, Arthur H. Hearn Fund, 1916

Sargent took care to find the exact tones to convey the form. In general he kept his edges soft, except for certain accent areas, to which he wished to direct attention.

FIGURE DRAWING. In teaching drawing, as well as painting, Sargent stressed fundamentals. He advised students to use a plumb line when drawing the model, to correct for their inherent bias to the right or left and to develop an appreciation for the vertical. According to one student, his basic formula was: "Get your spots [the main features] in their right place and your lines precisely at their relative angles." Everything about the pose had to be considered—the way the skull sat on the backbone, how the limbs moved, what the model's individualistic characteristics were. And it was not enough to get the pose in the first sitting and then refine it in subsequent sittings. Instead, Sargent instructed his students to register the drawing afresh at every sitting and to try each time to capture an interpretation of the whole.

Sargent actually demonstrated his ideas to his classes. With charcoal in his hand and his head thrown back, he first carefully studied the model; then he marked off the large masses of the head and shoulders, precisely noting the position of the head in relation to the neck and shoulders. After indicating the mass of hair, he positioned the features exactly and suggested their tonal values and any special characteristics. Finally, he put in the dark shadows and other accents.

COMPOSITION. Although Sargent believed a composition should look easy and accidental, that didn't mean a lack of planning. For him, a sketch was like a floor plan for a building. He urged his students to sketch and resketch a subject until everything came together, so the drawing worked not only as a pleasing pattern of shapes but also as a plausible arrangement, true to what was seen.

The important thing, Sargent insisted, is to develop your power of observation by constantly noting different postures and groupings. The more you look around, at everything, and the more you fix what you see in your memory, the better able you will be to select from what you see when you come to paint.

PORTRAIT PAINTER. Sargent believed that to be a good portrait painter you have to be a good painter first. He told his students that it was a mistake to concentrate solely on portraiture; instead, they should learn everything they could about painting. If they specialized too early and focused only on portraiture, they risked become mannerists.

In his portraits, as in his other work, Sargent concentrated on observing his subject and painting it with a fresh, unprejudiced eye. He once commented that it was easier to get an impression if he had not seen the subject before. If things went awry, he would

Developing the Brushwork

Sargent's oil paintings have a marvelous tactile quality, which you can see in the details of his painting *Repose* shown here. Every brushstroke describes something—whether it is the form, the rhythm, or the space. Sargent never added a stroke without a reason. At the same time he carefully avoided over-working his paintings. If anything went awry, he didn't hesitate to scrape the entire painting down and begin again.

To get the rich quality of paint so evident here, Sargent used a loaded brush. He probably painted no more than three or four strokes, and sometimes less, before dipping his brush into the pigment again. To paint in this way, it's important to choose brushes that are firm and have a lot of spring; old, weak brushes are useless. As Sargent advised, don't add to your difficulties by using inferior materials.

John Singer Sargent
REPOSE
1911, oil on canvas, 25⅛″ × 30″ (64 × 76 cm)
National Gallery of Art, Washington, D.C.,
Gift of Curt H. Reisinger

Juxtaposing Warm and Cool Tones

In general, warm tones are those that move toward yellow on the color wheel, whereas cool tones move toward blue. Sargent's standard palette included four warm tones: yellow ochre, English red, cinnabar (similar to cadmium red light), and Prussian blue (which is a deep greenish blue that moves toward yellow, as opposed to a blue-violet). He also used lead white, which is a warm white. On the cool side, his palette included Naples yellow light, red ochre, alizarin crimson, and ivory black. At times he added viridian and ultramarine blue, both cool colors.

In *Breakfast in the Loggia* you can see how Sargent juxtaposed warm and cool tones to heighten the vitality of his paintings. This painting is bathed in a warm, morning light, evident in places along the ground (A) and on the wall (B). Notice, however, that Sargent has cooled the light area (C) behind the statue to create distance between the relatively warm statue and the wall. Because this tone is cool, the adjacent shadow (D) is also cool. But as the eye travels up the wall to the ceiling, Sargent has alternated warms and cools (E, F, G) to add vibrancy to this area.

John Singer Sargent
BREAKFAST IN THE LOGGIA
1910, oil on canvas,
20½" × 28" (52 × 71 cm)
The Freer Gallery of Art,
Smithsonian Institution,
Washington, D.C.

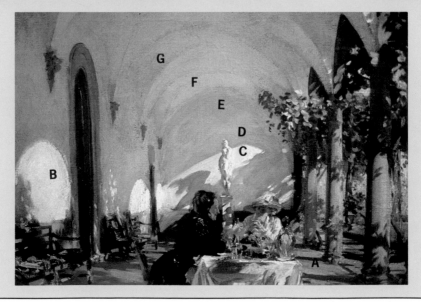

scrape down his canvas and begin afresh at a new sitting in an attempt to clarify his vision and capture the effect of the whole.

LANDSCAPES. For the most part, Sargent disliked the academic approach to subject matter and composition. In his landscapes he aimed to capture a more momentary, "snapshot" effect. The poet Edmund Gosse describes how Sargent would barge out of his house carrying a large easel, a canvas, and his painting materials. He would walk for awhile and then suddenly stop and plant himself down, nowhere in particular. It made no difference if he settled beside a house or in the middle of an open field, his aim was to reproduce exactly what he saw. Indeed, he told one friend that he didn't paint scenic vistas; he simply painted the objects in front of him.

To convey the effect of light, Sargent consistently adjusted his colors to a high key. Usually, when working outdoors, he shaded his paintings from the sunlight with a large umbrella. Doing this allowed the colors on the canvas to appear more nearly in their true brightness. Bear in mind that if you do a painting in direct sunlight, the canvas will appear "washed out" when you later bring it indoors.

Painting Techniques

While teaching at the Royal Academy in London, Sargent gave a number of portrait demonstrations, and his students' descriptions of these provide insights into his techniques. Miss J. Heyneman, for example, reports that he set up his easel directly next to the model so that, when he later stepped back from it, he could see both his painting and the model in the same light, from the same angle. To begin, he sketched the head on the canvas, using only a few, carefully placed charcoal lines. Then, to get rid of the excess charcoal and avoid any muddying of his colors, he gently wiped his drawing with a rag so the lines were barely visible. Using a bit of turpentine with his paint, he proceeded to give the background an overall tone and to suggest the outline of the head by indicating where the light and shadow met. All this was done very quickly.

Now Sargent began to paint in earnest. He didn't use any medium at all; instead, he believed: the thicker the paint, the more it flows. After he got the tone of the background and of the hair, as well as the transition between the two, he concentrated on the middle tones, simplifying the head into its basic planes. Everything, he advised, must be done as economically as possible, and every brush-

John Singer Sargent
THE HERMIT (IL SOLITARIO)
1908, oil on canvas, 37¾" × 38" (96×96 cm)
Metropolitan Museum of Art, Rogers Fund, 1911

Although Sargent is best known for his portraits, he also painted landscapes, in both oil and watercolor. Notice how, because of the loose brushwork, his paintings may seem chaotic when viewed close up, but the image is clear from a distance.

John Singer Sargent
BOATS ON THE LAKE OF GARDA
1913, watercolor, 15⅝" × 21" (40×53 cm)
Hirshhorn Museum and Sculpture Garden, Smithsonian Institution, Washington, D.C.

The psychological drama of this scene is accentuated by the light and dark contrasts. Notice, in the detail, Sargent's expert use of small touches of color.

stroke must count. The idea, he explained, was to draw with the brush, as if it were a pencil.

Following his own studies with Carolus-Duran, Sargent painted directly, working wet-into-wet. He didn't hesitate to paint the shadows as thickly as the lights. If a dark area looked transparent, he believed you should aim for the exact tone to depict this, rather than using a thin stain and letting the ground show through.

As he worked, Sargent developed the whole head as a unit. By constantly stepping back and viewing the work from a distance, he kept a check on the relationships among the different tones. Gradually the mass of the head took shape. This understructure had to be right before he added the features. Miss Heyneman describes how, "under his hands, a head would be an amazing likeness before he had so much as indicated the features themselves. In fact, it seemed . . . the mouth and nose just 'happened' with the modeling of the cheeks." It was because he paid so much attention to the underlying construction that when he added the mouth—to quote Miss Heyneman again—it "bloomed out of the face, an integral part of it, not, as in the majority of portraits, painted on it, a separate thing."

For Sargent, everything in a portrait depended on the underlying structure. He felt it was useless to try to correct the placement of an eye or an eyebrow if the initial construction was wrong. Instead, he would scrape down the entire canvas and totally repaint the head. It didn't matter how much time he had already spent on a portrait—if it wasn't right, it had to be done again. Sargent was quite ruthless in this. Even if a few parts were well painted, he didn't leave them, as they might later interfere with the overall unity he wanted.

Sargent's finished portraits may look spontaneous, but they obviously depended on a lot of hard work and careful observation. Nothing was haphazard. When at the end he added the accents, Miss Heyneman describes how each "was studied with an intensity that kept his brush poised in mid-air till eye and hand had steadied to one purpose." Although the actual brushstroke was laid in rapidly, its placement had been carefully considered. For Sargent, Miss Heyneman explains, these accents "were, in a way, the nails upon which the whole structure depended for solidarity."

Materials

PIGMENTS. Sargent's usual palette included Naples yellow (light), yellow ochre, English red, red ochre, cinnabar (now replaced by cadmium red light), Prussian blue, ivory (or cork) black, and silver white (white lead). At times he also used alizarin crimson, viridian, and ultramarine blue. Two of the pigments—English red and red ochre—are similar. Sargent probably used red ochre for his portrait work, as it mixes well with yellow ochre for flesh tones. English red was more suited for landscapes.

This drawing shows, from left to right, egbert, rigger, filbert, flat, and bright bristle brushes. Sargent often used rigger brushes, but filberts or egberts (more readily available) can be substituted.

As a teacher at the Royal Academy, Sargent instructed his students to load their palettes with lots of paint and to arrange the colors in the same order each day. He also recommended that students equip themselves with plenty of good, thick brushes that would hold the paint. As Sargent explained, painting is difficult enough without adding to the problem by using poor materials.

CANVAS AND GROUNDS. Sargent generally used smooth raw linen, sized with rabbit-skin glue and primed with coats of white lead. Sometimes he added some ivory black or raw umber to the final layer of lead to provide a toned ground.

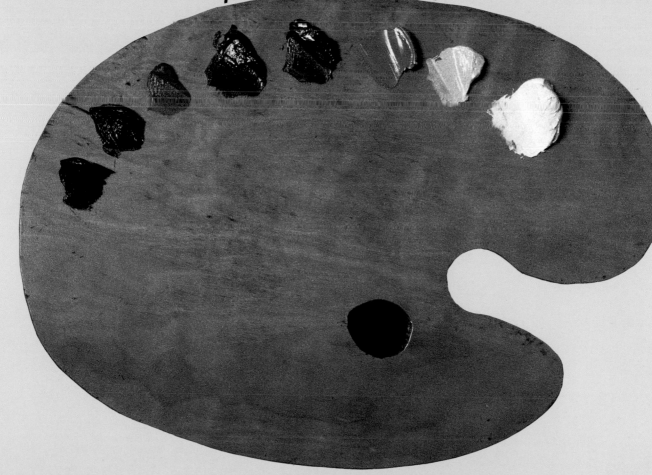

A modern-day equivalent of Sargent's palette includes flake white, Naples yellow light, yellow ochre, English red, red ochre, cadmium red light, Prussian blue, and ivory black.

Palette:
Naples yellow light
yellow ochre
red ochre
cadmium red light
Prussian blue
ivory black
flake white

Brushes:
egbert bristles
(nos. 3, 4, 5)

Demonstration: Portrait Head

What is remarkable to me is how Sargent created a work that appears to be spontaneously painted and yet maintains good drawing and proper proportions. His handling of values is also masterful. While speaking to a student one day, Sargent said, "Painting is an interpretation of tone. [The image is arrived at] through the medium of color drawn with a brush." As I worked on my copy of this portrait, I tried to follow this advice, simplifying the tones and using them to draw the head.

Another problem that fascinated me was Sargent's handling of the darks. Although the paint is thick all over, there is enough detail in the shadows to keep them from feeling heavy. Also notice how Sargent integrated the dark background with the figure in the front. The girl's hair has the darkest darks in the painting; the surrounding background tone—while still very dark—is slightly lighter in value. As a result, the figure stands out from the background, yet is related to it.

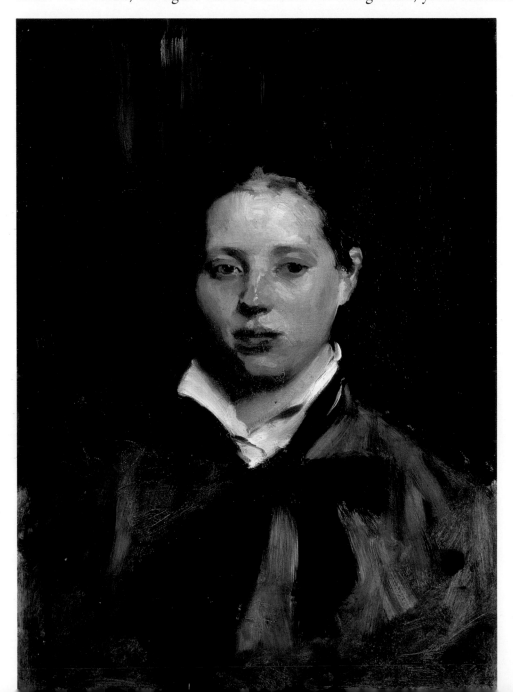

John Singer Sargent
PORTRAIT OF A YOUNG GIRL
(Dedicated to Desire Dihau)
c. 1880–84, oil on canvas
25¾″ × 18¼″ (65 × 46 cm)
The Baltimore Museum of Art,
Charlotte G. Paul Bequest Fund
BMA 1956. 286

106

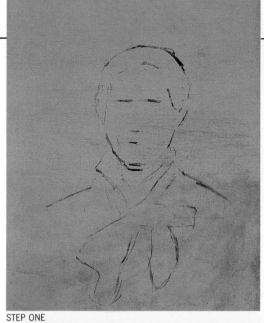

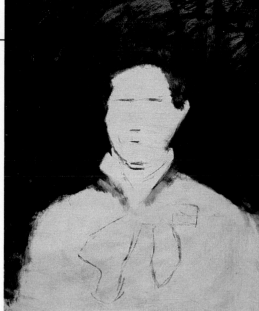

STEP ONE

STEP TWO

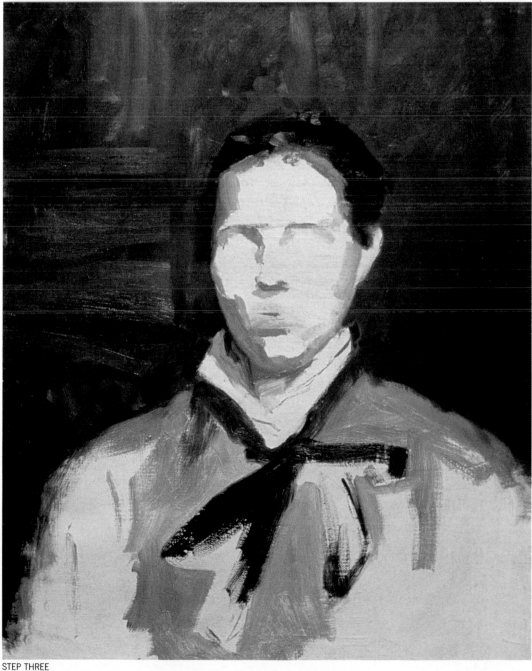

STEP ONE. Using only a few careful lines, I place the head on the canvas. After the drawing is laid in, I wipe the charcoal lightly to get rid of any excess charcoal, which might later muddy my pigments. You can also blow on the surface or spray the canvas with workable fixative to eliminate extra charcoal.

STEP TWO. Working with large brushes, a loaded palette, and a little turpentine to thin the paint, I lay in the background. Usually one would bring the background in only close enough to outline the head. Here, however, the hair and the background are very close in value, so I let the tones cover the hair. By overlapping edges of the background and the figure initially, I can fuse them together once the figure is laid in.

STEP THREE. Using thick pigment, I indicate the middle tones; I also darken the background and block in the clothing. Notice how I work all parts of the painting into each other, rather than painting areas side by side until the tones touch. To paint the face, I start by placing the darker middle tones. For the flesh tones, I use mainly two combinations: red ochre, yellow ochre, and white; and cadmium red light, yellow ochre, and white. To create cooler flesh tones, I sometimes add small amounts of Prussian blue. For the darker flesh tones, I add black and eliminate white.

STEP THREE

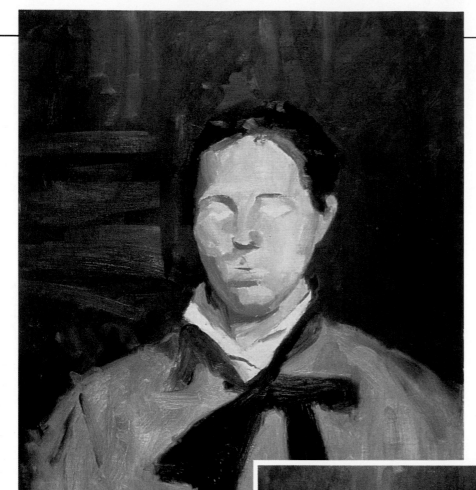

STEP FOUR

STEP FOUR. Using thick, flowing paint, I continue to add middle tones to the head. At times I mix Naples yellow light and alizarin crimson into my flesh tones. At this stage I concentrate on analyzing the different planes of the head and simplifying them, keeping them distinctly separate.

STEP FIVE. In this final step, I place more middle tones at the junctions of already-existing tones. Drawing with paint, I complete the features. To test the effect, I step back from time to time and look at the whole. Finally, I add a few highlights, using crisp strokes and working wet-into-wet. These highlights help to give the painting its look of bold spontaneity.

STEP FIVE

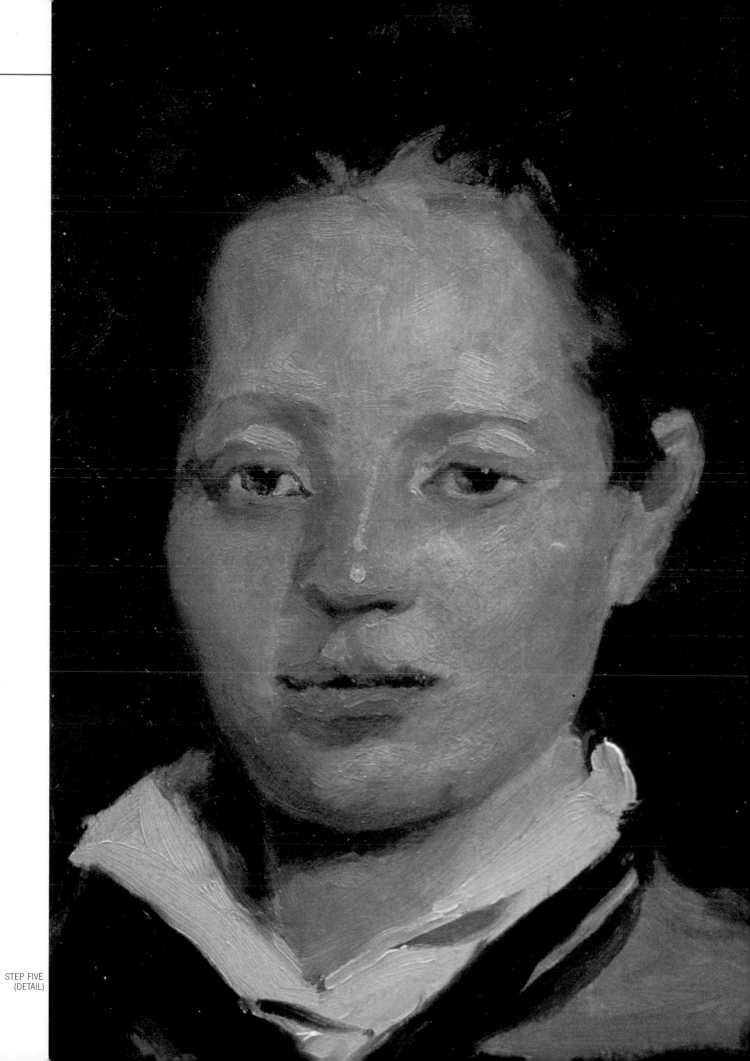

STEP FIVE
(DETAIL)

Palette:
Naples yellow light
yellow ochre
English red
red ochre
cadmium red light
Prussian blue
viridian
ivory black
flake white

Brushes:
egbert bristles
(nos. 3, 4, 6, 8)
round sables (no. 6)

Demonstration: Figure in Landscape

I was attracted to this painting by the calm expression of the beautiful young woman by the water, the bright spots of reflected light, and the play of color in the details. With a sure touch, Sargent has caught the gesture of the figure with seemingly little effort. In copying this work, I learned how Sargent selected only the important details of the scene for his painting and yet created the illusion of a complete picture. Enough information is given for the viewer's imagination to complete the details, and this participation by the viewer increases the painting's aliveness.

John Singer Sargent
THE BLACK BROOK
1908, oil on canvas, 22″ × 28″ (56 × 71 cm)
© Tate Gallery, London

John S. Sargent

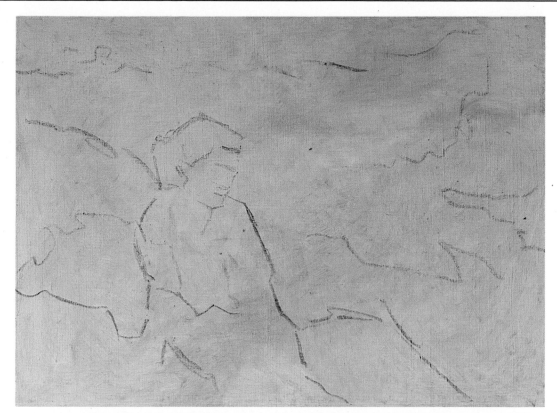

STEP ONE. Using medium charcoal, I place the figure in the landscape with a few lines. This drawing is only a rough indication of the composition; the real drawing will be done with the paint.

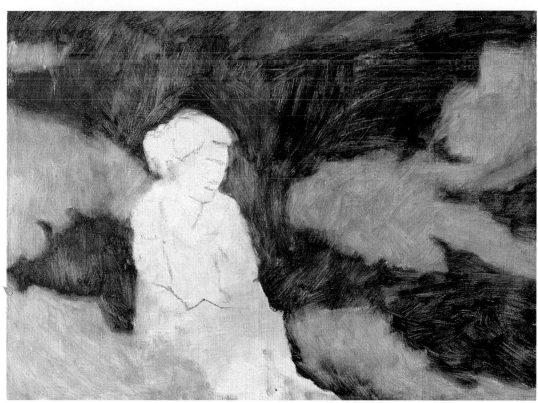

STEP TWO. Mixing my pigment with a little turpentine, I lay in the background, using mostly ivory black, with Prussian blue and red ochre added in spots. For the gray areas, I combine ivory black with a little flake white. Notice how the figure is silhouetted in the foreground.

STEP THREE. At this point I begin to work with thick, flowing paint. As I lay in the figure, I model the edges into the background. For the flesh tones, I use mostly yellow ochre, cadmium red light, and white, with red ochre added in places, or Prussian blue for cooler tones (as in the woman's right hand). The dress is a mixture of Prussian blue, yellow ochre, and white, but I take care in adding the Prussian blue because of its tinting strength.

STEP FOUR. As the painting takes shape, I try to keep both the figure and the background in similar stages of development. Working in this way allows you to balance one area against the other and to adjust the colors and values in the painting as a whole. Remember that everything in painting is relative: the effect of one color will depend on the other colors around it.

STEP FIVE. Now, as I add the features and final accents, the painting comes to life. Much of this vitality comes from the varied brushwork. In the figure, for example, I work wet-into-wet and let the strokes melt into one another. In contrast, for the grass to the left I use a drybrush technique. After letting this area dry partially, I drag a dry brush with unthinned paint across the surface. As a result, in places the grain of the canvas shows through, which gives the effect of sparkling light.

Palette:
Naples yellow light
yellow ochre
red ochre
cadmium red light
alizarin crimson
Prussian blue
viridian
ivory black
flake white

Brushes:
filbert bristles
(nos. 3, 4, 6, 8, 10)
round sables (no. 6)

Demonstration: Seated Portrait

I admire this painting very much because, although in some ways it is modern, it preserves a time-tested tradition—a quality that gives it a certain timelessness. What is also intriguing about this work is the way Sargent has added interest to the portrait by choosing unusual fabrics for the background and the dress of his subject. The somewhat transparent quality of the clothing and the Oriental designs in the background, combined with the delicate peculiarities of the woman's lips and eyebrows, give this portrait a slightly enigmatic feeling.

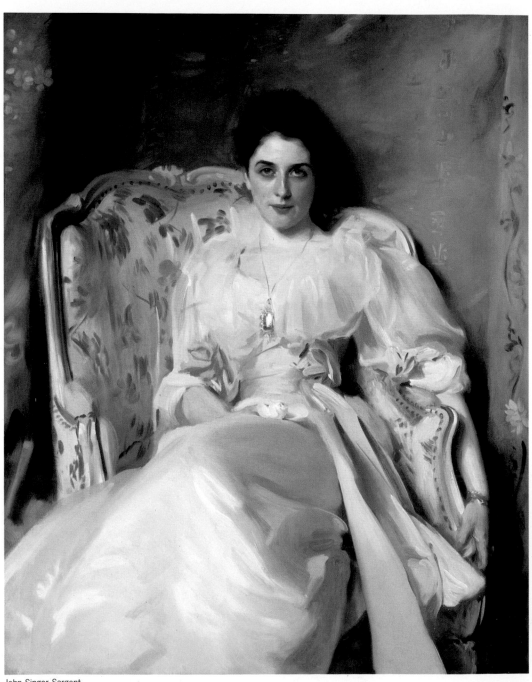

John Singer Sargent
LADY AGNEW OF LOCHNAW
c. 1892–93, oil on canvas, 49½″ × 39½″ (126 × 100 cm)
National Galleries of Scotland, Edinburgh

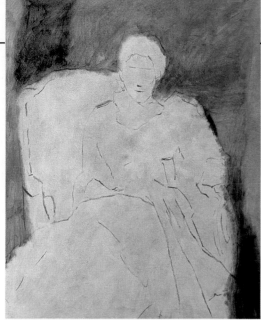
STEP ONE

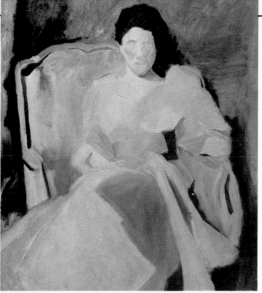
STEP TWO

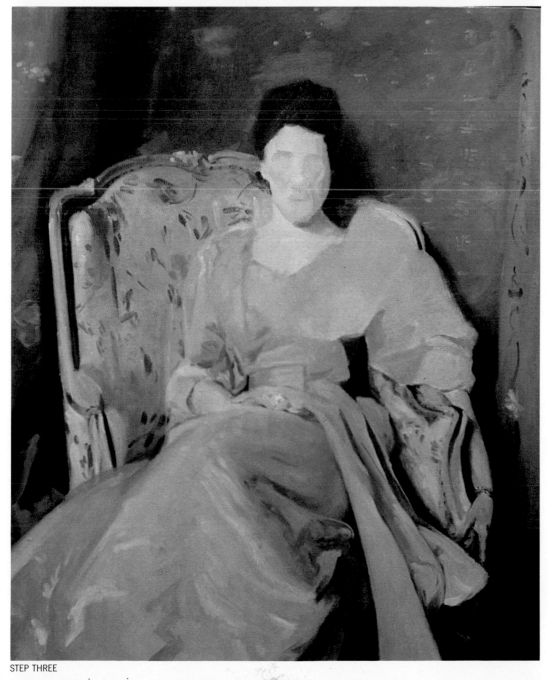
STEP THREE

STEP ONE. After sizing the canvas with rabbit-skin glue, I apply two coats of white, using a palette knife. Then I add an imprimatura coat of ivory black thinned with turpentine, which leaves a silvery color, ideal for portraits. After lightly sketching the large masses of the figure with charcoal, I take a no. 10 filbert bristle brush and lay in the background, using Prussian blue and ivory black diluted with some turpentine. Notice how the background overlaps the chair and figure by about a half-inch all around. This makes it easier to fuse the background with the rest of the painting later.

STEP TWO. Now I concentrate on the middle tones of the figure and the chair. For the flesh, I use different combinations of yellow ochre, cadmium red light, red ochre, and flake white, with ivory black and alizarin crimson added in places. As I work, I take care to fuse the edges into the background, so they become soft yet distinct. A particularly tricky area is the transparent sleeves with the flesh showing through. To get these right, I look carefully for the proper tones.

STEP THREE. Using thick, rich paint, I first work on the details of the chair and background. Then I turn to the details of the dress and sash, as well as the modeling of the hands and arms. Notice the color relationships between the dress and the chair, as well as the background. The chair is primarily a middle-tone gray (made of yellow ochre, ivory black, white, and some Prussian blue), but the patterns include notes of Prussian blue and white. The dress contains different tones of Prussian blue, ivory black, and white, with a little yellow ochre.

115

STEP FOUR. In this closeup you can see how I draw the features in with the paint. I take special care in fusing the flesh with the hair. Instead of simply blending the two together, I search for color and value changes to achieve the desired effect.

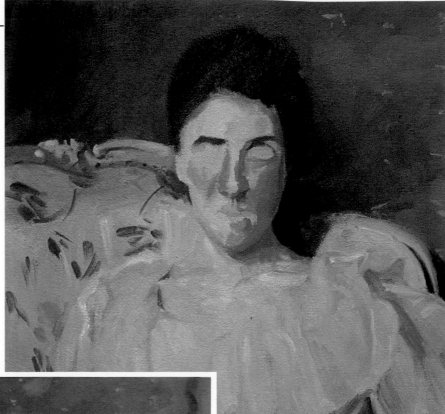

STEP FOUR

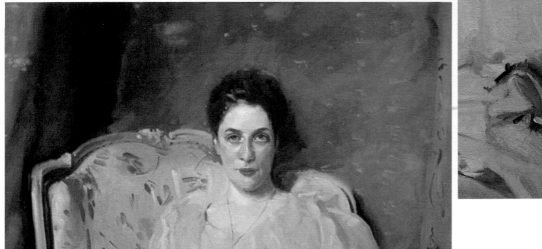

STEP FIVE

STEP FIVE. After completing the features and the necklace, I add the accents (the darkest darks), followed by the highlights. For both the accents and highlights, I use a loaded brush, working into the still-wet middle tones. Keeping Sargent's dictum about economy of means in mind, I employ only a few strokes, carefully placed.

STEP SIX. After the painting has completely dried, I apply transparent glazes (mostly alizarin crimson) to the cheeks and sash. In the finished painting, you can see how irregularities in a person's face can be accentuated to create a particular mood or character. Notice, for example, that the right eyebrow is slightly higher than the left. Had Sargent chosen to paint the two eyebrows in the same way, the woman's expression would not have been nearly as mysterious and enticing.

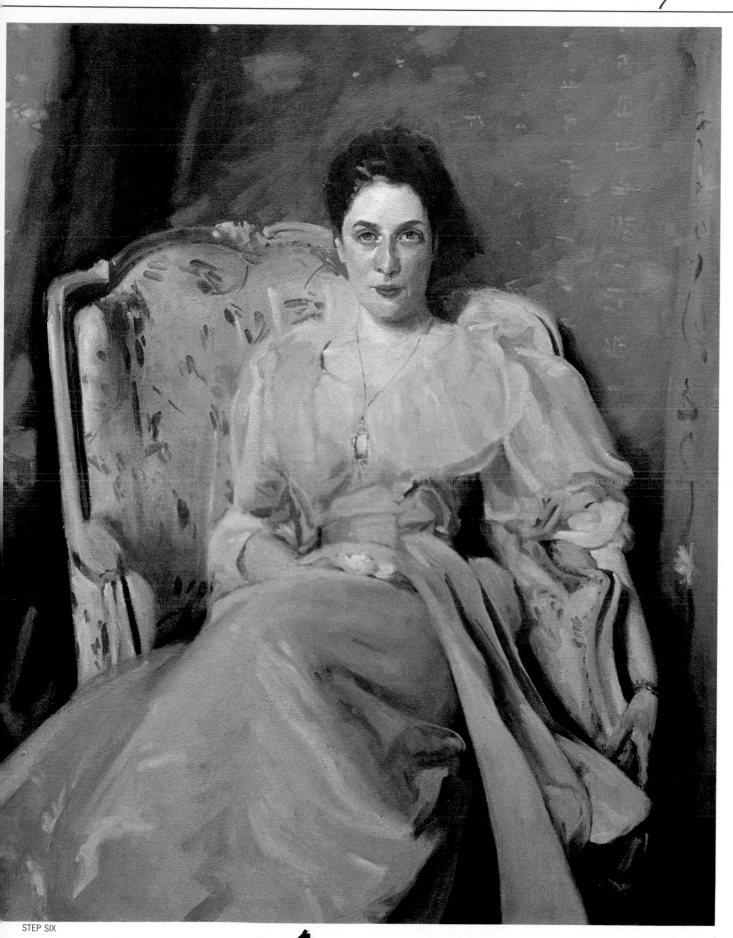

STEP SIX

Creator of Emotive Color

MATISSE

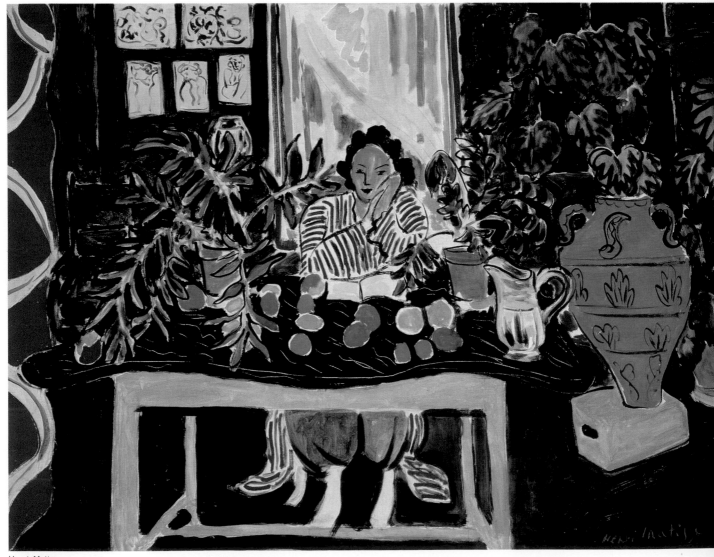

Henri Matisse
INTERIOR WITH ETRUSCAN VASE
1940, oil on canvas, 29″ × 39½″ (74 × 100 cm)
Cleveland Museum of Art, Gift of the Hanna Fund

H

ENRI Emile Benoît Matisse (1869–1954) stands with Pablo Picasso as one of the giants of twentieth-century art. Like Picasso, he was a highly versatile artist, who worked in a variety of art forms—not only painting but also sculpture, etching, lithography, book illustration, stage design, ceramics, and large gouache and paper cutouts.

Matisse's interest in the emotive impact of color and form can be found throughout his career. In the early 1900s he was a main force behind a group of artists called the "Fauves" (French for "wild beasts"). These artists broke with tradition by freeing color from representation and emphasizing its decorative and expressive potential. Although Matisse continued to base his work on nature, he simplified the forms and colors to express the essence of his reaction to a subject. His aim, he once said, was "an art of balance, of purity and serenity, devoid of troubling or depressing subject matter . . . a soothing, calming influence on the mind."

Life and Studies

Matisse was born on December 31, 1869, in Le Cateau-Cambrésis, a small town in the north of France. His father was a grain merchant and his mother, a painter of porcelain. After receiving a classical education, Matisse went to Paris to study law. In 1889 he passed his first set of law examinations and began working as a law clerk in St. Quentin, France. There he enrolled in a basic drawing class at the local art school and drew from plaster casts early in the morning, before going to work.

A turning point came the following year when, at age twenty, Matisse suffered appendicitis. During his long convalescence he acquired a box of oil colors and began to paint. He also read a popular book on how to paint pictures by Frédéric-Auguste-Antoine Goupil, who particularly recommended copying the great masters as a way of learning how to create and compose pictures. Goupil also advised that becoming a successful artist required a lot of patience.

In 1891 Matisse abandoned law and returned to Paris, where he entered the Académie Julian and studied under Adolphe William Bouguereau and his associate,

Gabriel Ferrier. Soon, however, he became disillusioned with his teachers and their attention to superfluous details. Although denied formal admittance to the Ecole des Beaux-Arts, in 1892 he entered the studio of one of its teachers, Gustave Moreau. From Moreau, Matisse received not only a traditional training but also intelligent and enthusiastic encouragement. Moreau advised his students to spend time copying the masters in the Louvre, but he also recommended that they draw outside the museum—in the streets that reflected everyday life. It was Moreau, Matisse later said, who taught him "to see and question the old masters," particularly the work of Jean-Baptiste Siméon Chardin. It was also in Moreau's studio that Matisse met Georges Roualt and Albert Marquet, who later participated in the Fauve movement.

During the summer of 1896 Matisse accompanied Emile Wéry on a painting trip to Brittany. Wéry was an Impressionist, and Matisse was influenced by his colorful palette. Soon thereafter, in 1897, Matisse became friends with Camille Pissarro, who also advised him on the Impressionists' use of color.

In 1898 Matisse married Amélie Parayre, and they set off on travels to London, Corsica, and Toulouse, where Amélie's family lived. When they returned to Paris, they at

Matisse's use of color and design to translate his feelings about a subject is evident in this painting. Notice how he has simplified the scene and emphasized what he experienced as essential.

Henri Matisse

As a student, Matisse copied paintings by Chardin. He was also greatly influenced by Cézanne's work, especially by the way he contrasted and connected colors.

first lived in constant poverty. Matisse was forced to take a job making theatrical scenery, where his wife opened a milliner's shop to help support the family (they eventually had two sons and a daughter).

Despite his poverty, Matisse bought a painting by Paul Cézanne—*Three Bathers*. This work, as well as others by Cézanne, had a profound impact on Matisse's art. At times Matisse borrowed directly from Cézanne's compositions and reworked a particular motif in his own way. More generally, Matisse was influenced by the way Cézanne organized what he saw into planes of color and used these planes as forces in a painting. What Matisse especially admired in Cézanne was his ability to synthesize nature and re-present its essential order and harmony.

As he evolved his own style, Matisse was also influenced by the work of Paul Gauguin and Vincent Van Gogh, as well as the Neo-Impressionists. In the early 1900s he himself painted in a Neo-Impressionist, or pointillist, manner for a brief period, but he felt that this systematic division of the picture surface into small dots of color was too rigid. Instead, he began to use broad areas of flat color in a more expressive way. It was at this point that he joined with such artists as André Derain and Maurice Vlaminck in the movement known as Fauvism.

Eventually regular collectors enabled Matisse to support himself solely from his art, overcoming the poverty he experienced as a young husband and father. In 1905 Gertrude Stein and her relatives began to buy his work, and the following year Claribel and Etta Cone, from Baltimore, purchased the first painting in what eventually became a large collection. Other important collectors included two Russians—Sergei Shchukin and Ivan Morosov—and Albert C. Barnes, who commissioned Matisse to do a mural decoration (now in the Barnes Foundation in Merion, Pennsylvania).

Around 1918 Matisse settled in Nice, on the French Riviera, but he traveled widely, voyaging to North Africa, the United States, and even Tahiti. He claimed that by changing locations now and then, he more fully appreciated the light and space in which he lived.

Matisse received numerous awards and honors and lived to see many one-man exhibitions of his work, including major shows in Europe, the United States, and Japan. In 1948, when he was almost eighty, he undertook a major project—the entire decoration of the Chapel of the Rosary in Vence, France. He saw this as the culmination of his life's work, an opportunity to unify many components—architecture, sculpture, ceramic panels, stained glass windows, vestments, and

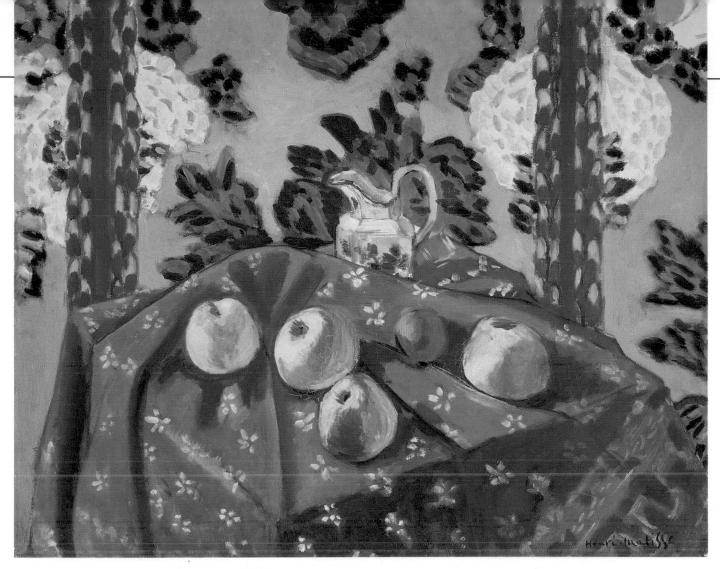

more—into one harmonious creation. The chapel was dedicated on June 25, 1951, and many have described visiting it as a truly religious experience.

A year later, in 1952, the Musée Matisse opened in Le Cateau, near his birthplace. Since Matisse's death on November 3, 1954, there have been several large retrospectives of his work, both in the United States and in Europe.

Ideas on Art

Matisse fortunately left a number of statements on art, from his "Notes of a Painter," published in 1908, to interviews given late in life. Yet Matisse would have been the first to point out that the best way to understand his ideas is through his artwork. He once jokingly remarked that if you want to be a painter, "you must cut off your tongue because your decision takes away from you the right to express yourself with anything but your brush."

Fundamental to Matisse's art is his concern with expression. By this, however, he did not mean simply painting his immediate reactions without any concern for order or structure.

For Matisse, expression went much deeper; he described it as a "condensation of sensations," a distillation of perceptions and responses in which he aimed for the *essential* feeling. What he was after was the inherent truth of a subject, rather than a momentary impression.

Matisse was fond of quoting Delacroix's remark, "Exactitude is not truth." For him, the goal of art was not to copy nature precisely and objectively, as a camera might do. Instead, he advised, the artist must look for truth in the very confrontation with nature, in the sum total of his or her emotional responses, not just in nature itself. Photography, he believed, freed the artist from any need for careful description. There was no longer any reason to produce an objective document. A painting should provide a different kind of truth—a subjective truth.

The artist's most important function, according to Matisse, is to create. "Where there is no creation," he declared, "there is no art." But he did not believe that creativity is simply a matter of talent—it requires a lot of hard work. A successful artwork is the culmination of a long process of assimilation, selection, and interpretation. Essential to this process is the ability to look at things freshly, without

Henri Matisse
STILL LIFE: APPLES
ON A PINK TABLECLOTH
c. 1922, oil on canvas
23¾" × 28¾" (60 × 73 cm)
National Gallery of Art,
Washington, D.C.,
Chester Dale Collection

The influence of Cézanne's compositions is quite clear in this still life, although the style is very much Matisse's own. Here Matisse has exploited the pattern of the tablecloth and the wallpaper to increase the decorative impact of the whole.

Using Color for Expression

Matisse had no set rules for the way he used color; instead, he was guided by his emotional reaction to his subject. He believed that color has a beauty and a power of its own, apart from any descriptive or representational value, and that it acts strongly on our inner feelings. His goal was to achieve an organization of colors on the canvas that corresponded to the feeling the subject evoked in him.

"What counts most with colors," Matisse insisted, "are relationships." In his "Notes of a Painter" he explained that he might begin with a vivid red, which related to the white of the canvas. As he added a yellow or a green, however, the relationship changed. The process of painting then became a kind of balancing act, with constant rearranging of the tones so they all worked together, without canceling each other out.

In another statement Matisse observed that he was not bound to a particular color. He might, for example, replace a blue with a black and yet retain the same overall expression by controlling the relationships. He also noted that the effect of color did not depend on quantity but on the organization of the colors. To make a blue or yellow stand out, for example, he might add red somewhere rather than more blue or yellow.

Matisse instructed his students to "make color follow the form," with variations in the light and shadow areas. He also advised them to use color relationships rather than thick paint to create a feeling of light. Instead of adding a highlight to bring out the form, he suggested that they might work on a background color, in relation to the form.

Henri Matisse
POT OF GERANIUMS
1912, oil on canvas, 16¼" × 13⅛" (41 × 33 cm)
National Gallery of Art, Washington, D.C.,
Chester Dale Collection

preconceptions, as if you were seeing everything for the first time, "with the eyes of a child."

Matisse insisted that there are no new truths in painting. Instead, the artist must try to discover the "deepest significance" of what is already known so that it takes on a personal meaning. Only by returning again and again to the fundamentals and being true to yourself, Matisse believed, will you find an original expression.

Matisse specifically cautioned young artists against the spell cast by their immediate predecessors. "The young painter who cannot free himself from the influence of the preceding generation is bound to be swallowed up," he observed. To avoid this, he suggested, you might look to the distant past or to different civilizations for inspiration. The important thing, however, is to challenge these sources and to continually ask yourself, " 'What do I want?' "

At the same time Matisse pointed out that "whether we want to or not, we belong to our time and we share in its opinions, feelings, even its delusions." Indeed, he proposed that the greatest artists are those who are most deeply marked by their time. His idea was that, to arrive at an honest expression, you cannot simply imitate great art from the past. Although you may study and learn from Raphael and Titian, for example, you have to go beyond them to find a vision appropriate to your own time.

ART INSTRUCTION. For a short time Matisse actually taught at his own art school, which he opened in Paris in 1908. One of his students—Sarah Stein—kept notes from his classes, and these notes shed additional light on Matisse's ideas.

As a teacher, Matisse emphasized three basic areas: a more complete perception of nature, the construction of a painting, and the overall purpose of art. His approach, however, was surprisingly traditional given the direction of his own work at the time. He insisted that students study both antique sculpture and the model and that they concentrate on portraying nature as exactly as possible at first. "You must be able to walk firmly on the ground before you can start walking a tightrope!" he exclaimed.

Matisse urged his students to study Greek and Roman sculpture to understand the fullness of form—how a head, for example, is essentially a ball shape. Unless you can see the whole form, he indicated, the parts will not make sense. And in turn every part has to be considered in relation to the whole for a feeling of unity to result.

As students moved on to draw from the

model, Matisse again insisted that they carefully observe the construction of the whole. "Draw your large masses first," he advised, and look for the relationships between the parts. Every line, he believed, must have a function, and each line must connect or relate to another to suggest the figure's volume. He also instructed students to search for the basic line of movement and even suggested that they assume the pose of the model to understand where the strain was.

Before beginning to paint, Matisse told his students, you should carefully observe the subject and try to understand it in its entirety. "What are you aiming for, above all, is unity," he proclaimed. To achieve this, he indicated, it is most important to organize the colors. "Construct by relations of color, close and distant—equivalents of the relations that you see upon the model," he stated. It was not a matter of actually copying the specific colors on the model but of finding a *translation* so that the colors in the painting had the same harmonious relationship, the same order, as the colors on the model. In one instance Matisse advised a student who was painting a dark-haired model against a gray cloth background to begin by selecting the lightest and darkest spots. Then, he said, "consider every additional stroke in addition to these." The point was to make the colors work together as a whole in the *painting.*

In his teaching, as in his own art, Matisse was concerned with expression. "To copy the objects in a still life is nothing," he claimed; "one must render the emotion they awaken." Everything must be brought together in a painting—the individual characteristics of the objects, the interrelations between them, and the emotional impact of the whole.

COMPOSITION. In his "Notes of a Painter," Matisse provided specific advice on composition, as well as on the use of color (see box, this page). "Composition," he stipulated, "is the art of arranging in a decorative manner the diverse elements at the painter's command to express his feelings." Everything in a painting—"the place occupied by the figures, the empty spaces around them, the proportions"—contributes to the work's expression. Unnecessary details should be eliminated, he insisted, for they may distract from what is essential and interfere with the overall harmony of the painting.

Because the aim of composition is expression, Matisse explained, the composition has to be altered if you change the size or proportions of the surface you are working on. If, for example, you decide to work on a larger surface, you cannot simply square up the composition and enlarge it. Instead, you should

Henri Matisse
ODALISQUE
pencil, 9¾" × 12¾" (25 × 32 cm)
National Gallery of Art, Washington, D.C., Rosenwald Collection

Although Matisse is best known as a colorist, drawing was essential to his work. Compare the rhythm of the line in the sketch above to the gesture of the figure in the painting.

Henri Matisse
LA COIFFURE
1901, oil on canvas, 37½" × 31½" (95 × 80 cm)
National Gallery of Art, Washington, D.C., Chester Dale Collection

Matisse used the same principles of color in executing his large paper cutouts as he did in his paintings.

reconceive the entire composition if you want it to have the same impact, or expression.

Techniques

Although Matisse did not write specifically about his techniques, there are clues to his working methods in various statements and interviews, as well as in his art.

DRAWING. Matisse claimed that he didn't really do preliminary sketches for his paintings; instead, he drew to learn about the form of a figure. Through his long technical training as a student, as well as continual observation of models, he had become so familiar with anatomy that this knowledge was second nature. As a result, when drawing, he was able to concentrate on the feeling of the figure and his emotional reactions to it.

Line, for Matisse, was one of the purest mediums of expression; it allowed, he said, for "the most direct translation of my emotion." The simplicity of his line drawings, however, required a lot of preparation. At times he did preliminary "studies" with charcoal and a stump (a short, thick roll of chamois, felt, or paper used for shading and blending). These preparatory drawings enabled him to become familiar with both the character of the model and the quality of light, so he could later synthesize all these aspects in a drawing done purely in line.

Although Matisse did not use traditional modeling in his line drawings, he was conscious of value relationships. In effect he used the line itself to model the white paper. As he put it, "I modulate with variations in the weight of line and above all with the areas it delimits on the white paper."

PAINTING. Before beginning a painting Matisse usually spent some time looking at and thinking about his subject. While doing this, he probably decided on the basic color scheme, and he may at times have closed his eyes and tried to visualize the picture. Matisse believed that this prolonged contemplative study enabled him to identify more fully with his subject and the execution of the painting itself.

To start, Matisse probably drew on the canvas with a pencil, putting down only the essential lines. At times he might enhance his pencil drawing with tints of cobalt blue applied with small, round brushes. As he proceeded to add color, he might begin with only three or four touches. Soon, however, he was working over the entire surface, considering and interrelating everything at once. A primary concern was the relationship between the colors. He was always aware that each stroke he put down affected the others that had preceded it, and that a change in one tone might necessitate changes in all the other tones.

Once in a while Matisse would stop, stand back, and consider the subject as a whole. His aim, however, was not to create a one-to-one relationship between the subject and his picture. Instead, he sought an emotional correspondence, in which the sense of harmony and balance in the painting was the same as what he experienced in the subject.

At a certain point Matisse might set the

painting aside for a day or two. Then, when he began painting again, he looked for a weakness in the whole. He claimed that by working his way back into the picture through its weaknesses, he eventually rediscovered the flow of the painting's expression, in this way resolving the initial problem

Another way in which Matisse sometimes resolved painting problems was to do what he called a "preliminary sketch." He would begin by preparing two canvases of the same size and then use the first canvas as a sketch for the finished picture. Essentially he worked out the painting on the first canvas and then redid the same subject on the second, but carried it further. In this way he could avoid belaboring a picture and at the same time clarify its decorative design.

For Matisse, a painting was finished when it captured the precise feeling he was after, and there was simply nothing more to add. He felt that he was then free of the work, that it could "stand on its own."

Some additional insights into Matisse's way of working come from an account written by one of his portrait subjects. This woman describes how the portrait took ten sittings to complete, with a few days between each sitting, although Matisse did not let her view the painting until the end. During the first sitting she tried on different clothes while Matisse searched for the right pattern. Once the painting began, she watched his palette and noticed that whenever he changed a specific color, he reworked the entire color scheme of the painting.

Materials

DRAWING. Matisse's drawings were executed in a variety of materials, including pencil, pen and ink, charcoal, black crayon, and lithographic crayon. He also used different shades of paper, such as white, off-white, cream, tan, buff and ivory. At times he worked with charcoal on canvas, or he might combine pen and ink with oil on canvas. For his gouache and paper cutouts, done toward the end of his life, Matisse claimed he drew with his scissors.

PIGMENTS. Matisse's palette probably consisted of the following colors:

Yellows: lemon yellow (probably cadmium lemon yellow), yellow ochre, chrome yellow, raw sienna.

Browns: burnt sienna, bistre (somewhat fugitive), bitumen (fugitive).

Orange: cadmium orange.

Reds: vermilion (or cadmium red light), Venetian red, garnace or madder lake (substitute alizarin crimson), scarlet lake (substitute alizarin crimson).

Greens: viridian, cadmium green, emerald green (a bright but fugitive green for which permanent green can be substituted).

Blues: ultramarine blue, cobalt blue, Prussian blue, cerulean blue.

Violets: cobalt violet, also possibly cobalt violet dark.

Black: probably ivory black.

White: white lead (flake white).

Matisse, however, indicated that he usually had no more than twelve colors on his palette at a time. His standard working palette may have included lemon yellow, yellow ochre, cadmium orange, vermilion, Venetian red, scarlet lake, viridian, emerald green, Prussian blue, cobalt violet, ivory black, and white lead.

In one interview Matisse commented that he generally applied his colors with small brushes and did not mix them too much. He also noted that he used black to cool his blues.

SURFACES. Matisse generally used ready-made linen canvas with a medium, medium smooth, or smooth texture. After the canvas was sized, a thin white lead ground, possibly with some chalk, was applied. For the most part Matisse preferred to work on a white ground, without an imprimatura. Often he let areas of the white canvas show in the finished painting. He also at times took the wooden end of his brush and scraped lines into an area painted with a flat tone, thus exposing the white ground.

This equivalent of Matisse's palette includes flake white, cadmium lemon yellow, yellow ochre, cadmium orange, cadmium red light, Venetian red, alizarin crimson, emerald green, viridian, cerulean blue, cobalt violet, and ivory black.

Henri Matisse

Palette:
cadmium lemon yellow
yellow ochre
cadmium orange
vermilion
Venetian red
alizarin crimson
emerald green
viridian
cobalt blue
cobalt violet
ivory black
flake white

Brushes:
round bristles
(nos. 2, 4, 6)

Demonstration: Still Life

For me, Matisse's painting *Goldfish and Sculpture* represents the more geometric side of his oeuvre. I especially like the way he has ordered the shapes within the picture plane and the extreme simplicity of his design. It could be said that this painting is so simple that it merely teases the eye, but I believe it does more than that. In this work Matisse expresses the joy of color and of the very act of painting.

Matisse has also created an intriguing tension between the illusion of three-dimensional space and the two-dimensional design. The foreshortened sculpture and the strong diagonal on the left lead the eye back into space while the relatively flat color brings the eye forward to the picture plane. There is a suggestion of reality, but it is always clear that you are looking at a painting, and it is what happens in the painting that counts.

Henri Matisse
GOLDFISH AND SCULPTURE
*1911, oil on canvas, 46" × 39⅝"
(117 × 101 cm) Collection,
The Museum of Modern Art, New York,
Gift of Mr. and Mrs. John Hay Whitney*

126

STEP ONE. For this demonstration and the one that follows, I decide to experiment with a method that Matisse describes in his writings. After preparing two canvases with the same dimensions, I place one on my easel and set the other aside for awhile. Before drawing the subject on the canvas with a pencil, I spend some time looking at the original painting and trying to understand its color scheme. Next, using emerald green, cadmium orange, and vermilion, I put in a few touches of color. My choice here reflects my own response to Matisse's painting and the colors I believe set up the emotion of the image.

STEP TWO. As I continue to add touches of color, I observe how each stroke I put down affects the colors already on the canvas. Instead of developing one area completely, I work all over, paying attention to the relationships and trying to keep everything in balance.

STEP THREE. Almost the entire canvas is covered now. Working in this way makes you aware of the power of even a small area of color such as the goldfish or the flowers. Notice, too, how the areas of white canvas, as well as the black outlines, affect the colors.

STEP FOUR. Now I stand back and analyze the picture as a whole to decide what changes are needed in color and composition. When making these changes, I work all over the canvas, as an adjustment in one place calls for another adjustment in another place. I keep standing back, reassessing, and moving in to make further changes. As I alter the colors, however, much of the spontaneous, fresh appearance of the image is lost. Knowing that I have a second canvas available is reassuring. It allows me to treat this as a "working" painting, as an opportunity to explore the color combinations without being afraid of ruining the picture.

STEP FIVE. Once I've decided on all the changes, I take out the second canvas and again draw in the subject with a pencil. All the work on the previous canvas pays off, for now I know what colors to use and can thus preserve a fresh paint quality. I do, however, make a few changes from the previous version to capture the emotional impact of Matisse's painting.

STEP FIVE

Palette:
cadmium lemon yellow
yellow ochre
cadmium red light
viridian
ultramarine blue
cobalt violet
ivory black
flake white

Brushes:
round bristles
(nos. 3, 4, 6, 8)

Demonstration: Figure in Interior

In this work I believe Matisse clearly exhibits his fascination with the decorative pattern of a painting while preserving a certain truthfulness to nature. The stripes in the robe and on the walls, the crosshatching on the floor, the ornamental designs on the table, and the various fabric patterns all contribute to the decorative scheme, yet none of the patterns seems an obvious fabrication.

This painting is also a fine example of how Matisse was able to achieve a vibrancy of color that few other artists have equaled. By juxtaposing intense colors against grayed tones or white spots, where the canvas shows through, he has made the bright colors read. This kind of relationship is important. If he had added more color, the brilliant tones would have canceled each other, creating a paradoxically colorless, garish effect.

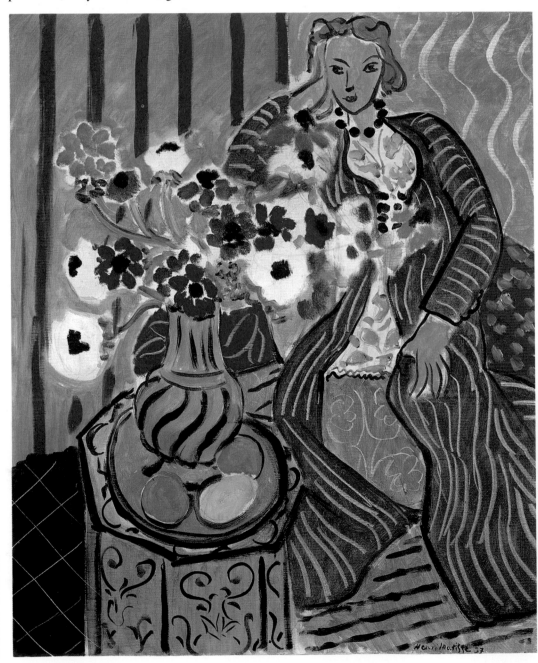

Henri Matisse
PURPLE ROBE AND ANEMONES
1937, oil on canvas
28¾" × 23¾" (73 × 60 cm)
The Baltimore Museum of Art,
the Cone Collection,
formed by Dr. Claribel Cone
and Miss Etta Cone
of Baltimore, Maryland
BMA 1950. 261

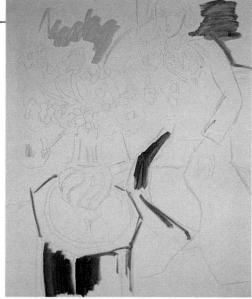

STEP ONE

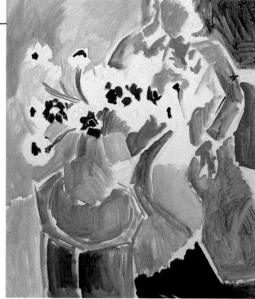

STEP TWO

STEP ONE. For this demonstration, I again prepare two canvases of the same size so I can use one to work out the painting problems. After drawing in the subject with pencil, I locate what seem to me the key colors in Matisse's painting: cobalt violet for the robe, cadmium lemon yellow for the left background, viridian for the right background, and ultramarine blue for the table. I thin the colors with turpentine so they will spread more easily.

STEP TWO. As I cover the canvas, I continually analyze the relations between the colors and their combined effect. Here you can see I've added yellow ochre to the left background and dulled the green on the right with some ivory black. What's important at this point is not to simply copy the colors in Matisse's final painting but to try to understand how he might have arrived at his choices.

STEP THREE. With each color that I add or change, I observe what happens to the other colors. Notice, in particular, what happens when I add more ivory black to the floor on the left and gray the vase.

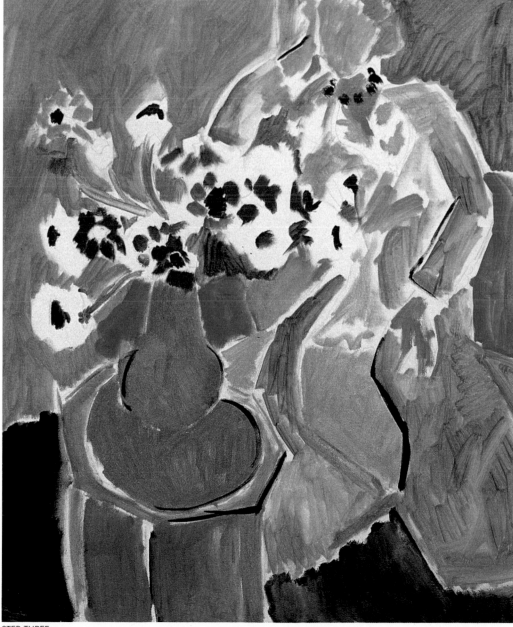

STEP THREE

STEP FOUR. Now the colors are beginning to come alive. Look particularly for what happens to the overall balance as I add red to the orange couch and lighten the floor area on the bottom right.

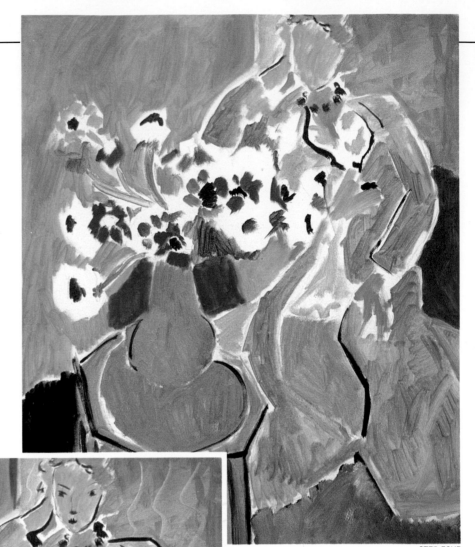

STEP FIVE. In this, the final stage of my study, I bring the colors up to their full intensity. Notice that I've changed the composition slightly to include less of the couch behind the figure; I've also added the fruit on the tray.

STEP SIX. Now I repaint the subject on my second canvas, making use of all that I have learned in the first painting. In places I let the white of the canvas show through, as Matisse did, and this adds to the overall brightness. In other areas I scratch out the paint to reveal the white canvas. To do this, you can use an ordinary steak knife or another similarly shaped tool. To make clean, crisp strokes, without cutting through the canvas, turn the painting on its side, hold the knife in your right hand, and then start on the left and make your strokes go to the right. Keep your strokes simple, and do not try to go back and alter them once they have been made.

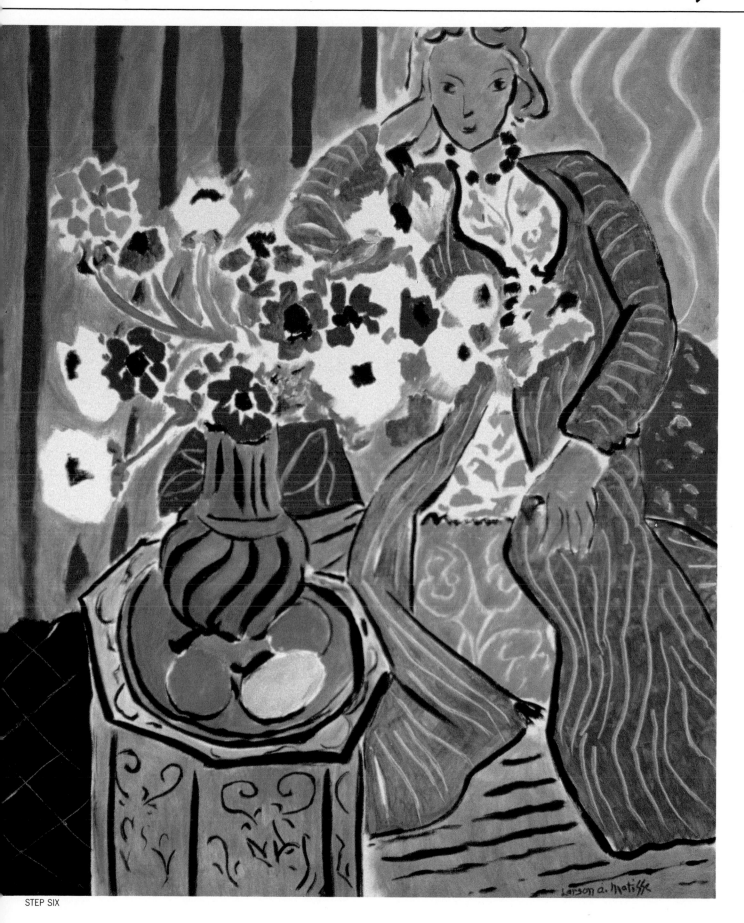

Developing Your Own Paintings

THE LESSONS learned from studying and copying paintings by the old masters provide a solid grounding for creating your own, original paintings. At almost every step of the painting process you can rely on what you have learned from the masters. Aim, however, to learn the lessons so well that they become second nature. This will free you to concentrate on whatever special problems your subject may present.

There are a number of things I consider before beginning a painting. First is deciding on the subject matter. For me, it is generally a choice between still lifes and figure studies, although I occasionally do landscapes. I enjoy doing still lifes because I like to work directly from nature, with the subject in front of me. With a still life, you can easily control the arrangement of the composition and leave the setup unchanged in your studio for the duration of the painting process. Fruit lasts at least four or five days, and even flowers usually last a couple of days, which should be long enough to paint them. Although figure studies are less convenient because of the difficulties in getting a model, they, too, offer an endless array of challenges. Painting a landscape, however, presents a different kind of problem because you can't physically rearrange the scene. Often, after deciding what the important elements of the scene are and what should be omitted, I rearrange the essential parts in my mind and on the canvas to create a more meaningful, eloquent design.

After choosing a subject, I decide on the key of the painting—whether it should be generally dark (low key) or bright (high key). Different subjects call for different keys. I try to set the key in the first stages of a painting and maintain it throughout the painting process. The idea is to have many similar tones or values, establishing the overall key of the painting, with a few strongly contrasting tones, such as a few highlights and dark accents. If you have strong contrasts all over your canvas, then the viewer does not know where to look and is likely to lose interest in the picture. It's best to keep your tones simple, and save a few accents and highlights for finishing touches.

Another important decision involves the composition of my painting. Generally I aim for a pleasing design that contains some tension and mystery. Tension adds visual excitement, while a certain mystery engages the viewer's imagination, in a sense asking the viewer to complete the painting in his or her own mind.

Often, while I am painting, I run into a problem that I am not sure how to solve. At this point I may return to the old masters and try to find examples similar to the subject I am working on, to see how a great artist solved this problem. Deciding on the right background, for example, is often difficult. The old masters frequently manipulated the background to either emphasize or disguise an object. If I am painting a white object, for instance, should I paint the background dark all around it, or should I make the background lighter in spots, to maximize the three-dimensional illusion of the painting? Observing how a number of different artists solved a similar problem can help you to see the alternatives for your own painting. Once you decide what you want, try it out. If it doesn't work, you can always scrape it out and try something else. Solving the problems you encounter can be the most interesting part of painting.

Dean Larson
STILL LIFE WITH TOE SHOES
1984, oil on canvas
12″ × 14″ (30.5 × 36 cm)
Collection of Christopher Beach

Keeping the colors alive in a painting can pose problems. Here I use the spot of green in the tabletop to provide relief from the dominant pink and purple tones.

Setup and Materials

For my own paintings, I prefer to work in a room with a window facing north. North light is the only constant light—unlike direct sunlight, which is always changing. I arrange my easel so the light falls over my left shoulder, as I am right-handed (reverse this if you are left-handed). In this way my hand-held palette remains in the light. The position of my easel then determines where I place other studio equipment such as the modeling stand or still life table.

The quality of the painting surface is also important. Heavy natural linen primed with many coats of glue and lead provides a ground that accepts paint well and is strong enough to withstand many years of canvas expansion and contraction (due to humidity and other natural phenomena). Paintings done on inferior canvas are likely to deteriorate relatively quickly, even if you use a strong medium.

In terms of mediums, I like to use the Maroger medium with my oil paints to give them a good working consistency. Essentially the Maroger medium is a mixture of linseed oil, litharge, mastic crystals, and turpentine (see Joseph Sheppard's *Learning from the Old Masters* and Mary Carroll Nelson's article on "Siegfried Hahn and Howard Wexler" for specific recipes). Although the permanency of this medium has long been debated, I have never had any problems with discoloration or cracking. It is important, however, to take care in its preparation and to use it sparingly when you mix it with your paints.

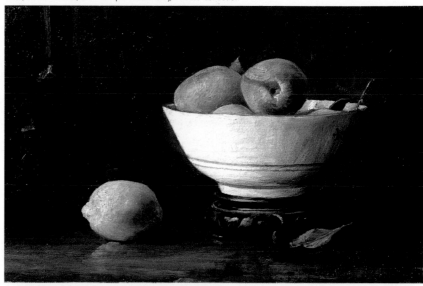

Dean Larson
STILL LIFE WITH PEACHES AND LEMON
1985, oil on canvas, 8″×12″ (20×30.5 cm), Private collection

Dean Larson
PEONIES
1985, oil on canvas, 22″×28″ (56×71 cm)
Private collection; photograph courtesy
of the John Pence Gallery, San Francisco

Creating interest in a painting presents a special challenge. In both the still lifes shown here, I juxtapose areas of bright light against areas of low contrast to give the paintings a dramatic quality. In the portrait I use the white collar to draw attention to the head. Then, to keep the colors in the face lively, I place bright hues in spots where the shadows meet the lights.

Dean Larson
MR. MICKEY GRIDLEY
1984, oil on canvas, 16″×20″ (41×51 cm)
Collection of Mr. and Mrs. Mickey Gridley

Palette:
cadmium lemon yellow
yellow ochre
burnt sienna
van Dyck brown
cadmium orange
cadmium red light
alizarin crimson
viridian
Prussian blue
ivory black
flake white

Brushes:
filbert bristles
(nos. 3, 4, 6, 8)

round sables (no. 6)

Demonstration: Still Life

Because I wanted a sense of mystery in my painting, I set my still life up within a shadow box. The shadow box allows for areas of strong light as well as dark shadows, which envelop the objects. There is thus an intriguing juxtaposition of high-contrast and low-contrast areas.

In arranging the actual objects I decided to use an arc shape, similar to the one in the painting by Jean-Baptiste Siméon Chardin on page 120. As I experimented with the arrangement, however, I found that it was difficult to fit all the objects I wanted to include into one continuous shape. Because of this, I decided to use two arc shapes, instead of the single arc that Chardin used. You can see this compositional device clearly in the first step of my painting.

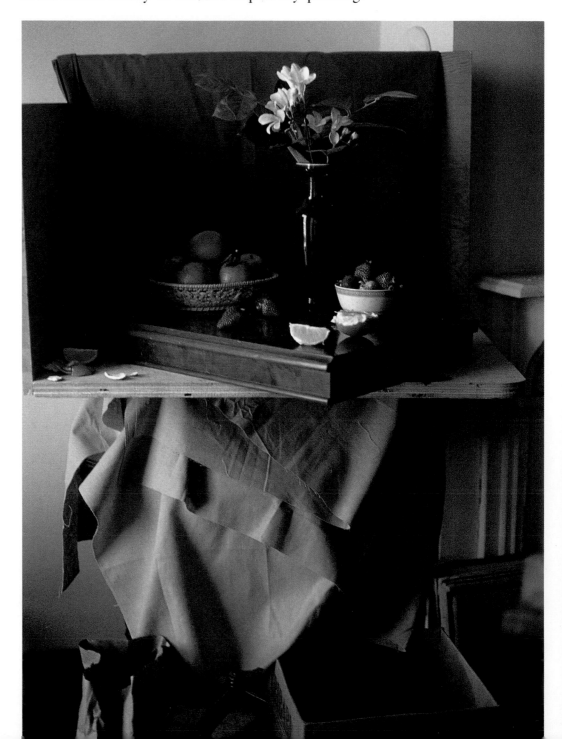

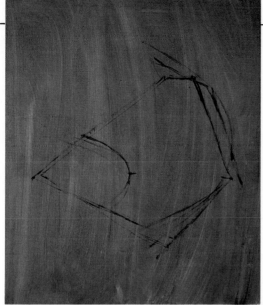

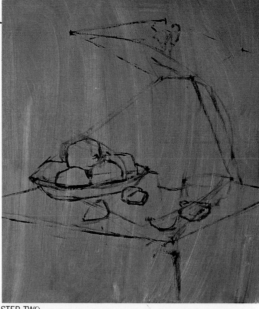

STEP ONE. After applying an imprimatura of burnt sienna, I register the overall shape—the two arcs—using van Dyck brown thinned with turpentine. Then, to draw the objects, I pick out points at the outermost areas of the still life. (The point on the left is the side of the basket of oranges and the one on the right, the shadow side of the bowl.) After placing the first point on the canvas, I hold my brush at arm's length and use it to gauge the angle between the first point and the second. I then register that angle on the canvas and estimate where the second point falls on the line of the angle. For the third point I again match the angle between that point and the first point and mark it. Then I do the same for the angle between the third point and the second. Where the two angles meet on the canvas is the third point. From these three key points I can locate all the remaining points needed to draw the image.

As you continue, be sure to check each new point by gauging the angles to at least three other points. If the angles don't end up at the same point, then your drawing is off. Recheck your original angles and points until you find the error. This process can also be used to change the position of the arrangement— just move your key points.

STEP TWO. Here you can see how I draw the object in using the key points as references. Once everything is drawn, I check and recheck the objects' positions to make sure they are exact.

STEP THREE. Now I lay in the background color. In places I let it overlap the original lines so that, when the objects are added later, I can easily model the edges into the background (see the Sargent demonstration on page 107). For the

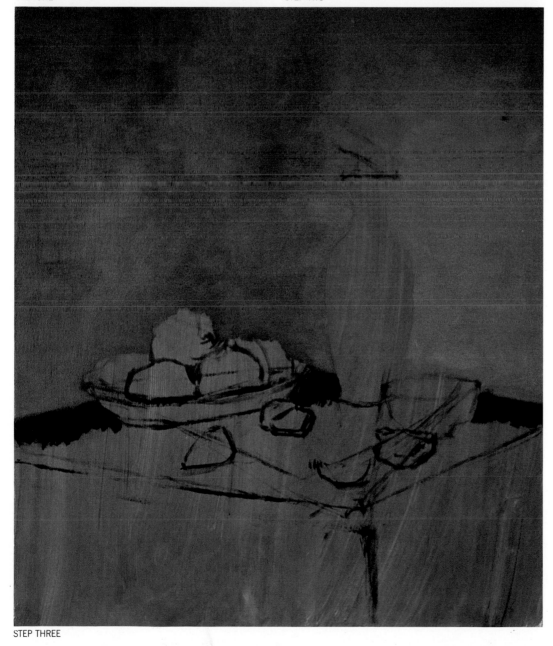

background I use a combination of ivory black, flake white, and yellow ochre, with touches of viridian. In choosing gray for the background, I am guided by the lesson from Henri Matisse's *Purple Robe and Anemones* (page 130)—that to make bright colors read in a painting, you need areas of "non-color." I also think about the lesson from Diego Velázquez (see page 41)—that the background color represents the color of the atmosphere in the painting, and that all the shadow colors should contain some of this color.

STEP FOUR. While the background is still wet, I block in the vase, freesia, oranges, and strawberries in an attempt to get a finished look as soon as possible—there will be plenty to do later. For the greenery I use viridian, with spots of van Dyck brown and cadmium lemon yellow. The vase contains mainly alizarin crimson, ivory black, and cadmium red light, with touches of the background tones in the shadows. The oranges (cadmium orange, cadmium lemon yellow, burnt sienna, and van Dyck brown) also have the gray-green background mixture in the shadows.

STEP FIVE. After letting the painting dry, I again apply colors in a rather direct fashion. To get the character of the strawberries, I carefully observe their odd-shaped highlights and the values of the seeds in the shadows. The colors I choose for the strawberries include cadmium red light and cadmium lemon yellow, with yellow ochre in spots, as well as alizarin crimson, ivory black, and the gray shadow mixture.

STEP SIX. Now I lay in the tabletop using burnt sienna and cadmium orange. In the shadows I use burnt sienna, van Dyck brown, ivory black, and touches of the gray mixture.

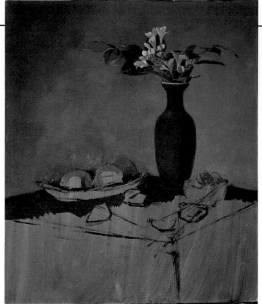

STEP FOUR

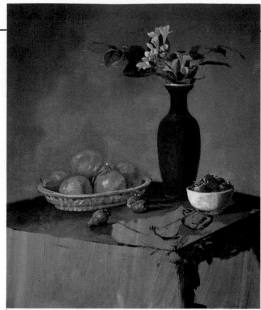

STEP FIVE

STEP SIX

STEP SEVEN. Even in the final stage the painting continues to evolve and changes are necessary. I find that adding another strawberry, in the shadows behind the oranges, enhances the mysterious quality I want. I also notice that the table seems very heavy and bland. To alleviate this problem, I make the angles of its ledges more horizontal.

Problems continually arise in painting, and success depends on finding the best solutions. The solutions may not come immediately; that just means you have to dig in and try harder. Sometimes the answers do not come at all. If a painting is not working well, do not force it. But try to find out why it is not working and avoid the problem the next time.

Dean Larson
STILL LIFE WITH FREESIA, ORANGES, AND STRAWBERRIES
1986, oil on canvas, 20″ × 24″ (51 × 61 cm), Private collection

Bibliography

GENERAL

Callen, Anthea. *Techniques of the Impressionists.* Secaucus, N.J.: Chartwell Books, 1982.

Cateura, Linda. *Oil Painting Secrets from a Master.* New York: Watson-Guptill Publications, 1984.

Charpier, Jacques. *The Art of Painting.* New York & London: Hawthorn Books, 1964.

Church, Arthur H. *The Chemistry of Paint and Painting.* London: Seeley, Service & Co., 1915.

Cooke, Hereward Lester. *Painting Lessons from the Great Masters.* New York: Watson-Guptill Publications, 1967.

Doerner, Max. *The Materials of the Artist and Their Use in Painting,* rev. ed. Translated by Eugen Neuhaus. New York: Harcourt, Brace, 1946.

Dunstan, Bernard. *Painting Methods of the Impressionists.* New York: Watson-Guptill Publications, 1983.

Eastlake, Sir Charles Lock. *Methods and Materials of Painting of the Great Schools and Masters,* 2 vols. New York: Dover Publications, 1960.

Goldwater, Robert, and Treves, Marco, Editors. *Artists on Art.* New York: Pantheon Books, 1945.

Harley, R. D. *Artist's Pigments c. 1600–1835.* New York: American Elsevier Publishing, 1970.

Hiler, Hilaire. *The Painter's Pocket Book of Methods and Materials.* London: Faber & Faber, 1937.

Januszczak, Waldemar, Consulting Editor. *Techniques of the World's Great Painters.* Secaucus, N.J.: Chartwell Books, 1980.

Laurie, A. P. *The Painter's Methods and Materials.* London: Seeley, Service & Co., 1960.

Maroger, Jacques. *The Secret Formulas and Techniques of the Masters.* New York & London: Studio Publications, 1948.

Massey, Robert. *Formulas for Artists.* London: B. T. Batsford, 1968.

Mayer, Ralph. *The Artist's Handbook of Materials and Techniques,* 3rd ed. New York: Viking Press, 1970.

———. *A Dictionary of Art Terms and Techniques.* New York: Thomas Y. Crowell, 1969.

Murray, Peter, and Murray, Linda. *A Dictionary of Art and Artists.* Baltimore: Penguin Books, 1959.

Nelson, Mary Caroll. "Siegfried Hahn and Howard Wexler: Classical Principles and the Maroger Medium." *American Artist* (March 1976).

Rewald, John. "The Impressionist Brush." *Metropolitan Museum Bulletin,* no. 3 (1973/1974).

Sheppard, Joseph. *Learning from the Old Masters.* New York: Watson-Guptill Publications, 1979. (Paperback edition: *How to Paint Like the Old Masters.* New York: Watson-Guptill Publications, 1983.)

Vasari, Giorgio. *On Technique.* Edited by G. Baldwin Brown. Translated by Louisa S. Maclehose. New York: Dover Publications, 1960.

RUBENS

Braham, Allan. *Rubens.* London: Thames and Painters in National Gallery, 1972.

Brown, Hilton. "Looking at Paintings with Hilton Brown." *American Artist* (June 1983).

Buck, Richard. "The Gerbier Family: Examination and Treatment." *Studies in the History of Art.* Washington, D.C.: National Gallery of Art, 1974.

Feller, Robert L. "Technical Examination of the Pigments and Paint Layers: The Gerbier Family." *Studies in the History of Art.* Washington, D.C.: National Gallery of Art, 1974.

Held, Julius S. *Rubens and His Circle.* Princeton, N.J.: Princeton University Press, 1982.

VELÁZQUEZ

Beruete y Moret, Aureliano de. *Velázquez.* Freeport, N.Y.: Books for Libraries Press, 1971.

Brown, Hilton. "Looking at Paintings with Hilton Brown." *American Artist* (August 1983).

Gudiol, José. *Velázquez.* New York: Viking Press, 1974.

McKin-Smith, Gridley. "On Velázquez's Working Method." *The Art Bulletin* (December 1979).

Von Sonnenburg, Hubert. "The Technique and Conservation of the Portrait *(Juan de Pareja)*." *Metropolitan Museum Bulletin* (June 1971).

TURNER

Boisbaudran, Lecoq de. *The Training of the Memory in Art and the Education of the Artist.* London: Macmillan & Co., 1911.

Gage, John. *Color in Turner.* New York & Washington: Frederick A. Praeger, 1969.

Hanson, N. W. "Some Painting Materials of J. M. W. Turner." *Studies in Conservation* (October 1954).

Hardy, George; Lloyd, Mary; Westall, Richard J.; and Ziff, Jerold. *Turner Studies: His Art and Epoch.* London: Tate Gallery (Summer 1984).

Walker, John. *Joseph Mallord William Turner.* New York: Harry N. Abrams, 1983.

Whitley, W. T. "Relics of Turner." *Connoisseur,* vol. 88 (1931).

DEGAS

Janis, Eugenia Parry. "The Role of the Monotype in the Working Method of Degas." *Burlington Magazine* (January 1967).

McMullen, Roy. *Degas: His Life, Times, and Work.* Boston: Houghton Mifflin Co., 1984.

Reff, Theodore. *Degas: The Artist's Mind.* New York: Harper & Row, 1976.

Index

Editorial concept by Bonnie Silverstein
Design by Bob Fillie
Graphic production by Gladys Garcia
Text set in 10-point Janson